Pegi by Herself

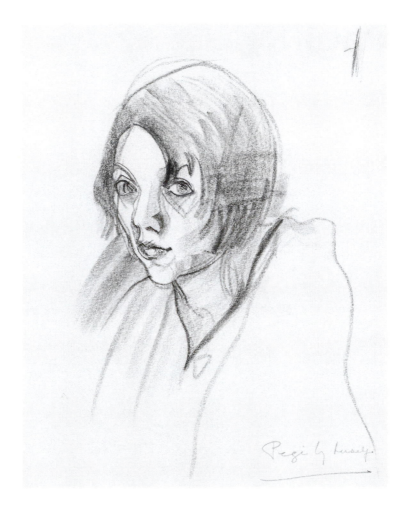

LAURA BRANDON

Pegi by Herself

The Life of **Pegi Nicol MacLeod**

Canadian Artist

McGill-Queen's University Press

Montreal & Kingston • London • Ithaca

© McGill-Queen's University Press
ISBN 0-7735-2863-6

Legal deposit first quarter 2005
Bibliothèque nationale du Québec

Printed in Canada on acid-free paper

This book has been published with the help of a grant from the Canadian Federation
for the Humanities and Social Sciences, through the Aid to Scholarly Publications
Programme, using funds provided by the Social Sciences and Humanities Research
Council of Canada. Its publication has also been generously supported by the
Beaverbrook Canadian Foundation.

McGill-Queen's University Press acknowledges the support of the Canada Council for
the Arts for its publishing program. It also acknowledges the financial support of the
Government of Canada through the Book Publishing Industry Development Program
(BPIDP) for its publishing activities.

Library and Archives Canada Cataloguing in Publication

Brandon, Laura, 1951-
 Pegi by herself : the life of Pegi Nicol MacLeod, Canadian artist / Laura Brandon.

Includes bibliographical references and index.
ISBN 0-7735-2863-6

1. MacLeod, Pegi Nicol, 1904–1949. 2. Painters – Canada – Biography.
I. Title.

ND249.M292B72 2005 751.11 C2004-905356-6

Typeset in 11/14 Electra and Futura.
Book design and typesetting by Glenn Goluska.

Contents

Abbreviations

AEAC	Agnes Etherington Art Centre, Queen's University
AGGV	Art Gallery of Greater Victoria
AGH	Art Gallery of Hamilton
AGO	Art Gallery of Ontario
AGT	Art Gallery of Toronto
AGW	Art Gallery of Windsor
AO	Archives of Ontario
CAS	Contemporary Arts Society
CBC	Canadian Broadcasting Corporation
CCF	Co-operative Commonwealth Federation
CGP	Canadian Group of Painters
CMC	Canadian Museum of Civilization
COA	City of Ottawa Archives
CPR	Canadian Pacific Railway
CSPW	Canadian Society of Painters in Watercolour
CWAC	Canadian Women's Army Corps
CWM	Canadian War Museum
HMCS	His Majesty's Canadian Ship
LAC	Library and Archives Canada
LSR	League for Social Reconstruction
MAA	Maritime Art Association
MP	Member of Parliament
NA	National Archives of Canada
OA	Ottawa Archives
NGC	National Gallery of Canada
PANB	Provincial Archives of New Brunswick
RAF	Royal Air Force
RCA	Royal Canadian Academy
RCAF	Royal Canadian Air Force
RMG	Robert McLaughlin Gallery, Oshawa, Ontario
UAAC	Universities Art Association of Canada
UN	United Nations
UNB	University of New Brunswick
UNBA	University of New Brunswick Archives
UTA	University of Toronto Archives
WAG	Winnipeg Art Gallery
WPA	Works Progress Administration (U.S.)
WRCN	Women's Royal Canadian Naval Service

Illustrations

Preface
Rediscovering Pegi

THIS IS THE BIOGRAPHY of an unusually appealing, creative, and significant Canadian woman painter whose life encompassed the first half of the twentieth century. A complex and sometimes-contradictory individual, Pegi Nicol MacLeod was for many people a beacon of Canadian bohemianism; she was an original and successful artist, widely admired by her contemporaries. I have written about her because I have found both her life and her art unfailingly stimulating and believe that she should be far better known. She was a uniquely gifted painter and a remarkable Canadian. I tell her story in the context of her times and as much as possible through her own words and paintings and the reminiscences of her friends and colleagues. The tale is, none the less, a subjective recreation of her life and must of necessity bear the mark and personality of her biographer.

I bring to this study of Pegi, as she was always known and remembered, as much of myself as she brings of herself to me.[1] My approach to her life is shaped by my encounters with her on a personal basis over the course of my own, and the subjectivity of my response to her life and work frames this biography. My model here includes Simon Schama's *Dead Certainties (Unwarranted Speculations)* (1992), which explores in one section the influence of Francis Parkman's personal life on his historical studies of New France. My version of Pegi's life therefore will inevitably differ from that of another writer with a different subjective bias. This same

subjective influence shapes the memories and recollections of her friends. They responded to those aspects of her character and work that they found personally meaningful and engaging, and these recollections took priority in their understanding of her. There was never one Pegi for those who knew her – only the myriad Pegis that became the stuff of personal memory. Yet while her friends' kaleidoscopic views of her art and personality provide some equilibrium to the subjectivity of this biographer's story of her, it is Pegi's own views of herself, as recorded in her paintings and letters, that provide balance to both.

The writing of women's biographies has been the subject of significant analysis in recent decades, and I owe a debt to this important genre.[2] Feminist approaches and gender analysis have made it increasingly possible to explore women's lives within parameters that were hardly imaginable a generation ago. The so-called private sphere is now a legitimate topic of examination for its impact on the public lives of women and men. A biographer can thus look at a woman's professional life in the context of her life cycle and its transitions or rites of passage, such as marriage and childbirth. Moreover, he or she can also factor in the effects of the inherent restraints that accompany these markers. Most notably, one can now explore a multiplicity of identities for the female subject without letting any one detract from any other. The subject can be woman, mother, artist, friend, and wife together and separately. These liberating breakthroughs allow exploration not only of the documented evidence of women's lives but of their emotional responses too, expressed perhaps in less than traditionally evidential ways. In the case of Pegi Nicol MacLeod, this flexibility has proved very stimulating for me, although, in any final analysis, my book is not obviously reflective of these approaches.

In terms of Canadian art history, the subject of Canadian women artists has received significantly greater attention in recent decades although the literature is still not substantial. The published work of many notable Canadian art historians including Christine Boyanoski, Maria Tippett, and Esther Trépanier is referred to throughout my book. Special credit must be given, however, to the leadership in this field of study shown by the late Natalie Luckyj of Carleton University. Almost single-handedly, she engendered appreciation for Canadian women artists in several generations of Canadian students. That there is a literature on Canadian women artists at all is in large measure the result of her commitment. Her own work is exemplified in her exhibition catalogues on Prudence Heward and and Helen McNicoll.[3]

I think that I must have always known about Pegi. From the ragbag of memory come recollections of my Toronto-bred mother, Mary (Greey) Graham, telling me of a Canadian artist in New York whom she had known during the Second World War, who always drew and painted wherever she found herself. "It just flowed out of her like water out of a tap," as her artist friend Caven Atkins later commented.[4] In the 1950s and 1960s, a painting by Pegi that hung in our family room in London, England, for as long as we lived there triggered my mother's recollections of her (Fig. 13.3, p. 168). A vibrant street scene in New York, full of swirling, colourful people, it remains to this day something of an oddity in my post-war childhood reminiscences, which consist predominantly of Dickensian vistas of London's rain-drenched, black-slated roofs; wet and slippery side-walks of grey York stone; bombed buildings; and the constant and curiously comforting throb and hum of traffic, animated only by an ever-swirling, thick, opaque, greenish-yellow smog. Like some cheerful souvenir of a long-ago Caribbean holiday, Pegi and her painting hung around the fringes of our family's life. While she made her presence felt as an acceptable storyline from my mother's Canadian and wartime past, she was irrelevant to my life. She was already dead and had no place in my own evolving world.

I moved to Canada in 1976, first to Toronto with my husband. It was not until I relocated to Prince Edward Island in 1979 and saw an exhibition in Charlottetown in 1980 that I remembered Pegi.[5] Her painting in the show was of young hockey players. I can remember every detail.[6] That chilly scene of young people and the way the paint was put down made me stop in my tracks. Later, I began to ask people about Pegi and found in the early 1980s that while her work was quite well known in the Atlantic provinces, no one knew much about her life. I determined to find out more and gathered enough material for a short article that appeared in *Arts Atlantic* in 1983.[7]

In 1982, Gallery 78, a small establishment in Fredericton, New Brunswick, toured her work, and the show came to the island.[8] Before I left the centre that displayed it, I called my mother to tell her how much the paintings had moved and impressed me. It was the first substantial body of work by Pegi that I had ever seen, and it stiffened my resolve to find out more about what seemed to me to be a most original artist. I decided to write a book.

I had heard of Pegi all my life and had seen one of her watercolours since babyhood; now, living in a region that meant so much to her in her

last decade, I found that she became a strong presence in my life. When I first expressed a wish to write about her I was in my thirties, as she was when she first arrived in Fredericton, and I had a child the same age as her daughter, Jane, had been at that time. Pegi and I shared – at a similar age and in similar circumstances – a growing need to expand our horizons and found inspiration in the same region. Unlike Pegi, however, I could reconsider my role in the light of feminism and the women's movement. For me, in the 1980s, recovering a near-forgotten woman artist enabled me to discover myself. And, in the course of this journey, I learned about the country and personalities that had shaped both Pegi and my Canadian parents.

Educated wholly in England, I knew little of Canada's history, and absolutely nothing about its art. Through Pegi I have learned about turn-of-the-twentieth-century village and small-town Ontario, where my own and her forbears lived, and about the contrast between stolid Toronto and vibrant Montreal. I have met Canada's First Peoples: Pegi was a member of the group of artists who went to the west coast in the 1920s to depict them and their crumbling culture. Like Canada's celebrated Group of Seven, a Toronto-based association of painters whom I had newly encountered, she too loved the wilderness and found it a romantic subject. Through her, I have met earlier Canadian intellectuals and their circles. Some of them, in due course, came to govern Canada and helped make the country more politically and culturally mature. I have seen how such people reacted to the Depression, to war, and to changes in the social structure and fabric of their lives. I had known nothing about the 1930s and its pain, which shaped so much of Pegi's life – this even though at its depths my father had lost his job, and my grandfather, his wealth.

And there was more. I think that it must have been her personality that reached across the decades and attracted me. I am not at all unusual in this response to her. People who met her only as children or who knew her really well over seventy years ago recalled her as a charismatic character, who left her mark on an astonishing variety and range of people. As I encountered them in the course of my research, many found it hardly believable that she had been dead so long – since 1949 – such was the enduring strength of her personality. Her two closest friends, Marian Scott and Madge Smith, had kept her letters. Writing in her journal shortly after Pegi's death, Marian noted: "Been going over Pegi's letters bringing her more alive to me than perhaps she has been in the last ten years. A warm

tenderness of regret – and yet it could not really have been otherwise. But she is one of the people I feel grateful for."[9]

I never met Pegi in person; I was born after she died, but in the research for this book, I have come to know her very well. For me it was an intense experience to recreate the personality, mannerisms, hopes, and dreams of a lifetime of someone who no longer exists, except in people's memories – in this case, very happy ones. Clearly, as occurs in the biographical act, that which I have wanted to know about her also pulled me in. She may be a product as much of my own desires and wishes as of the letters, paintings, and others' memories that constitute her material legacy. In tracing Pegi's life and work, which remain inextricably linked, I have fallen under the spell of her compelling personality. I have enjoyed the process immensely, finding myself caught up both in her infectious exuberance and by her very real tragedies, struggles, and sorrows. In the end I have understood why Pegi had mattered so much to my mother, who had also responded in much the same way. This journey to understanding has taken a long time.

Pegi by Herself

Introduction

An Urban Life and Vision

AT THE TIME OF HER DEATH IN 1949, Pegi Nicol MacLeod was an established and nationally known Canadian artist with a reputation that merited the remarkable achievement of a memorial exhibition at the National Gallery of Canada.[1] Furthermore, Vincent Massey, then at the height of his career and the most influential layperson in the arts in Canada, opened the show. In response to this display, one writer heralded Pegi's contribution to Canadian art as "work that is possibly more refreshing, more expressive of our times, than that of any other woman painter."[2] Another noted that her "early death is a great loss to Canadian art. Had she lived only a few years longer, she would have reached a new peak in her painting, a style perhaps more disciplined and solidified, the ultimate mastery of her prolific genius."[3]

What was this work that so impressed critics? The exhibition contained the traditional subject matter of portraits, self-portraits, landscapes, cityscapes, still lifes, and figure subjects. What made them different, however, was how they were painted. In some, the paint was controlled and the brushstrokes were regular and even, but in a majority the ebullient, swirling curves of brightly coloured paint that were Pegi's trademark combined to create an impression of bright energy and infinite liveliness. Pegi's paintings are like jazz. Whatever the subject, her colours and lines weave a complex and often energetic or discordant harmony that is unforgettably hers.

We must not, however, separate her painting from her personality. Her admirers liked her as much as they liked her work, and once the prop of their friend and colleague disappeared her work was less secure. The memorial exhibition was, in some respects, her swan song. There was limited follow-up. She had been living in New York and had no promoter in Canada, and Norman MacLeod, her husband, died shortly after her, leaving only their teenaged daughter, born and raised in New York and just barely aware of her mother's significance in Canadian art history. Only in the Maritimes have occasional exhibitions kept her star burning — but as an artist of regional significance. The same has proved true of the literature. J. Russell Harper's extensive 1963 article on her in the *Dalhousie Review* has the title "Pegi Nicol MacLeod: A Maritime Artist."[4] While Pegi moved in the highest of art circles in Canada, that did not assure her a long-lasting national reputation.

In national terms the more recent published literature has been modest. Charles Hill's exhibition catalogue *Canadian Painting in the Thirties* (1976) provides a biographical overview, places her in the context of her time, but does not explore her approach to painting in any detail.[5] Dorothy Farr and Natalie Luckyj's *From Women's Eyes: Women Painters in Canada* (1975) includes a brief biography.[6] Luckyj's exhibition and catalogue *Visions and Victories* (1983), again on Canadian women artists, draws attention to the personal nature of Pegi's subject matter.[7] This element comes across even more strongly in Joan Murray's volume of Pegi's letters (1984). In this first significant study on Pegi, a substantial essay by Murray positions her as a painter whose art at her death was moving towards the abstract.[8] In response to the increasing amount of published information on Pegi, Dennis Reid included her briefly in the second edition of his survey of Canadian painting (1988).[9] She also appears in several contexts in Maria Tippett's survey of Canadian women artists (1992).[10]

In general, however, beyond an acknowledgement of the personal focus to her work, there has been little study of its meaning and origins. I attempted to address this gap in my MA thesis (1992) but restricted myself to her self-portraits. This volume acknowledges that her work as a whole is of significant and unusual strength and that, in particular, the art of Pegi's last fifteen years should be better known. Pegi responded to developments in contemporary painting and evolved a unique technique and approach that has no Canadian equivalent in the period. Her work also sheds light on the changes in Canadian art in the years just after the Second World War.

Pegi was a quintessentially Canadian artist. Formed in small-town Ontario, she had early training at the beginning of the 1920s – at the Art Association of Ottawa and the École des Beaux-Arts in Montreal – that exposed her to several influences – most notably, the Group of Seven, tempered by a European academic tradition. Onto this she later grafted the influences of early- and mid-twentieth-century New York. She lived in that city virtually permanently from the age of thirty-three, and there in 1947 she launched a memorable touring exhibition for Canada entitled *Manhattan Cycle*. Its subject was metropolitan New York, and its intended audience was the small-town Canada that she had left.

The Canada that nurtured her has vanished. In her day there was no strong public support for artists – no Canada Council, for example; only a few private individuals encouraged and collected contemporary Canadian art; and only the odd private institution offered help in kind. For example, it was the Canadian Pacific Railway that transported Pegi west in 1927 and 1928 so that she could paint Native life and culture, then seen as threatened. She was relatively unusual in painting across Canada, from Prince Rupert to Cape Breton, with long sojourns in Toronto, Ottawa, Montreal, and Fredericton, but her country also confined her. While she encountered it geographically, she never really left the small-town culture that had formed her. She did not measure herself against an international standard of any kind. The dominant collective goal of artists in her early years in the 1920s – one shared by virtually all her friends and colleagues – was the development of a national school of art, and it was within this framework that she made her reputation.

Although Pegi reached artistic maturity in New York in the 1940s, she resisted abstraction. While she was not actively anti-abstraction or reactionary, the influences of her youth, in the form of National Gallery of Canada director Eric Brown and his circle, led her to prefer a narrative technique and subject matter that did not fit easily into the abstract art proliferating around her in New York. She remained strongly tied to a Canadian culture, in which "interest in modernist art developed slowly and entered the Canadian consciousness initially in theoretical literature and experimental ideas imported from England and the Continent rather than being stimulated by the work of actual artists."[11]

Pegi's death coincided with the beginning of a new era in Canadian art. Within two months of her death, Vincent Massey became chair of the Royal Commission on National Development in the Arts, Letters

and Sciences (Massey Commission), whose recommendations led to a new structure for government support for the arts in Canada.[12] In 1955, H.O. McCurry would retire as director of the National Gallery, and his successor was Alan Jarvis, who promoted modern art. The 1950s in Canada featured a burgeoning number of professional art curators, expanding art markets to accompany the new post-war affluence, and an enormous growth in professional institutions to show art. The art world was increasingly international in its focus, and countries such as Canada moved from creating national schools to measuring their domestic reputations against the international and dominant standard that was modernism. For many Canadians, New York set the international standard. Timing is one of the ironies of Pegi's career. She left Canada too early to imprint herself on the history of Canadian art and died too soon to take advantage of her exposure to modern art in New York.

Pegi placed painting at the top of her list of priorities all her life. It was her career, and she was professional in her approach to it. During the Depression she struggled to make a living as a painter and illustrator and did comparatively well – in those times, a poverty-line existence. Marriage and motherhood did not stop her painting, although her husband may well have longed for the more settled domestic existence of his contemporaries. In her maturity, she remained dedicated and ambitious. She exhibited continuously in group shows and organized a number of significant solo exhibitions for herself. As well as painting, she taught, illustrated, and designed and also wrote criticism, poetry, drama, and fiction. She was also musical. She possessed a compulsion to create and a need to share that which she found compelling.

Pegi drew her subject matter from her immediate surroundings and personal experiences. In general she painted and drew her world as she found it, while occasionally, sometimes brilliantly, layering in the political and intellectual concerns of her circle and acquaintance. Almost always her own circumstances and opportunities determined her compositions – as in her concentration on her child and her daughter's friends as subjects when she was home. This focus on her private sphere is what gives her work as a whole its unique cohesion. She received no commissions that led her to produce works reflecting the viewpoints of others, and the swift immediacy of her technique only rarely allowed for the thought-provoking or the abstract. Her few works that contain more general reflections still emerge from her own understanding of her personal

world. As a result, her oeuvre as a whole constitutes a portrait of a person, a period, and an environment.

To the great benefit of would-be biographers, Pegi left a significant body of revealing documentation, both painted and written. Letters to friends express her frustrations in combining wifehood, motherhood, and a painting career in Canada during the Depression and in the United States during the Second World War. Those to close friends such as Marian Scott provide insight into her life as an artist and a woman. Friends kept her letters as bearers of memory and of her "unique and vivid individuality," as her admirer Vincent Massey put it.[13] "She gives so much of herself in her letters," noted Marian Scott.[14] Virtually none of the replies has survived, however, save for those from employees of the National Gallery of Canada, which document fully her remarkable relationship with the country's premier art institution.

Additional material includes Pegi's own published writings, newspaper reviews and critical essays on her work, and other people's diaries and photographs. These primary sources have been essential to my assessment of her life and work. Interviews in person and by letter over the past twenty years with those who knew her have also been invaluable.

Most significant, however, is the autobiographical record that Pegi created in her self-portraits and her renderings of other subjects from her life. From 1925, when she was twenty-one, until 1939, when she was thirty-five, she painted and drew herself more than two dozen times, ultimately depicting even the development of her own sexuality.[15] Her use of personally meaningful symbolic material makes these paintings building blocks for the mature compositions of the 1940s, which, using emblematic imagery, centred on women's lives in wartime. Furthermore, Pegi's possibly last undated self-portrait (c. 1939) links her earlier work with her major compositions after 1945 (Fig. 8.3, p. 109). "She revolves in her own personal symbolism," noted Marian Scott in her journal.[16]

Many of Pegi's works have remained in private and often modest hands. In many cases, the original owner and Pegi shared a significant moment of which the painting served as a souvenir. The picture may not have been a direct record, but it may have had a special aura and so continued to hang prominently on the first owner's walls. Most stayed there until the owner's death. In many cases the children of these original owners have been similarly compelled to retain her works. In the course of my research

I photographed and documented over five hundred paintings and draw-
ings, most of them in such collections.

Even though so much of her life was relatively hard, Pegi seems to have
maintained a courageous buoyancy throughout. This is a characteristic
perhaps of her chosen circle – Canadian professional intellectuals and
artists who enjoyed some prominence in the 1930s. The era was curiously
full of hope, a time in which Canada achieved a level of maturity and
independence. Her group truly believed that it was throwing off the shack-
les of the past – forging a modern age. Her 'bohemian' way of life reflected
this hopefulness, enthusiasm, and infectious eagerness to set everything to
rights. She was a romantic herself, and her undeviating joy in painting
reflects her openness to the world.

PART ONE

An Emerging Talent

1904–1926

1.1 Pegi aged about two and
Isa Austin, undated

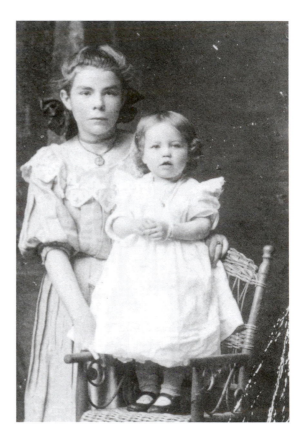

1

An Intense Gaze

1904–1922

IMAGINE, FOR A MOMENT, A BLUE CARDBOARD PHOTOGRAPH MAT – not large – embossed with the words "C.A. Lee, Main St. Bridge, Listowel" (Fig. 1.1).[1] A faded white border creates a distinct vertical rectangle in its centre that frames a black-and-white figure of a young girl of about twelve, standing behind a wicker armchair on which stands a toddler. The toddler is Pegi Nicol MacLeod at about two — our earliest encounter with her. Dressed entirely in white, with a locket round her neck, a bracelet on her right arm, and white socks and polished, neatly strapped dark shoes on her feet, Pegi wears her glossy hair parted in the middle and combed straight, before it breaks into short but riotous curls at ear level. Her mouth is half open, and she is staring intently at what one presumes is the photographer and his or her complex apparatus. Isa Austin, Pegi's young babysitter, is not just a backdrop element. Her left hand brushes the bottom of Pegi's dress, and her right firmly holds it at waist height on Pegi's right. For the sake of a clear photographic image, Isa ensures that Pegi's fascination with her surroundings is held in check. At age two Pegi is visually alert and curious.

Apart from this photograph, there exists virtually no evidence about Pegi's early life, and she herself never wrote about it. She was born in the town of Listowel in southwestern Ontario on 17 January 1904.[2] Christened Margaret Kathleen Nichol, she chose in her twenties to abbreviate her surname to Nicol and to amend her nickname "Peggy" to Pegi.[3] Her father, William Wallace Nichol, grew up in nearby Stratford, and her mother,

Myrtle Ivy Riggs, was a local girl. William and Myrtle married in 1902 (Fig. 1.2).[4] Pegi was their only child. The family lived in Listowel until she was four. The town marked her indelibly: she never ceased to need some measure of rural community, but she also came to find it parochial, inhibiting, and suffocating.

It was the culture of Listowel, so ingrained in her, that later hampered her adjustment to New York. Small towns such as Listowel and nearby Stratford treasured their British connections and took their names from places in the United Kingdom, peppering them with memorials to royalty. Nearby London on the River Thames is namesake of the British capital and has a hospital called after Queen Victoria. Colonists bearing surnames such as Riggs and Nichol had founded these communities – and most small Ontario towns of the period – early in the nineteenth century. Many of them had immigrated from England, Scotland, or Ireland in response to land-company advertisements. Others had moved up from the United States during the early days of British rule in Upper Canada. These people remained the predominant stock, apart from a few German-speaking communities, some of them Mennonite.

Fortunately the land was good and fruitful, so farming could produce a fair living. The original Native inhabitants had not fared so well. Displaced, neglected, frequently corrupted and diseased by the English and French during the battles for Canada's fur trade and icy lands, survivors led a crumbling existence in reserves. Their web of trails survived in roads bearing the names of colonial engineers, surveyors, and governors. Assiduous settlers collected their artifacts and examined their burial grounds, often donating what they found to the country's new museums. In this area there was also little evidence of the earlier French-Canadian presence.

When Pegi was born in 1904, Listowel was a sizeable community of 2,000, with banks, stores, seed and grain merchants, liveries, a mill, schools, and many churches.[5] There were doctors, lawyers, and local government officials, for the most part linked closely to farming – the area's main industry. The town had plenty of trade with Britain and continental Europe and, as a consequence, road and railway links with Toronto, Montreal, and Quebec City, with the latter two offering frequent sailings to Europe. Art, music, theatre, poetry, and literature — for the most part amateur – were also, as elsewhere, part of rural life. Canada's development owes much to the business acumen and professional, political, and cre-

1.2 Mr and Mrs W.W. Nichol in old age with an unidentified companion, undated

ative skills fostered by towns such as Listowel. Inevitably possessors of some of these talents succumbed to the lure of the United States, whose northern border is close by, and of course to the larger cities of Canada such as Toronto. Equally significant, for the gifted, such communities could be overpowering in their narrowness of outlook, conventionality, and materialism. Nevertheless, then as now, they offered a pleasant environment often denied their metropolitan counterparts.

Until recently, the town itself retained a good deal of the shape and look that Pegi would have known. Some streets remain broad and tree-shaded, and the elegant façades of some of the many imposing clapboard, shingle, and brick houses still boast carved 'gingerbread' ornamentation. The business area consists essentially of one street of shops and offices. The fertile countryside around is somewhat featureless, rolling only as it rises up to the Laurentian Shield to the north. Here and there a stump or snake fence still weaves across the flat acres, marking the strenuous hand-labour of early settlers. A few of the original log cabins survive, but more common are the ample Victorian farmhouses and barns. Apple trees and lilac

hedges surround them, while peonies and lilies flourish in their gardens in the spring. In the autumn a profusion of peaches, corn, pumpkins, and tomatoes still marks the end of the growing season before harsh winter snows blanket the land.

Pegi's mother, Myrtle Riggs, came from a well-established Listowel family. Her father had owned a dry-goods business and had some banking interests. She had four brothers and two sisters, one of whom, Josephine, married Francis Wellington Hay, later mayor of the town, a Liberal member of the provincial legislature, and the party's chief whip. Pegi and her parents often visited their pleasant red brick house near the centre of town. Myrtle herself was small, rather plain, and seemingly very conventional in her attitudes. Perhaps she made William happy enough, but, as Pegi's friends recalled, she seems to have been short on spirit and imagination, patient but not generous. The early photo of Pegi at about two suggests that she was tiny like her mother but in feature more like her father, with whom she always had a much stronger bond.

William Wallace ('W.W.') Nichol was made of different stuff from Pegi's mother. He is remembered as able, intelligent, humorous, and tolerant; he was tall and good-looking. Several members of his Stratford family worked at the town jail, where his father, Hugh, was superintendent.[6] His father was also known for his significant collection of First Peoples artifacts, which made their way into a number of public collections in the province. William did well at school and attended the University of Toronto in the 1890s. He was an able student and a good athlete, in due course becoming captain of the university baseball team.[7] He apparently wrote for the Stratford *Herald* newspaper while at university.[8] He graduated in 1896.

A post-secondary education would usually lead to a job, and William now became a mathematics teacher at Listowel High School.[9] His progress was steady. In 1908, already principal there, he accepted a new post at the Ottawa Collegiate Institute, later the highly respected Lisgar Collegiate Institute.[10] Four years later, at forty-one, his star still rising, he became principal of the new Ottawa Technical School. He remained there until his retirement in 1933, overseeing his school's growth from seven hundred pupils to a remarkable five thousand in 1923, when returning soldiers from the First World War swelled the numbers. His portrait still hangs in the school's auditorium.[11] Thin-faced, bespectacled, and balding, he has a face that radiates gentle intelligence.

Although it had been the capital of the Dominion of Canada for decades, the Ottawa where the Nichols settled in 1908 was a small civil-service town. A bit ramshackle, it was beginning to grow into a national capital. It was predominantly English speaking, although the province of Quebec lay just across the Ottawa River. The small French-speaking town of Hull on the Quebec side related hardly at all to the life of the capital except for providing a good restaurant – Henri Burger – and supplies of wine.

The layers of Ottawa society were clearly marked when Pegi and her parents moved there. At the top, representing the sovereign, was the governor general, who lived in the charming official residence, Rideau Hall. The country's government came next, housed in the impressive Parliament Buildings, which stood on a majestic site on the Ottawa River. Next down came civil servants, professionals, tradesmen, and a few old families that had been engaged in the lumber trade – then virtually the town's only industry. They lived close to the centre, in neighbourhoods bearing names such as New Edinburgh, Sandy Hill, and the Glebe. At the bottom was a substantial working class, many of whose members lived close to the river to the west of Parliament Hill. A small pocket of francophones lived in the Lower Town, to the east of the capital's centre. Ottawa was remote from the real life of Canada and the actual sources of power, which lay in the commercial cities and in the labour of industrial and mine workers, fishers, and farmers elsewhere.

In the fine arts, Ottawa had quite a lot to offer. In 1880, both the Royal Canadian Academy (RCA) and the Fine Arts Association of Ottawa (after 1883 the Art Association of Ottawa) had been established. The RCA organized annual exhibitions, and the art association established a school. There was also a National Gallery — albeit in small but growing form. Artists of some note such as Franklin Brownell and Ernest Fosbery lived and practiced in Ottawa.[12] As in Listowel, a plethora of amateur and semi-professional organizations provided for the literary, theatrical, poetic, and musical interests of the educated population. All told, Ottawa was a pleasant town in which to live; convenient to Montreal and Kingston and surrounded by hills, rivers, and small lakes, with the nearby Gatineau Hills in Quebec being quite famous.

William and Myrtle's life together in Ottawa was modest and unassuming. They and Pegi lived on Frank Street, close to the centre, which was convenient to Pegi's elementary Cartier Street School and to William's job at the Ottawa Collegiate Institute. They returned to Listowel frequently.

There is a photo of Pegi taken there on one of the family's summer trips back home (Fig. 1.3).[13] She is six years old and surrounded by Riggs cousins. Named Marg in a handwritten note on the back of the picture, she sits on the edge of a wooden deck, dressed in cotton gingham, with a huge bow on her head. She is undoubtedly cute. A smile plays around her lips, dimples animate her cheeks below deep-set eyes, and she cocks her head slightly to one side, atop a delicate neck. Even in this faded and damaged image Pegi radiates more energy and intensity than any of the other children. She looks ready to leap off the porch the minute the photographer has finished. She also looks comfortable with the other youngsters. All her life, she was easy with people of all ages, and they with her.

Pegi was ten and close to completing elementary school when war broke out in 1914, only two years after her father had settled in at the Ottawa Technical School. William did not enlist, being already in his forties, but a brother lost his life, as did one of Myrtle's brothers.[14] Instead, he took a leave of absence to go to Toronto, where he ran a Soldier's Aid Commission concerned with the re-education and rehabilitation of wounded returned soldiers.[15] During the family's three war years in Toronto, Pegi attended Harbord Collegiate Institute.[16]

When the Nichols returned to Ottawa after the war, Pegi enrolled at the Ottawa Collegiate Institute, where her father had first taught.[17] It was a very good school, according to Pegi's schoolmate Eugene Forsey, later a distinguished left-wing political scientist and Liberal senator. Teachers with nicknames such as 'Cornflakes,' 'Gilly,' 'Hank,' 'Hopping Harry,' 'Napoleon,' 'Nosey,' 'Porky,' 'Shorty,' 'Sis,' and 'the Colonel' provided a good and thorough liberal education.[18] From skimpy school records, however, it seems that Pegi was an average pupil, good at some things, and poor in others. She was athletic, she acted, and she received good marks for art. At one point she was on the school's gymnastic team.[19] The school's journal for 1920–21 reports that in "The Captain Crossbones" operetta "Miss 'Peggy' Nichol as Miss Pelling, a female tutor, certainly lived up to her part." She stands out in a photo wearing tutor-like glasses. The column "Personal and Humorous" notes her presence as well: "Lois meeting Peggy in Luke's furniture store, 'Hello Peggy, starting housekeeping?' Peggy, 'No, I'm looking for a crib for my Virgil'." The column attributes to Mr Mabee, a classics teacher, the words: "Remember, Miss Nichol, I require constant attention."[20]

This seemingly uneventful high-school record adds little to the sparse documentation of Pegi's youth. She wrote nothing of it. To her these years

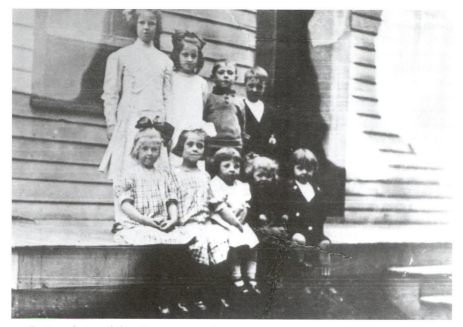

1.3 Pegi aged six with her Riggs cousins (bottom row, second from left), 5 Aug. 1910

may have seemed simply unsatisfying, unexciting, and disappointingly counter-productive – unworthy of recollection. Certainly she quickly put this period behind her, allowing little of it to spill over consciously into her subsequent life and career. Yet her interest in the creative arts undoubtedly resulted from her exposure to them at high school.

In June 1921, when Pegi left school, she was seventeen and a half and had never been out of Canada, or very far into Canada (Fig. 1.4). Her horizons were probably as modest as those of her parents, with her life bounded by school, home, holidays, school friends, and neighbours. None the less, the world into which she stepped reflected dramatic social changes. The First World War had profoundly affected many Canadian families such as the Nichols. It was perhaps a combination of the consequences of war, where she lived, and her education that began to shape Pegi's personality into something utterly different from that of her parents.

In Canada, the end of conflict had brought about unemployment and a noticeable move to urban centres. Women who had explored wartime opportunities found a range of jobs available. Girls whose mothers had stayed at home waiting for 'Mr. Right' could and did go into the labour

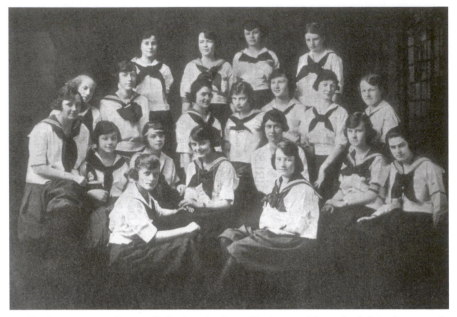

1.4 Pegi's gym team, Ottawa Collegiate Institute (Pegi second from the left in the second row), 1920

market, competing with men – many of them returned soldiers – for positions and lived on what they could earn. They accepted that there would be discrimination and that they would receive less pay for similar work, but independence was important to them and often counted against marriage. As well, an appalling number of men – some 66,000 in Canada – had died in the war. In the 1920s there were widows who had to work and girls who had to make their own way because there was no social insurance and there were not enough men to marry. Some made a choice, but many had none.

Many women enjoyed their new freedom and, with the voting rights granted at the end of the war, discovered a new political and social awareness and a voice to express their opinions. Fashion reflected this confidence as skirts shortened and tight waists fell seductively to easy hip lines now free of corsets. Women bobbed their hair, and girls such as Pegi threw their bodies about in fast-kicking dances such as the Charleston and listened enthusiastically to jazz music.

Pegi participated in this new world with alacrity. Her interests at school made it clear that she was well equipped to respond to it, but whether she

understood it in any intellectual sense was another matter altogether. Even at this early stage it was apparent that her strength lay in intuitive observation more than in logical analysis. She was clearly intelligent, but it was instinct, not study, that drove her ambitions. For reasons not documented, she gave up the idea of the teaching career mentioned in her final report card in June 1921 (although she ended up teaching in some way or other all her life) and decided instead to become an artist.[21] Her wish to be an artist was not unusual. Good teaching and encouragement at school led her to believe that she was good enough to merit training. What is unusual is that the dedication showed itself so early and remained strong and constant for the rest of her life.

In the autumn of 1921 Pegi enrolled at the newly re-established Art Association of Ottawa school at 114 Wellington Street. There are no records of what she studied, but classes offered drawing, painting, and commercial art virtually full time. Undoubtedly she took landscape, portrait, and figure painting with Franklin Brownell, director of the school (but under a variety of umbrellas) since 1886. Brownell had studied in Boston and in Paris, was a competent painter, if not particularly innovative, and preferred landscapes.[22] He had good connections to the local art establishment. His friend Eric Brown, director of the National Gallery, acquired a number of Brownell's works for the institution. Pegi's time at the school introduced her to the Ottawa art world.

After two years, nineteen-year-old Pegi went to the new École des Beaux-Arts in Montreal. There is no evidence to explain why she chose Montreal. The school was the city's only one, the old one at the Art Association of Montreal then being closed. One can only assume that someone had recommended the school and that, as she had already lived in Toronto as a teenager, she may have relished something different.

In 1923, Montreal was the largest city in Canada and predominantly French-speaking. Situated on the St Lawrence River in the province of Quebec, it was a great seaport and a lively metropolitan centre, with a cosmopolitan air unknown elsewhere in the country. It was a city of big businesses, dominated by British-Canadian interests. It boasted fine streets; handsome buildings, houses, and churches; good universities and schools; and elegant shops and hotels. Culturally, like Toronto, it was philistine and puritanical, despite the new art school and traditions in music and

theatre. Years earlier Samuel Butler, author of *The Way of All Flesh* (published posthumously in 1903) had, while living in Montreal, found a copy of the classic, naked *Discobolus* hidden in the basement of the Art Association of Montreal. "Oh God! Oh Montreal," he had wailed in a poem to commemorate that moment.[23]

At the École des Beaux-Arts there were both French and English students. The new, purpose-built structure stood in the francophone district east of McGill University on the rue St Urbain off Sherbrooke Street. The school offered free tuition from imported French teachers, led by Emmanuel Fougerat, in a wide range of subjects and crafts drawn from the traditional academic model for art training.[24] There was much drawing from plaster casts of Roman and Greek figures, but both painting and drawing classes used live, discreetly draped models. Portraiture, the painting of flowers, and decorative work also featured. The perceptive art critic, editor, and friend of Pegi's Donald Buchanan attributed her and many of her classmates' interest in the figurative to their training at this school.[25] Indeed, Pegi's later subject matter of portraiture, the figure, and flowers undoubtedly developed in part as a result of her training there. Discipline was strict, and orderly behaviour required. If a student was late more than three times he or she forfeited the place to a willing replacement, so doubtless absenteeism was rare.

If the city dazzled Pegi, the school and the friends whom she met there positively inspired her. Some fellow students became established artists, such as Paul-Émile Borduas, Lillian Freiman, Goodridge Roberts, Anne Savage, and Marian (Dale) Scott, who became her closest friend.[26] Pegi loved their company, their conversation, their talk of pictures and books, and, of course, their ongoing pursuit of happiness. People remembered her from those days as a vivid, lively little person, often dressed dramatically, and with an infectious enthusiasm that made her always the centre of an admiring group.[27] Marian Scott recalled that Pegi wore zany bedroom slippers instead of shoes. She also remembered discussions on combining marriage with a career in art and concluding – presciently for both of them – that it would be close to impossible.[28] Pegi also kept a journal from which she would – to general amusement – read excerpts to her friends during class breaks.[29] It has not survived.

There is a striking photograph of her as a student (Fig. 1.5). She appears at the front of the class, a small, large-eyed figure in a becoming and very crumpled smock. Her hair is bobbed, and her gaze is intense. She is work-

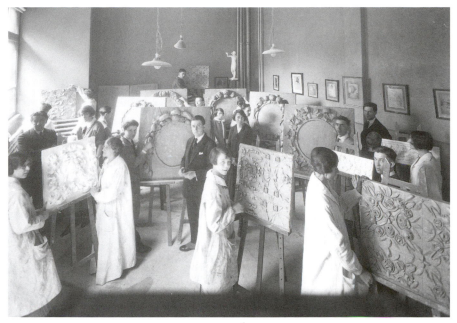

1.5 Atelier de modelage décoratif ornamental, École des Beaux-Arts de Montréal (Pegi in the centre), 1924

ing on a decorative clay panel of uncharacteristic tidiness. Surrounding her are the clay wreaths and panels of her fellow artists. Another photo shows Pegi peeking from behind her work at the centre of a life class.[30]

At the end of her year in Montreal (1923–24), Pegi returned to Ottawa, more than ever determined to become an artist. She had done well at the École, winning prizes for watercolour painting, ornamental modelling, copying from the antique, and overall effort.[31] Years later, she told Donald Buchanan that what she had learned there was that a line put down on paper or canvas took on an expressive reality in itself and should never be changed.[32] She kept that expressive line all her life – it appears again and again, directing the paint.

On one of her train journeys between Ottawa and Montreal she had talked with a tall, thin, monocled Englishman. This was Eric Brown, director of the National Gallery and her erstwhile teacher Brownell's friend. He reported to his wife, Maud, that he had met an entrancing young woman and had invited her round to see them.[33] Pegi came the next day and continued to come, again and again, for many years, welcomed so

warmly by the childless Browns that she became almost a daughter. She later wrote that they became as father and mother to her, filling a need not met in her own family, where she felt a bit of a changeling. "I never could have painted in Ottawa at all if it hadn't been for Eric, because my parents hate it and all art classes I have attended and all artists I know," she wrote a decade later to her friend and fellow-artist Charles Comfort (later director of the National Gallery and a well-known muralist.)[34] Through the Browns, Pegi, though barely twenty, was able to find and move into a new circle with a different perspective. There she found interest, encouragement, and company that she was to make her own for the rest of her life.

A New Life

1923–1926

ERIC BROWN TOOK A PHOTO OF PEGI ON SKIS one winter (Fig. 2.1). Always athletic, Pegi had become a willing participant in the outdoor life that both Browns loved. Dressed warmly in dark outerwear, she leans on a pole, her skis and boots snow-covered. The trees on either side of her are robust, with bare branches, and deep, white powder reaches back into the woods behind, under a clear, chilly sky. Pegi looks confident and purposeful. This is a young woman who identifies herself with the land and with the challenging climate and revels in it all.

Pegi's first encounter with Eric Brown transformed her life. The circles that she entered through him and his wife – and in which her parents played no part – were different from any that she had known or could have known. Her home life and her school experiences could not have prepared her for this artistic and intellectual milieu. She met people seized of a nationalist movement galvanized by Canada's role in the Great War, epitomized by its forces' extraordinary success in the Battle of Vimy Ridge in April 1917.

For many people in the arts, nationalism meant also a new look at and a new treatment of the Canadian countryside and wilderness.[1] The landscape artists among them felt that nineteenth-century academic European techniques and subject matter could no longer reflect the colour, form, and majesty that they now saw around them. In central Canada the Group of Seven had had its first collective exhibition in 1920.[2] Its celebrated

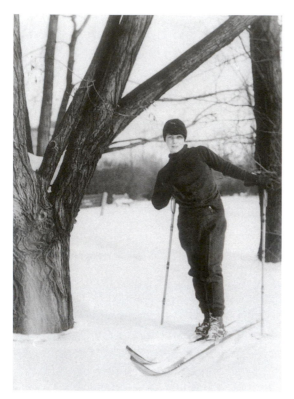

2.1 Pegi on skis, undated

rebellion against the traditional was, in fact, one more of subject than of substance, of colour treatments and of technique rather than of ideas. While the National Gallery became a strong supporter of its work, in the 1920s private purchases were modest. Ubiquity was yet to come. Most of the few collectors of Canadian work still preferred old-fashioned paintings, such as the mills, hayricks, and teams of horses depicted by artists such as Horatio Walker and Homer Watson. The artistic revolutions of France, Germany, Italy, and Russia were becoming known, particularly in the United States, but little affected Canadian art. Canada's artistic links were still with Britain – even the new approach to landscape painting had notable seeds in the English artist Paul Nash's paintings of the Western Front, as well as in the British Arts and Crafts movement. This ongoing kinship perhaps helps explain why, when the work of the Group of Seven showed internationally in 1924 at the Wembley Exhibition in London, it received much praise.

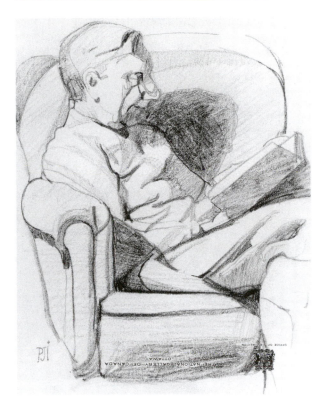

2.2 Study for *Portrait in the Evening (Eric Brown)*, c. 1926; charcoal on paper, 25.4 × 20.3 cm

Brown became perhaps the greatest supporter of the Group of Seven, although his taste went beyond its renditions of ice, snow, hills, and pine trees. He had seen many Canadian artists develop since he joined the gallery in 1910. He bought their work and with missionary zeal persuaded others to do likewise – genuinely believing that a nation could define itself by its art.[3] Until the Depression severely affected the gallery's purchasing budget he was able to work wonders. Pegi knew that she was fortunate to come under the wing of such a man at such a time. In admiration – and perhaps out of love – she painted his portrait. She drew the initial sketch of Brown, absorbed in reading a book in a comfortable armchair, on his own National Gallery notepaper (Fig. 2.2).[4]

Brown provided stimulating companionship for a young girl such as Pegi, so quick to absorb the new and exciting, despite being the offspring of retiring and conventional parents. She mixed easily with the creative people of all ages whom she met and found many who could pull strings

for her, make arrangements, and provide introductions. Maud Brown thought Pegi "an astonishing person … Bursting with vitality and ideas she was always ready for a discussion. She could act, dance and ski, and was fearless in the water."[5] Pegi also began with the Browns her life-long habit of painting and drawing when and wherever she found herself with pencil and paper to hand. But Brown's influence was also restrictive. His less-than-positive attitudes to some forms of contemporary art – in particular abstract art – may well have influenced Pegi's own response to such art long into her maturity.[6]

In 1925, she took a job teaching art at Elmwood School, a girls' private school for the Ottawa establishment.[7] There is no record of exactly what she taught or to whom. None the less, it was probably the combination of her father's position at the technical school and Brown's support that gained her the job, along with the fact that she could play piano for dance classes. She made lasting friends of one or two of her young charges. And, as pupil Letitia (Wilson) Echlin noted in a letter: "An extraordinarily high proportion of her students at Elmwood became quite good artists."[8]

One was Marjorie (Borden) Oberne, who remembered Pegi talking about the magic to be found in nature and the need to exaggerate the image perceived when painting landscapes. "If you see a *slightly* blue light in a shadow, make it *very* blue."[9] She also recalled some of Pegi's notoriety at Elmwood: she not only wore trousers but also once arrived on the back of a motorcycle. "Girls thrilled, headmistress *not* thrilled," Marjorie noted.[10] "She was a rare and inspiring teacher," she added, "broke through the academic rules, and got us all thinking in terms of creation rather than copying."[11] This statement indicates the limited influence on her art of Pegi's year in Montreal and says much about the role of her new Ottawa circle – many of its members were staunch supporters of Christian Science. For them, as Douglas Ord has pointed out, creativity was revelatory.[12]

Even in the coldest weather, Pegi and Marjorie would sketch outdoors, taking mittens, caps, and sleeping bags to cover their legs (like members of the Group of Seven). "We carried our cumbersome oil paint boxes and painted directly from nature on small plywood panels primed with shellac," Marjorie wrote.[13] Pegi and her protégé found other subjects close by in the village of Rockcliffe, which housed Elmwood School. "Pegi was scornful of people who felt they had to 'go someplace' to find something to paint," commented Marjorie. "She said that an artist could turn out

2.3 *Ashbury Hill*, c. 1925; pastel on wood panel, 27.6 × 22.8 cm

a lifetime of masterpieces and never move away from his house and his backyard."[14] And in this – an interesting rejection of the Group's practice – as Pegi's career was to prove, Marjorie was prescient. Many of Pegi's paintings traced back to this period – several dozen to date – are small, charming, competent views of the Gatineau River and nearby lakes and hills. Robust line, rich colours, and a sculptural quality to the paint application generally characterize them. Many of them echo the Group's subject matter, which strongly influenced her generation of Canadian artists. That the buying public too was slowly developing a taste for this kind of painting must also have made it attractive for a young artist.[15]

She also experimented with other media at this time. One example is *Ashbury Hill* (c. 1925)(Fig. 2.3). The subject is likely the grounds of Ashbury College, then a boys' private school located near Elmwood. In

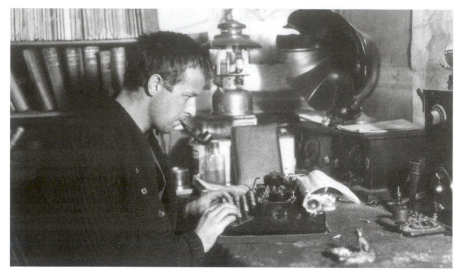

2.4 Richard Finnie typing notes at his "Kogluktuk" base, January 1931

her choice of this subject, Pegi demonstrated her interest in landscape – not a subject she had pursued in Montreal but one that was common to the practice of her new circle. There is little to be seen in the work of the ebullient brushwork and audacious colour that she developed later in her career but it shows that at the age of twenty-one she was technically a capable and proficient artist. This composition provides evidence of the expertise that warranted her inclusion in Brown's circle and justified the opportunities that were made available to her.

By 1925, Pegi had begun a five-year relationship with Richard Finnie, two years her junior. A talented, adventurous young man, he travelled in northern Canada, initially as a radio operator on a sailing ship and later as a photographer and filmmaker.[16] In a photograph from this time his head looks solidly shaped; his close-cropped dark hair, the pipe in his mouth, and the eyes focused intensely on the typewriter give him something of the look of a polar explorer (Fig. 2.4). Pegi and he often performed together in productions put on by the Ottawa Drama League, initially on its stage at the Victoria Memorial Building, also home to the National Gallery. Both were keen and apparently quite good actors. Many in her new circle also appeared in these shows. Reviews described Pegi variously as "gifted" and "excellent."[17]

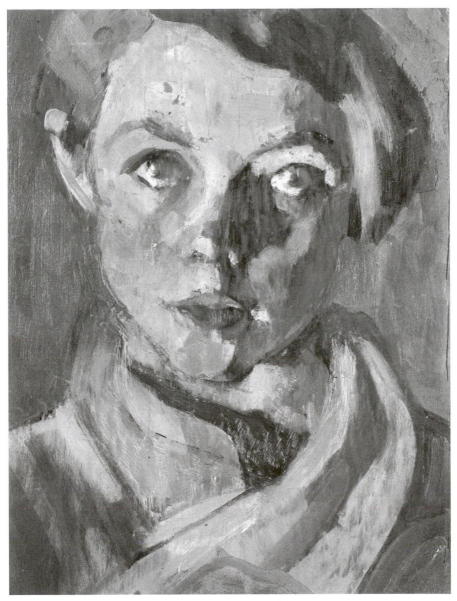

2.5 *Self-Portrait*, c. 1926; oil on plywood, 30 × 23 cm (Plate 1)

Finnie remembered her as "pretty in a pixieish [sic] way, with large, blue eyes set in an oval face. She frequently showed her even teeth as she smiled and laughed," he wrote. "Her hair was brown, rather short and often tousled. She was small but surprisingly strong. She was gentle and would not have wanted to harm anyone, but once during a lively party she playfully punched one of my eyes with enough force to blacken it, to her regret and embarrassment … She was a true bohemian in her outlook, dress and deportment. Conservative Ottawa people at that time, likely including her parents, regarded her as an oddity."[18]

Pegi's exploration of self-portraiture also began in Ottawa in 1925. Finnie owned one of the earliest completed portraits; it showed "her precisely as I remember her when she was watching or hearing something of interest."[19] A small painting, it has pigment laid on thickly; the forms of the head and face emerge from the relationship of edge to edge and through the contrasts of illuminated and shadowed planes (Fig. 2.5). Pegi looks pretty yet serious. Her brown hair is bobbed, and the effort of fixing her features in paint from her reflection in the mirror keeps her eyes wide open. Despite the obvious bloom of youth and the gamin quality that she never entirely lost, the strong lines of her jaw and pointed chin indicate her resolute strength of character. Another early self-portrait drawing captures the same intensity, but with the eyes shadowed. It belonged to the Browns yet depicts not the buoyant personality that they loved but the person that she saw in the attic-studio mirror in her unsympathetic home (Frontispiece).

Pegi and her parents now lived in a small, new brick house on Second Avenue in a central part of Ottawa known as the Glebe. Their home, in a development built by entrepreneur David Younghusband in the 1900s, was like its neighbours, inside as well as out (Fig. 2.6). "There was nothing very memorable about Pegi's home," recalled Marjorie. "It was just the same as every other house on the street. Square, two-storey [plus the attic], a carport beside the front door, a Pontiac sedan parked in the driveway. Mr. and Mrs. Nichol went for a drive every Sunday afternoon [after morning service at Chalmers Presbyterian Church], as did everyone else on the block … Nondescript furniture."[20]

Pegi transformed the wood-lined attic – a relatively substantial space with windows at both ends and a flight of stairs down to a door on the second floor – into a private if not very comfortable studio retreat (Fig. 2.7). There she entertained her friends, read – always widely (Katherine

2.6 370 Second Avenue, Ottawa, 1928. Pegi's home, at number 356, was identical.

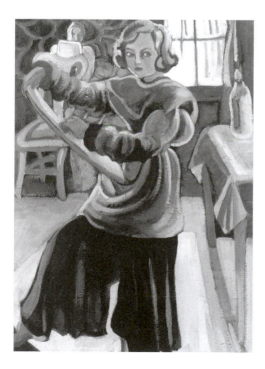

2.7 *Costume for a Cold Studio*, undated; oil on canvas, 43.1 × 38.1 cm

Mansfield, Karl Marx, Henry Miller, Anaïs Nin, T.S. Eliot, Ezra Pound, D.H. Lawrence, Wyndham Lewis, and Shakespeare) – played her records, and painted.[21] The view from her window was a frequent subject. "Actually the ceiling was too low for comfort," recalled Marjorie, "and there wasn't much light, but it was a cozy private place, and we would sit on the floor and talk and think of ourselves as very bohemian."[22] Finnie also remembered it well. "I often visited her in her makeshift studio in the attic of her parents' home on Second Avenue," he recalled. "If I happened to be there at lunchtime, her mother would quietly leave a sandwich and a glass of milk for each of us at the foot of the stairway."[23] Her parents approved of the relationship – Finnie's grandfather was, after all, a former general manager of the Bank of Ottawa.[24]

The residence was at times a battlefield, for the temper of the twenties did not sit easily with Pegi's parents, and she frequently felt that they disapproved of and misunderstood her. However, lack of parental sympathy was a popular theme for a generation that soaked up the writings on the libido of psychiatrist Sigmund Freud and birth-control advocate Marie Stopes. Bitter words on this subject appear in the work of one of Pegi's near-contemporaries, the poet and writer Elizabeth Smart, also an Ottawa girl who grew up in a similar milieu.[25] And Marjorie, who considered Pegi's house a second home, had only limited good to say of Pegi's parents.

[Her father was] a quiet man, with a gentle acceptance of his strange and only child. Her mother was a prosaic woman, bitterly resentful of Pegi's being so different, and infuriated by her changing her name from Margaret Nichol to Pegi Nicol. She took this as a personal affront. She also expressed her distaste for Pegi's work. Pegi and her mother fought a lot, and one way Pegi had of ending a fight was to go to the piano and pound out "Rhapsody in Blue" as loudly as possible. Mrs. Nichol was offended by that too. When you say that she was not encouraged to paint by her parents, it was not that exactly. It was more the *way* she painted that they could not understand. The books she read, the music she played, everything she thought and did was contrary to their conditioning, so you can see how alarming this was to Mrs. Nichol.[26]

There was some truth in the feelings of some of Pegi's contemporaries that her parents may have been censorious and lacking in interest. Marian Scott believed that they destroyed some of her early work, in particular her poetry.[27] Charles Goldhamer, an artist contemporary, recalled her telling

him that she once returned from Montreal and "found her mother burning all her work."[28] And although they did attend her 1936 wedding to Norman MacLeod in Toronto and provide her with a home for periods of her adult life, they were not with her at the birth of her child in New York or at her dying in that same city. Their apparent failure to respond as she would have liked to her successes and tragedies was relentlessly discouraging – a fact to which she alluded in her 1932 letter to Charles Comfort.[29]

None the less, her mother and father were themselves prisoners of their own age and time, and while Pegi herself may have responded well to her new circle and environment and they to her, she quite clearly worried her parents. Even though she was teaching and painting and developing a professional reputation within her peer group, her increasingly liberated ways caused them concern, and their group of upper-level bureaucrats did not view Brown and the artists around him as necessarily the best of influences. Indeed, Pegi's father had his 1933 retirement portrait painted by Ernest Fosbery, who the previous year led the attack of the Royal Canadian Academy of Art on Brown's collecting policies at the National Gallery. That the Browns were scarcely young and appeared to be nothing but admiring and supportive of Pegi carried little weight with her parents. They saw the friendship as rebellion.

Finding an Approach

1926–1934

3.1 Marius Barbeau,
1942

"The one who falls in the lake"

1926–1931

NEITHER THE CIRCUMSTANCES OF PEGI'S HOME LIFE nor her 'rebellion' impeded or repressed her development. She continued to paint, to teach, to develop her professional reputation, and to expand her horizons. She was able to travel across Canada and see for herself the eastern and western rims of the country. In 1926, she accompanied the Browns to Nova Scotia on the Atlantic seaboard (where exactly is not documented). This trip was the first time that she had seen and smelt the open sea. Maud Brown remembers that "the notebook came out as sitting on a rock she sketched the waves creeping in."[1] In this period Pegi drew and painted constantly, with growing confidence and maturity. Portraits and still lifes became increasingly her favourite subjects.

In 1927 and 1928, she travelled to the west and northwest. In this venture a second mentor, Marius Barbeau (Fig. 3.1), assisted her. The noted ethnographer, a colleague of Brown's, who probably introduced them, shared Brown's enthusiasm for the young artist. A charismatic Québécois and former Rhodes scholar, Barbeau worked at the National Museum of Canada, housed with the National Gallery in the Victoria Memorial Building.[2] His collections of early Canadian artifacts were notable (more so, certainly, than those of Pegi's grandfather Hugh Nichol), as were his continuing efforts to record the folklore and music of Canada's First Peoples. He had made many visits to northwestern Canada to collect material. In 1924, the celebrated New York artist Langdon Kihn accompanied Barbeau on a

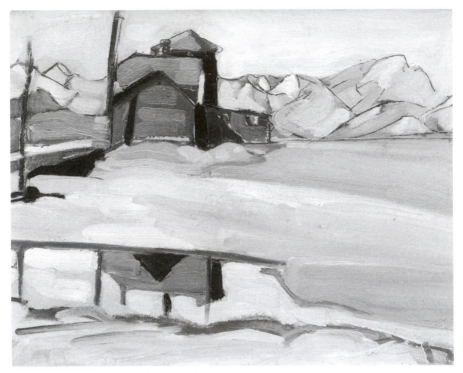

3.2 *Morley Station*, 1927; oil on board, 22.3 × 28.1 cm

western trip. Kihn had been painting the Native populations of the north-
west for some time, and shows of his work in Toronto and Montreal
attracted attention. In his wake several Canadian artists, including Edwin
Holgate, A.Y. Jackson, George Pepper, and Anne Savage, began to make
painting expeditions – often subsidized by the railways – to these areas to
depict the landscapes and Native ways of life.[3] The region's increasing
numbers of settlers, explorers, adventurers, travellers, and investors also
fuelled interest. The well-reported and extensive journeys of Governor
General Baron Byng of Vimy excited the imaginations of many Canadians
– especially of those who had served under him in France and, above all,
at Vimy Ridge and who idolized him.

Thanks to the beneficence of the Canadian Pacific Railway and to the
arrangements of Barbeau, Pegi received free transportation and occasional
accommodation.[4] In terms of output, her 1927 summer trip was success-
ful. She lived and painted at Morley Station in the foothills of the Rockies,
among the Nakota or Stoney, who had abandoned their traditional lodg-

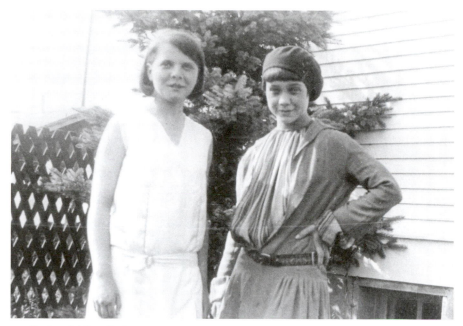

3.3 Pegi and Alice Garbutt, 1927

ings for permanent homes on reserves. She painted the station (Fig. 3.2). En route she stayed in Calgary with the F.G. Garbutt family, enthusiastic supporters of the arts and particularly interested in the Nakota. Garbutt was president of the Alberta Society of Artists, and Brown may have set up her stay there. The Garbutts remained Pegi's friends for life.[5] A photograph of her with Alice Garbutt shows a slim, confident young artist; hand on hip, beret on head, she is wearing something almost exotic with the garment's oversize striped cuffs (Fig. 3.3).

Pegi's portrait of Alice reflects the artist's confidence in its competent and straightforward execution.[6] None the less, her increasing use of contour lines in portraits of the Nakota, such as *Peter Ear*, was far from mature (Fig. 3.4). Her increasingly linear approach was a clear response to the work of Walter J. Phillips, a friend of the Garbutts and noted local artist.[7]

On her return to Ottawa, Pegi exhibited two of her Nakota portraits in a major exhibition, *West Coast Art – Native and Modern*, at the National Gallery organized by Barbeau and Brown in December 1927, and they received favourable reviews (Fig. 3.5).[8] "Miss Pegi Nicol showed a series of portraits of Indians on the Stoney [Nakota] Reserve at Morley, Alta," noted

3.4 *Peter Ear*, undated;
pastel on paper, 60 × 46 cm

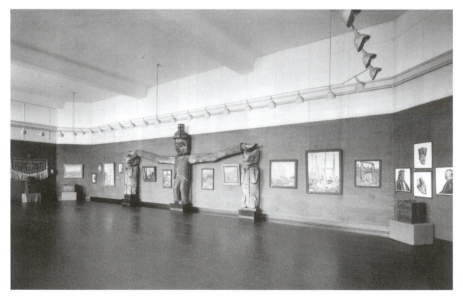

3.5 View of exhibition installation of *West Coast Art – Native and Modern* at the NGC,
1927

the reviewer. "Her work is strong and shows amazing promise. A thorough knowledge of anatomy is displayed and great skill in rendering values."[9] That show, much written about, marked the first significant effort to include the northwest coast in the story of Canadian art that Brown, in particular, was envisaging. But poor attendance (apparently the invitations had failed to arrive on time) revealed the limits of his and Barbeau's inroads into the Canadian obsession with European art. Some critics saw the decorated masks and boxes as of ethnological interest, and contemporary artists' inclusion of subjects such as totem poles did not bridge the gap. The show included a number of works by Emily Carr, the BC artist and writer; she attended the opening and noted in her diary:

We got there in a cab. I thought we were the first but there were a few others. Not many came after us. It was a dead, dismal failure. The big rooms with the pictures hanging in the soft pleasant light were almost empty. The grand old totems with their grave stern faces gazed tensely ahead alongside Kihn's gay-blanketed Indians with their blind eyes. I was glad they were blind. They could not see the humiliation. The Browns were there, a trifle too forced in their gay humour. A great many of the few present were introduced to me. They were all enthusiastic in their praise. Maybe it was honest, maybe not. Mrs. Barbeau's eyes were flashing angrily. Her body was tense. It was as though she could slay the Browns. 'Look at my husband,' her eyes seemed to say, 'They've wounded him and humbled him and hurt him.'[10]

Carr met several central Canadian artists and art lovers who impressed her, and she intrigued them. The young Pegi danced attendance on the eccentric lady from Victoria, who thought her nice, but a poor if enthusiastic painter – "feeble," she wrote in her diary.[11] Still, Carr's ongoing correspondence with Eric Brown indicates that she fully expected to see Pegi the next year and quite clearly thought of her as a peer. While Pegi did go west again in the summer of 1928 to paint in the Upper Skeena River area, the two did not meet.[12]

Pegi's friends remember notebooks with drawings from this trip, but no trace has surfaced. A draft for a book on her experiences on the west coast has disappeared.[13] Marjorie Oberne recalled Pegi reading excerpts. "She told me that the Indians considered her to be possessed of magic powers. In one village she was known as 'The one who falls in the lake and does not die.' None of those Indians could swim, she said, and the whole village

turned out to see her dive into the water and swim and come out alive. They were very curious about her body as she had very tiny breasts and wide shoulders, and she told me that they wondered if she was really a woman or maybe an androgynous spirit."[14]

She produced mostly portraits and exhibited a number.[15] In its theatrical patterning and over-composition, *Bianinetnan, Aged Indian Woman of Hagwelget Canyon* (c. 1928) speaks more to technical proficiency and imagination perhaps than to close observation (Fig. 3.6). In this portrait, the deep lines in the woman's face are echoed in the ancient and rugged erosions of the mountains behind her. The rocky landscape equates with the subject's long, hard life. The landscapes were disappointing, and Pegi added portraiture to at least one. A rather dull rendition of Hagwelget Canyon, entitled *Skeena Landscape* (1929), re-emerges as the background to an exhibited composition, *Indian Boy at Hagwelget Canyon* (1929).[16]

Just over two years later Pegi wrote an article for the Canadian National Railway Company's magazine about her 1928 trip. Barbeau edited it severely, for it contains none of her chaotic and creative prose, but Pegi comments that most of her potential subjects at Kitwanga had been away at the salmon canneries in Prince Rupert.[17] One older woman refused to sit, saying apparently, "I receive no benefit and my people laugh at me."[18]

This article was Pegi's first significant writing about art. She had begun only very recently, undoubtedly encouraged by the Browns. A review for an Ottawa newspaper of the National Gallery's RCA exhibition of 1929 is notable:

The academy is interesting this year for its evidence that ideas of old and new are amalgamating … The more academic have raised their color key. The so-called moderns show more conventionality than ever and imitators of both are abundant. The old powerful mood of lake, hill, everlasting hill, comes to the eye from the surface of the canvas. My inner being was not stirred much, though it is true a lovely, lonely feeling for the unpopulatedness of my country began to flourish in my soul … something must soon happen to break up our artistic conspiracies. Our moderns are getting to be as narrow as they claim not to be. There seems to be much more of politics than of art among our painters.[19]

In general, however, Pegi's artistic career was going well, and she regularly added to her now quite substantial body of work. Her sales too were as good as those of most of her contemporaries, and she was proud that the

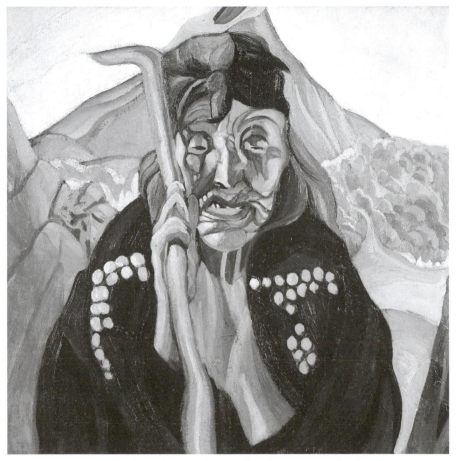

3.6 *Bianinetnan, Aged Indian Woman of Hagwelget Canyon*, c. 1928; oil on board, 61 × 61 cm (Plate 2)

National Gallery had bought her 1926 portrait of Eric Brown.[20] During the week of 4–11 February 1928, she had a solo show – *Portraits, Landscapes and Studies by Pegi Nicol* – in Montreal at the recently formed Leonardo Society, which sold reproductions of contemporary European paintings, still very scarce, and had begun to display avant-garde Canadian work.[21] During this year the Group of Seven invited her to exhibit with it in Toronto – an invitation that confirmed her reputation as an up-and-coming young artist.[22]

Selling well did not, however, provide a livelihood for many Canadian artists, established or aspiring. Apart from the National Gallery and a

few provincial equivalents, there was virtually no public sponsorship. Throughout the 1920s and 1930s private support remained limited too. There were few dealers and few suitable locations to hold exhibitions. The RCA held a yearly exhibition – not restricted to members – and the Art Association of Montreal had a show each spring. A number of artists' societies were maturing, and their annual group shows displayed new work, but there were no wealthy companies, banks, or institutions looking to buy art as an investment or seeking just to support Canadian art. In English Canada, the daily press and inspired weekly journals such as *Saturday Night* did publish reviews, but the general public received little information and displayed less interest, being unaccustomed to having original Canadian paintings at home. In Quebec, matters were better as both the English and French daily newspapers covered art extensively.

Pegi's growing confidence as an artist, inspired by the Browns and their circle, countered what she and her friends regarded as belittling parental disapproval, especially on the part of her mother. She captures the continued dichotomy in her life in *The Slough* (1928) (Figs. 3.7 and 3.8).[23] Ronald McCall (who also owned a self-portrait) commissioned this curious double-sided self-portrait as a wedding present for Marian and Frank Scott.[24] Marian had married the law professor–poet in 1928.[25] This picture later hung in the *Second Exhibition of Quebec Artists* in 1929 at Eaton's in Montreal.

In *The Slough*, Pegi signed only one side, which she seemingly designated the public portrait (Fig. 3.7). The artist's head and hands encircle a flowering pink cyclamen. The flower's blooms reach towards her face, while her gaze is directed outwards. She seems self-absorbed, if not rather sad. The technique is decorative, with colour and tonal areas carefully separated and delineated. The image on the back is very similar but includes fewer cyclamen blooms (Fig. 3.8). In a startling effect, Pegi's large eyes directly engage with the viewer's in a challenging stare more full of confidence and life than the image on the other side. In both, at certain points, the petals of the flowers almost merge with Pegi's face.

This painting is also a development from the single-sided earlier portraits of herself and others. In the tradition of portrait painting, the inclusion of a specific plant – the cyclamen – suggests revelations about the sitter, particularly given its prominence on both sides. Pegi would have become familiar with such symbolic tools through reproductions and

through paintings at the National Gallery, which in the 1920s acquired the richly emblematic portrait of Lady Dacre by the English artist Hans Eworth.[26]

Pegi was also a proficient painter of flower pieces.[27] Flowers were one of the most accessible and popular subjects for women painters in Canada beginning in the nineteenth century and especially during the long, harsh winters. She specifically refers to cyclamens in a letter to Marian; she certainly painted them several times.[28] As a symbolic flower, the cyclamen refers to the Virgin Mary in Christian traditions. The red spot at its heart signifies the bleeding sorrow in Mary's heart; hence the additional name "bleeding nun."[29]

At least three factors in Pegi's life may have informed the particular symbolic content of this double-sided portrait – her trying home life, her relations with Richard Finnie, and even a play in which she was acting. In 1928, when she painted *The Slough*, she was three years into what is recalled as a tumultuous relationship with Finnie – perhaps the most important of her life. She was also rehearsing and playing a leading role in an Ottawa Drama League production of *Mary the Third* (1924), a drama by American playwright Rachel Crowther. As a review records in the Ottawa *Citizen*, "'Mary the Third' … is searching in its analysis of the marriage question."[30] Pegi played the third Mary, the first two having mistaken "an ancient species of alchemy for a grand and eternal passion, and [having] wed." The reviewer continues: "Mary the Third is a modern girl … she is disgusted with the sham of … conventional marriage. She talks with the gusto of a girl who has discovered the historic significance of the dependence of women, and intersperses with her own words bits she has remembered in … [a] bootlegged copy of Dr. Marie Stopes."[31]

Given the subject of this play, a difficult home life, and a volatile relationship, Pegi may well have been in some mental turmoil. Revealingly, she called her self-portrait *The Slough*, a word that can also mean "quagmire" and "bog" and was then most associated with Christian's difficult time in "The Slough of Despond" in John Bunyan's famous *A Pilgrim's Progress*. She expressed in the work some of her emotions by depicting a vigorous and luscious plant as a counterpoint to her own somewhat diffident self-portraits. She both controls the plant by holding it and lets it control her, by caging and caressing her.

The relationship with Finnie did not survive. "Our natures sometimes clashed," he later wrote. "A long-term intimate relationship would have

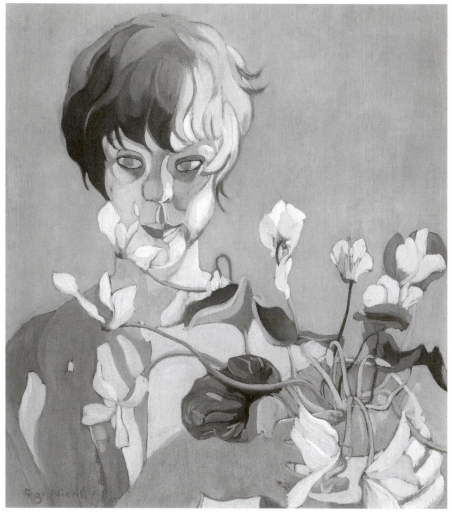

3.7 *The Slough* (recto), 1928; oil on board, 61 × 54.7 cm (Plate 3)

been mutually hazardous."[32] Much of Pegi's anger at the liaison's ending in 1930 found expression in a scene that she depicted on a batik scarf: Finnie sits, head bowed and engulfed in flames, while behind his left shoulder glare four women, whom he apparently met in Paris.[33] According to Marian, Pegi never really recovered. She even married a man who looked somewhat like Finnie, and emotion overcame her when she met him accidentally years later.[34] He too never forgot her. "She left me with an indelible impression vividly enduring to this day. She was so youthful and so full of the joy of life."[35]

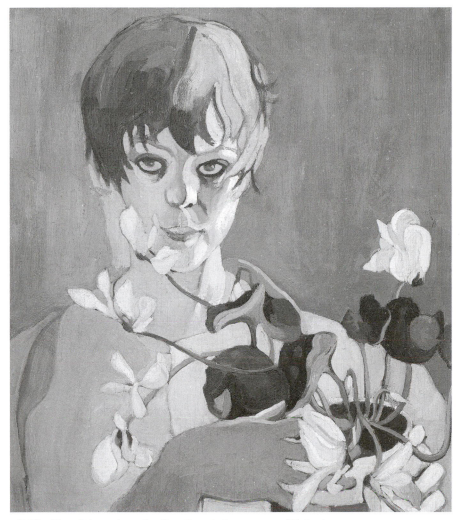

3.8 *The Slough* (verso), 1928; oil on board, 61 × 54.7 cm (Plate 4)

Pegi always had many men admirers and probably did not lack solace, but the affair with Finnie, if such it was, had had a major impact. In terms of defining who she was, he had been a significant figure. Without his interest in the north, she probably would not have had the courage to make her two trips out west. Her ongoing interest in film and photography also began with him. Yet the relationship's demise signalled an aspect of her nature that later became more apparent – namely, that her dramatic personality and strong individualism might make her a difficult partner in marriage.

It is impossible to guess how venturesome Pegi's free life and, perhaps, free love were at this time. Her generation tended to keep such matters to itself. Finnie recorded skinny-dipping in a Gatineau lake, but this was not unusual in their circle.[36] Pegi herself often gave the appearance of being liberated, but it was something that she did not fully express. Thus, for some people she epitomized the bursting freedom of the 1920s, while others saw in her a strong puritan streak – she was, after all, brought up as a Presbyterian.

In general moral terms, however, the 1920s, even in Canada, 'roared,' and it was unlikely that Pegi ignored the prevailing fashion. She undoubtedly moved beyond the opinion that she had expressed at the École des Beaux-Arts – that marriage and a career in art did not mix. Instead, girls such as she (although there is no evidence that Pegi read the book) responded to the example of women such as Isadora Duncan, who in her autobiography, *My Life* (1927), recalled an early decision: "I would live to fight against marriage and for the emancipation of women, and for the rights of every women to have a child or children as it pleases her … and I made a vow that I would never lower myself to this degrading state … one of the fine things the Soviet Government has done is the abolishment of marriage … I believe my ideas are more or less those of every free-spirited woman."[37]

In the 1920s Pegi established her reputation as an artist. Her paintings found increasing acceptance in the few major shows that took place in Montreal, Ottawa, and Toronto. Reviews were generally positive or better and praised her distinctive and original technique. The apotheosis of these good years came in the form of the Willingdon Arts Prize set up in 1928 by the governor general, Lord Willingdon.[38] The competition was open to all the arts, including music and drama, and to all the artists of Canada. Former Canadian official war artist and Group of Seven member Frederick Varley's fine portrait *Vera* shared first prize in 1930 with Pegi's contemporary the noted painter George Pepper's *Totem Poles, Kitwanga*. Pegi's portrait of a dark-haired young woman in a red-patterned dress, *My Western Cousin* (undated), gained honourable mention in 1929, as did her *Indian Boy at Hagwelget Canyon* in 1930.[39] The 1931 competition drew many entrants, including Pegi's friends Nan Cheney, Charles Comfort, Pepper, and Varley.[40] Pegi won, accepting $200 for *The Log Run* (c. 1930) (Fig. 3.9). It was a significant achievement and put her at the forefront of the post-war young generation of artists.

3.9 *The Log Run*, c. 1930; oil on board, 59.7 × 59.7 cm (Plate 5)

This picture is characteristic of her landscape work in the period in choices of both subject and treatment. The theme is probably the Gatineau River, which feeds into the Ottawa River, and she depicts it as a transportation route for timber culled in woods deep inside Quebec. The technique is rigorous and accomplished, but the heavy swirling of the paint application owes much to the increasingly mainstream Group of Seven.

Pegi's success was enough to gain her another solo exhibition of almost twenty paintings at the Lysle [*sic*] Courtenay Studios in Ottawa, which E.W. Harrold reviewed perceptively in the *Citizen*. He noted her growing originality but considered the show uneven.[41] Although much of her work remained tied to the École des Beaux-Arts and the Group of Seven, her

increasing use of watercolour had generated a spontaneity and occasional chaos that marked another transition.

A picture of her in the Ottawa *Citizen* of 19 June 1931 accompanies the news of her Willingdon Prize and shows a striking little head with dark hair slicked close. She looks far younger than her twenty-seven years. In a contemporary drawing of her by Group of Seven member and art educator Arthur Lismer, we see a pert little face framed by dark bobbed hair. Her dress and shoes are rather stylish. She is sketching intensely at one of the Browns' soirées. Caught in profile, her strong but small figure bends over in concentration, doing what she liked to do best.[42] "Pegi's art was her life," wrote Marjorie Oberne. "She would wake in the night with a vision, and leap out of bed to paint frantically until she was exhausted."[43] Though perhaps dissatisfied with her personal life, Pegi could savour her reputation as an artist. Her connections and friendships and her established status situated her well for success.

Left-Wing Flames

1931–1932

IN THE AUTUMN OF 1931 twenty-seven-year-old Pegi moved to Montreal. One can surmise, in the absence of evidence, that she hoped to further her burgeoning career. As well, her recent professional successes may have suggested that she could survive independently. Living with her parents had become increasingly irksome; they saw her as merely unmarried and self-employed, and her presence seemed a reproach to their values. She probably also wanted to get away from Ottawa and memories of her failed relationship with Richard Finnie. Too honest not to be aware of her early good luck as an artist, she doubtless also realized that she was no longer the Browns' little daughter-cum-protégée, no longer the aspiring artist, but well established.

However, she had not counted on the Depression. In response to the crash of the New York stock market in October 1929, the Canadian industrial economy had begun to unravel. By 1931, the jobless were in the streets, and the downward spiral was relentless. By 1932 industrial production had dropped by a third, and a year later the country's unemployment rate was twenty per cent. In 1933, a third of Montreal's labour force was to be out of work. With no developed relief programs in place, the poor became visible. As a civil-service town, Ottawa was somewhat protected, but in Montreal the consequences of economic collapse were palpable. What limited support there was for artists disappeared.

If Pegi had hopes, promises, of paid work in Montreal, virtually none was forthcoming. Possibly she had been naïve to hope for a self-supporting

life in such difficult times, but artists with no independent means tended to expect a thin time of it in any case. Her contemporary and friend Carl Schaefer remarked that in Toronto he earned in 1930 only $12 from sales of work, and in 1931, nothing.[1] None the less, the difficult times provided Pegi with yet another direction, formed in the crucible of the left-wing ideologies to which her Montreal circle introduced her.

Montreal had long been Pegi's spiritual home, and after several moves in the city in late 1931 and early 1932 she found a nest for herself – "a wonderful studio ... an old stable made over ... primitive and charming," she wrote to Marius Barbeau.[2] 3410 rue Ste Famille was close to the École des Beaux-Arts and to several of her friends.[3] The area was attractive and she discovered challenging subject matter in this new urban environment. *Montreal Street Corner* (1928) displays her growing skill (Fig. 4.1). However, her studio burned down; there is no record of what she lost. But this event may help explain why we know nothing about so much of her exhibited early work. Still, she had enough to show in 1932 in Ottawa, Toronto, and Vancouver and at the Royal Canadian Academy in Ottawa.[4]

In February 1932, at Eaton's store in Montreal, she showed fifty-one paintings ranging in price from $10 to $250.[5] The exhibition was well received, and she sold three pieces.[6] An extensive review in the Montreal *Star* was complimentary. It praised her developing style and termed her approach to portraiture "striking." "They are mostly painted with hard strokes, not altogether unlike theatrical make-up, which, like good make-up, suggest form and character well with the right point of view." However, in showing so much work, which included many sketches, Pegi perhaps exposed the unevenness of her output. "Miss Nicol is making her own way of painting," the reviewer concluded, "and some of her pictures seem to be experiments of which the results do not quite carry out her intentions."[7] Her approach to painting, though still generally similar to that of many of her contemporaries, was beginning to reveal individuality and, not infrequently, unregulated spontaneity. From now on her works could be uniquely brilliant or closer to slapdash.

Despite the fire and some hardship, Pegi found the six months in 1931–32 living in Montreal much to her taste. She was delighted to be starting her wholly independent life in a place and circumstance so sympathetic. Superficially, of course, the city retained its gloss – at least in its anglophone quarters. The great ocean liners steamed into port, and Sherbrooke Street sparkled with elegant façades. The arts were active and

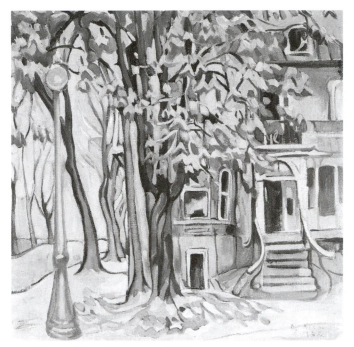

4.1 *Montreal Street Corner*, 1928; oil on canvas, 51 × 51 cm

4.2 *Blind Joe's Wife*, 1932; linocut in brown
ochre on chine, 28.9 × 18.7 cm

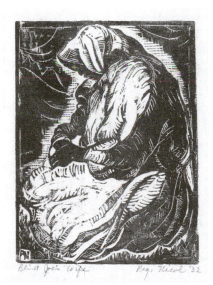

she learned of many new directions – particularly modern European art, which centred on the activities of the artist John Lyman. With character-istic enthusiasm Pegi attended classes again, in wood engraving with Edwin Holgate, and probably turned up at his informal life sessions too, for she began to paint the nude, and some of her figure studies and wood engravings resemble his work.[8] She also encountered the figurative paint-ings of Prudence Heward, which were to inspire a number of her own por-trait compositions a few years later.[9]

The sessions in wood engraving encouraged her to complete a commis-sion for Barbeau to illustrate several of his collections of French-Canadian folk tales. The results were not entirely successful, and she does not appear to have done any more work for him, although illustration remained, as it had been for some years, a minor feature in her life.[10] *Blind Joe's Wife* (1932) is a rather more complex example of her work in this genre (Fig. 4.2).

In 1931 she already had several good friends in Montreal who could help her over rough spots. Chief among these were Marian (Fig. 4.3) and her husband, Frank Scott. She was often with them and was soon absorbed into related circles both in Montreal and Toronto that she found most congenial and that welcomed her warmly. These networks of friends and acquaintances were to be the most important of her life. Friends like Bertram and Aurilla Brooker would use a visit to Toronto from Pegi and Marian as an excuse for a party (Fig. 4.4). In Montreal, she associated with an assortment of young people in their twenties, including academics, lawyers, journalists, businessmen, artists, writers, and strong supporters of the arts. A selection of names would include Raleigh Parkin, an invest-ment analyst with an interest in the Arctic, and his wife, Louise, whose brother was the British socialist journalist Claud Cockburn. King Gordon (Fig. 4.5) – a young professor of Christian ethics at the Montreal Theo-logical College and the son of the Rev. Charles W. Gordon, the celebrat-ed author who wrote under the name of Ralph Connor – was also in their group, along with his sister, Lois.

The artist André Biéler and his wife, Jeanette (an interior designer who assisted in the mounting of art exhibitions at Eaton's), became life-long friends, as did journalists John and Florence Bird. Jeanette Biéler had been a student at the École des Beaux-Arts with Pegi.[11] Other friends included architect Hazen Sise and politician Brooke Claxton – brother-in-law of the painter Anne Savage. Another friend was Oxford-educated Ronald McCall, who had arranged the show of Pegi's pictures at the

4.3 Marian Scott, undated

4.4 Party for Pegi and Marian at Bertram Brooker's, Toronto, 1933: from left to right: Pegi, Louise Comfort, Marian, Thelma Ayre, Robert Ayre, Aurilla Brooker, and, in the front, Will Ogilvie and Brooker

4.5 King Gordon, undated

Leonardo Society three years earlier and who, according to the Biélers, had been her lover.[12] André's businessman brother Jacques was also a close friend.[13]

Many of Pegi's friends were people of considerable distinction, and most were anti-establishment and irreverent about contemporary politics. The majority remained outside the cliques of political power but closely and aggressively followed and promoted political and social reform. The Methodist-inspired Social Gospel movement, which sought to implement social change, had influenced the parents of many of them. The Depression directly affected their own ideas.

The Scotts and their circle had strong links with Great Britain. Marian's family was from England, and she had studied there, and Louise Parkin was British-born. King Gordon, Raleigh Parkin, Frank Scott, and others had attended Oxford University in the 1920s. Their intimate connections with the old country made some of them sympathetic and keen to maintain traditional links and patterns of behaviour. However, pro-British views became increasingly difficult to uphold in the wake of the 1931 passing of the Statue of Westminster, which declared the dominions independent nations. Others in the group had been disenchanted by their exposure and

in many instances had become severely anti-British. For some, an attractive alternative became pan-Americanism – the fostering of an association with Central and South America.

In the absence of consensus, nationalism linked itself increasingly with isolationism and pacifism. The Great War was still a recent event that had revealed the horrors of modern warfare. Canadian losses had been staggering (over 60,000 dead), and the sufferings of many survivors, maimed physically or psychologically, remained formidable. Raleigh Parkin, who had joined the British Expeditionary Force and survived the disastrous campaign at Gallipoli to endure a lifetime of nightmares, was an ever-present reminder of the war for Pegi's group. As time went by, people remembered the horrors with ever more vigour, whereas the glories and sacrifices grew dim. As a result, many in the circle rejected patriotism, whatever the circumstances. The United States was isolationist, and there was a similar mood in Britain and in Europe in general, where it was strongly linked to socialism.

Canadian socialism found its main inspiration in Britain, where the Labour Party had taken office in 1924. The pamphlets and studies of the Fabian Society and the magisterial writings of R.H. Tawney had helped transform popular discontents and resentments in the United Kingdom into political activity. Throughout Canada there were vigorous and articulate pockets of support for socialism both in and out of the universities and especially in the Prairie provinces. There were labour members of Parliament (MPs) and sympathetic MPs from farming areas in the west. The fallout from the Depression precipitated them into action. The League for Social Reconstruction (LSR) formed in 1932 to outline, promote, and define the aims of the Canadian socialist movement. Many significant early meetings took place at the Scotts' house in Montreal, and several participants later went to Ottawa to the Co-operative Commonwealth Federation (CCF), established in August 1932, with J.S. Woodworth, a labour MP from Manitoba, as its first president.

Communism flourished along with socialism. Soviet experiments provoked intense interest, and many young people, including King Gordon and Frank Scott, visited the Soviet Union and returned impressed. The differences between the two ideologies were not entirely clear, but there was a popular belief that capitalism had failed and that alternative political systems, as exemplified by the Soviet Union, could provide another way. Many people associated war with capitalism, capitalism with fascism,

and armament manufacturers with both. Socialists and communists developed weapons too, but their putative peaceful objectives seemed to distinguish them from the warmongering capitalists. The arguments were powerful and persuasive, and throughout the 1930s the pacifist movement in Canada remained strong. However, the European situation deteriorated, and after 1935 collective security failed to curb Italian aggression in Ethiopia or German reoccupation of the Rhineland. Increasing numbers of erstwhile pacifists began to realize that isolationism was no longer viable in a world grown ominously small.

Pegi become seriously involved with the political opinions of her Montreal friends and retained an interest in politics for the rest of her life. She had little aptitude for political theory, but a natural sympathy for the underprivileged made her responsive to any whiff of injustice or exploitation. Many of her later paintings of disadvantaged children in New York attest to the impact that this period had on her development as an artist.

Her guide in these matters was King Gordon, with whom she had forged a strong bond, as he was one of Marian's husband's closest friends. Gordon, like Scott himself, was doubtless captivated by Pegi's vivacity and seemingly uninhibited way of life. Both men came from somewhat severe Protestant families, both had fathers who were church ministers, and both admired artists and creative people particularly. Pegi found Gordon fascinating. Not only was he close to her own age – rather unusual in her life – but his dedication to matters about which she had thought little before was exciting to her.

"I am afraid of you," she wrote to him in her large, untidy, sloping hand. "I've never been with a man who burns with quite the same flame as yours, their burnings have been quite quite different!"[14] For this rather gentle, charming, and engaging man she made efforts to be more politically aware, even attending a session of the Commons, where, she wrote, Prime Minister Mackenzie King had been "whining."[15] In the same letter she also admitted that in politics the "critical sense" of most artists was "naïve." Architect Humphrey Carver, who was married to Gordon's sister, Mary, believed that Gordon loved her, and it is likely that she loved him too – but the match eluded them.[16] If any potential long-term relationship foundered on the rocks and shoals of their different needs and personalities, they remained friends throughout their lives, always warmly in touch. And she wept at his wedding.[17]

With the group itself Pegi identified wholly. It had many good times, many earnest discussions, much fun. Members met in one another's hous-

es to dine, to talk, to listen to records, to sing, and to practise the fox trot or the tango. Jeanette Biéler remembered Pegi at parties. "She would kick off her shoes and start dancing on her own – her spontaneity came out time and again."[18] Sometimes they would meet at a Russian restaurant, *The Samovar*, and sip borscht soup.[19] Some were well off, and some were not. Some lived in modest homes, and some in more affluence near the McGill University campus and, if they could afford it, drove an old Ford or an air-cooled second-hand Franklin. Pegi painted a lively watercolour sketch of the Scotts' Franklin crouched in their yard.[20]

They all thought highly of Pegi and remembered her well. Lois Gordon recalled a gurgly laugh and a lovely smile and observed that Pegi took very little responsibility for herself or anyone else, but was very loving. She remembered that she would come in with a wide grin, brown hair, and green eyes and that when she smiled her whole face wrinkled, and she looked like a child.[21] People listened to what she had to say. "She had a remarkable personality in that when she was in a room she dominated it entirely," wrote the artist Jori Smith.[22] Louise Parkin felt that "she had an extraordinary wisdom about life which underlay her gaiety and her intense vitality. She knew what things really mattered in life."[23] And these were the things that she chose to paint all her years.

Lack of money inevitably drove Pegi permanently home to Ottawa in 1932, but she remained in close touch with the Scotts' world, which now meant so much to her, and visited frequently. She had matured in Montreal and left behind the precociously talented and bewitching young girl of promise. However, it was to be in sober Ottawa, with a roof over her head and with the resented parental sustenance at hand, that she was to begin the hard journey to sustained excellence in her chosen vocation. The short period away from Ottawa had helped her to identify and focus her direction, and her determination to remain an artist remained firm.

A self-portrait captures the essence of this much more intense yet perhaps mature Pegi. Framed by a curiously abstracted late-winter landscape of earth, snow, bare trees, and open water, she looks reproachfully out of the canvas. This is not an entirely confident personality, but it is one that has known sadness and uncertainty. She used the spring break-up in the background perhaps to symbolize her growing need to move on from the influence of the Group of Seven's landscape technique and abstracted elements in favour of a more contemporary approach.[24]

5.1 *Untitled
(Nude Study)*, c. 1934;
watercolour on paper,
68.6 × 52 cm

Kaleidoscope

1932–1934

MUCH AS SHE MOURNED THE LOSS of her Montreal life and her independence, as winter 1932 made its mark felt Pegi settled back well enough into her parents' attic. She painted the floor blue, acquired an orange cover for her bed, and proceeded to get to work.[1] As always, she wrote. As part of the Playwrights' Group she adapted for radio Hans Christian Andersen's *The Snow Queen*.[2]

She also sketched her friends. She mentioned the activity in a 1932 letter to Frank and Marian Scott: "I am recruiting the figures of all my friends. I lure them up to the Gatineau in the Ford, then strip them and paint them."[3] Artist Kathleen Daly Pepper recalls them drawing each other as early as 1930. "We spoke of getting more practice this way as models were beyond our means in those days."[4] Marian's son Peter remembers his intense embarrassment at coming across his mother and Pegi sketching in the nude when he was about seven.[5] By 1933, Pegi was also attending life classes three times a week.[6]

A triple-view nude self-portrait by Pegi from this time features three fleshy and voluptuous views of her torso (Fig. 5.1). The classical arrangement of the three studies reflects perhaps Rubens's *The Three Graces* (1620) – a subject and artist that she would have known in reproduction. Pegi's triple nude heralds another new direction in her art, with repetition of multiple views and versions of the same scene and subject matter throughout a composition.

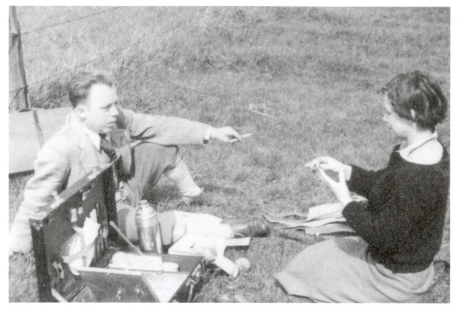

5.2 Charles Comfort and Pegi at Locust Hill, Ontario (the White farm), May 1934

She sketched regularly in the streets of Ottawa and in the surrounding countryside. On her visits to Toronto she would go sketching in the country with Charles Comfort and other artists (Fig. 5.2). One Ottawa friend, civil servant Erica Selfridge, recalled that in order to obtain a good perspective on a subject Pegi would bend down and look at it backwards though her legs.[7] Although landscape remained a preference, her range had broadened substantially – more urban and human subjects, perhaps as a result of Montreal's political and architectural stimulus. Certainly, urban subjects featured in Marian Scott's and others' paintings of the time. More important was the influence of her Montreal artist contemporaries, both anglophone and francophone, in painting real life. In this they had been influenced by New York's Ash Can School, a group of American artists a generation older in age whose work was later to influence Pegi's mature painting substantially. During these years of concentrated dedication to painting in the early 1930s, Pegi produced increasingly fewer landscapes, and less and less under the influence of the Group of Seven.

Montreal Harbour from St. Helen's Island (1933) represents one of her earliest attempts at depicting an urban landscape (Fig. 5.3). The strictly disciplined oil paint defines the architectural nature of the scene in its

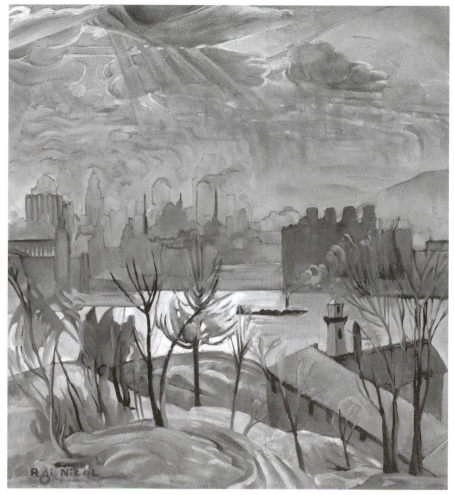

5.3 *Montreal Harbour from St Helen's Island*, 1933; oil on plywood, 65.8 × 60.4 cm
(Plate 6)

luminous, heavy, winter light. On a visit to Montreal, she worked on it for
a week alongside Marian, and the perseverance and concentration affect
the final outcome, which shows little of her often incomplete and hurried
technique.

Pegi did more works on paper, and her proficiency grew in watercolour,
a medium on which she put her personal mark. Pegi had rediscovered the
inexpensive material in her unemployed state. These ebullient composi-
tions display the distinctive, supple brush strokes that were to become her
trademark, enabling her to catch the fleeting, pulsating, intangible nature

and moods of life around her. Carl Schaefer perceived that she had "the light but strong touch and you could feel that immediate release, not laboured in her work."[8] She was selling and showing regularly, and a solo exhibition at the Ottawa Art Association in 1933 revealed her colleagues' high regard.

By 1934, she had produced a notable watercolour – *Amateur Hockey*, which she exhibited with the Ontario Society of Artists at the Art Gallery of Toronto in March. This picture of homely yet proficient youngsters on their skates was one of her first successful depictions of children's daily lives – particularly popular subjects in the 1930s. At about the same time she showed a watercolour of young people digging in the school garden across from her parents' home.[9] She returned to this subject again and again through the years, adding more figures and more action. The angled view from her attic studio inspired her (Fig. 5.4).

That "kaleidoscope vision" – her later phrase for the results that she sought – was emerging at the forefront of her approach.[10] She wanted to portray the urban life around her, seemingly as candidly and immediately as a snapshot – the moment captured before it moved and changed, but in essence still solid in structure. Pegi had found her own way and had grown away from the themes and manner of the Group of Seven – the solemn land, majestic mountains, pine trees, and blazing autumn colours – to a new and effervescent technique, instantly recognizable as hers. She knew that her work was good and felt confident that the marked shift was right for her.

This development reflected a sea change in the art establishment that she knew. Eric Brown was winding down his long and fruitful directorship of the National Gallery and coping with the effects of the Depression on official attitudes towards the arts. Inevitably the gallery had been caught up in federal politics, its budget and policies ever more closely scrutinized.[11] In late 1932, a petition signed by one hundred academic painters challenged his curatorial judgment. Quite a few of them – their leader was Ernest Fosbery (soon to paint Pegi's father) – were members of the Royal Canadian Academy, which had orchestrated the document, having long been jealous of the gallery's ascendancy. A manifesto in response expressed support for Brown and carried over three hundred signatures. In a letter to Charles Comfort, always a good friend, Pegi expressed her anger at this turn of events.[12] "I love the gallery so much," she added, "and especially

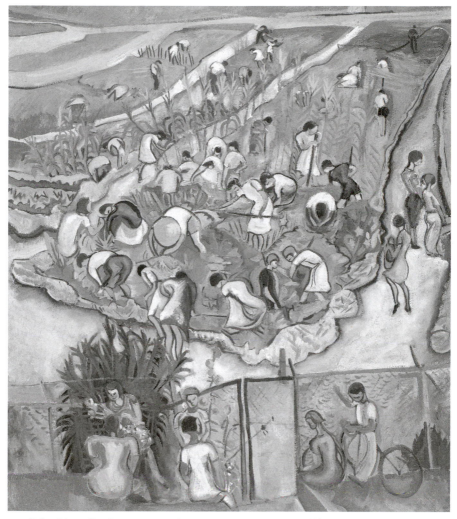

5.4 *School in a Garden*, c. 1934; oil on canvas, 112.4 × 99 cm (Plate 7)

the modern room that I feel I am in the midst of life there, more than in any other place."

The affair did create a tempest. The petition cast Brown as a doctrinaire arbiter of taste and undoubtedly shook what remaining prestige the Academy enjoyed. The artists themselves probably enjoyed the lobbying and politicking, but the ageing Brown himself was chastened, remarking in a letter to his assistant, H.O. McCurry, "I am getting rather doubtful of the wisdom of trying to push Canadian art forward as much as we do … I

think it would be wise to withdraw from current art activities gradually or at least temporarily so as to give us time for more study and peace of mind at least."[13]

In 1933, the gallery hosted its last annual exhibition of Canadian art; it had made regular purchases from the event in the past. The Group of Seven had held its final collective show in Toronto in 1931 – a decade after its first. In 1933, the Canadian Group of Painters formed as a direct spin-off, perhaps spurred on as well by the National Gallery's suddenly low profile in Canadian contemporary art and a developing interest in educating the public about the social value of art. This body gave many English-Canadian practitioners across the country some unity and identity and an annual showcase that often toured. Dealers and commercial galleries were still scarce, so artists' organizations were crucial. Some major private buyers were emerging, including Douglas Duncan, J.S. McLean, and Vincent and Alice Massey. Prices were not high, so artists did not benefit much from sales, but these collectors played a key role in the 1930s.

Generally speaking, however, interest in the visual arts remained confined to a small group.[14] Study of the fine arts as an academic subject was slow in developing in Canada. In the Maritimes, both Acadia University (in 1928) and Mount Allison University had well-established fine arts courses by the 1920s. In the early 1930s, Queen's University, in Kingston, Ontario, offered only one such course, in the art of the Renaissance, with visual aids consisting of small rotogravure reproductions.[15] But in 1933, Queen's obtained funding for extra-mural fine arts courses from the (U.S.) Carnegie Corporation.[16] Goodridge Roberts was the first artist-in-residence there in 1933, followed by Pegi's Montreal friend André Biéler in 1936. The University of Toronto and McMaster University in Hamilton also began offering fine arts courses in 1933. The University of Toronto set up a chair of fine arts in 1934 also with assistance from the Carnegie Corporation.[17]

Other levels of education became active, too. Several private schools provided good introductions – for example, Upper Canada College in Toronto and Miss Edgar's and Miss Cramp's School in Montreal. Pegi's own work as an art teacher at Elmwood in Ottawa in the mid-1920s was also notable. Arthur Lismer also taught for many years in art schools and art galleries in Halifax, Toronto, and Montreal. However, throughout Canada nursery schools and kindergartens lacked trained art staff and facilities for creative painting and drawing. Some of the established gal-

leries and other interested groups did endeavour to fill the gaps. Pegi herself had taught children at the National Gallery, where, according to Maud Brown's recollections in *Breaking Barriers*, she assisted in the Saturday art classes for children – perhaps from her return from studying in Montreal in 1924 until she moved to Toronto in 1934.[18] Marian Scott and Fritz Brandtner worked with youngsters in Montreal in the 1930s.[19]

These developments were encouraging. The numbers of people knowledgeable in the fine arts began to increase, and the public could read books and articles by such critics as Walter Abell, Robert Ayre, Donald Buchanan, and Graham McInnes.[20] Nancy Clark has argued that these non-artist-critics created the conditions for the acceptance of modernism in Canada.[21] Reviewing in the daily press improved, although specific expertise was rare outside Quebec, where art journalism enjoyed a higher profile. Journalists such as Augustus Bridle of the Toronto *Star* covered all branches of the arts. In the Toronto *Globe and Mail* Pearl McCarthy reviewed art – she was perhaps notable more for being a woman than for the perspicuity of her columns.[22] There were no exclusively art magazines, but *Saturday Night*, under its distinguished editor, B.K. Sandwell, made a unique contribution, dispensing information as well as opinion.

Ottawa itself was slowly changing. No longer a small, rather stuffy town, it had a burgeoning population, and many new arrivals were looking for excitement and stimulation. Government was widening its concerns beyond regulation, taxation, economic reconstruction, and the mechanics of Canadian independence. It did not entirely neglect the arts either. The growing number of private radio stations led to the establishment of the Canadian Broadcasting Corporation (CBC) in 1936. Plans for a documentary film institute led later, in 1939, to the creation of what was to become the National Film Board under the guidance of the mercurial English filmmaker John Grierson.[23]

Pegi fitted into the improving social scene easily. Her Montreal friends such as Marian and King Gordon were frequently in Ottawa, and she could draw on their world for outside stimulation. The Ottawa artist Henri Masson commented: "She was, in the Thirties, the 'enfant terrible' of the rather dull and small group of Ottawa artists, strange dresses, active in the theatre group … she was so much more alive and interesting than the majority of Canadian painters who painted dull Canadian landscapes."[24] Peter Aylen, a broadcaster, saw a good deal of her, sometimes at musical evenings at the home of his brother-in-law, the poet Duncan Campbell

Scott. He recalled: "Ottawa at that time was a dull, stuffy Victorian town and I remember Pegi as one of the brig[h]t spots in the drab settings. She was lovely and high spirited and wrapped up in her painting."[25] Lawrence Freiman, a cousin of the painter Lillian, met her often at the Browns on Sunday afternoons for high tea – a meal frequently followed by games. "Some evenings we would play records and talk – of art, politics, the theatre, or the continuing depression which we were beginning to believe would never end."[26] And there were always the expeditions. During a drive in the country, she suddenly shouted for him to stop. "Look at the light on that barn," he remembered her saying.[27]

Undoubtedly Pegi's life at home was now easier, if duller. Her long-suffering parents, if unsympathetic, were none the less forbearing and not intrusive. Their lives were virtually separate from that of their daughter. They did not take meals with her, or holidays, and scarcely entered her world, small though Ottawa was. It was clear that they now recognized the practical problems associated with the Depression and understood that their daughter had chosen a not particularly remunerative path in life. Perhaps they also now recognized what she had achieved in her chosen profession. Nevertheless, while they would always accept Pegi into their home and provide practical support when she needed it, they would make little effort to enter or grasp her new world. She herself seems to have remained resolutely apart from their milieu.

But this was not the complete story. When they died some years after Pegi, they left their Glebe home to their granddaughter, Jane, who scarcely knew them. Boxes and boxes of Pegi's paintings, going back to her Ottawa art-school days, formed part of that inheritance. Pegi's parents had, it would seem, finally recognized the importance of art for their daughter and had kept much of what she left with them, however casually – and she was casual with her art – as a tangible reminder of her.[28] The days when her mother destroyed her work, which her friends remembered, did finally end.

For Pegi the years 1931–34 in Montreal and Ottawa challenged her vocation and her creative capacity. In January 1933 she told Marian in a letter that she had given up "plays, radio, everything" in order to paint well. "I just came to a conclusion after a solid day's painting," she noted. "At the end of the day I was just beginning to do what I wanted and then I thought of all the days of being ill, Christmas holidays, back to doing cards,

rehearsing for plays, right back to November and although all these dis-
tractions were quite unimportant they had crowded out my ambitions for
that period almost entirely."[29]

It was an uphill struggle to produce good work, as she wrote to Marian
from Ottawa in 1934 after a visit: "I saw my own works with such disgust
since I got home … I wonder I had such an obsession to show."[30] She
had come face to face with the fact that unless she focused entirely on art
the work that she produced was far less than her best. She learned that
in order to create good paintings she had to work hard and avoid distrac-
tions. Still her emotional responses had developed, conditioned in part
by the company that she kept and the social and political mores of the
socialist movement.

Portraying life as she found it became her obsession, and her unique
approach to this subject matter became her legacy to Canadian art. It is
possible that she mourned the passing of the landscape element in her
work. "The manifestations of nature as themes of interest are now out of
fashion," she wrote Marian. "Simple flowers and rainbows are out of
place."[31] Nevertheless Pegi could now consider herself in the vanguard of
English-Canadian art. She had received some good reviews, won a presti-
gious prize, exhibited widely, and shown herself to be an artist to notice.
She was, however, well aware of limited horizons and the dangers of too
small a pond. It was time to leave home again. This time she moved to
Toronto.

PART THREE

Toronto and New York

1934–1939

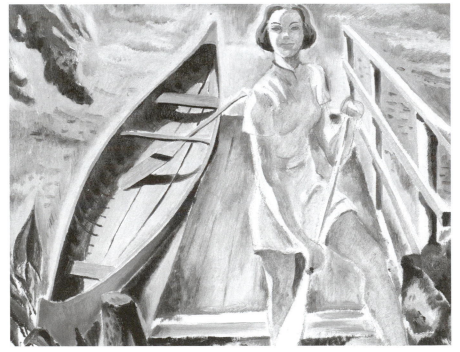

6.1 Will Ogilvie, *Pegi Nicol at Durham House in the 30s*, 1934; oil on plywood, 30.5 × 40.7 cm

Cyclamens and Begonias

1934–1935

PEGI SPENT MUCH OF THE SUMMER OF 1934 as the guest of Vincent and Alice Massey at Port Hope near Toronto. She had met them in Ottawa through the Browns (Massey was a trustee of the National Gallery from 1925 to 1952, when, a widower, he moved into Rideau Hall). She also had a personal connection with them through her Montreal friend Raleigh Parkin, Alice's brother. While this summer opportunity was probably what led her to leave Ottawa, it was not necessarily the reason she lived in Toronto afterwards.

The Masseys were both enthusiastic patrons of the arts and had the largest collection of contemporary art in Canada.[1] Taller and older than her husband, and well connected, Alice Massey was also energetic and lively and liked to take people under her wing. In the summers of 1933 and 1934, she and her husband gathered around them groups of musicians and painters, putting them up at Durham House, a commodious and elegant nineteenth-century farmhouse on the Batterwood Estate that they had acquired in 1926.[2] They themselves lived in the newer, grander Batterwood House, built near Durham House in 1924.

The group that Pegi joined at Durham House included the painters David Milne, Lilias Torrance Newton, and Will Ogilvie. Musicians Harry and Frances Adaskin were also there – Harry had in 1923 been a founding member of the famed Hart House String Quartet.[3] By all accounts Durham House was home to productive and mutually entertaining

sojourns, with picnics, games, and impromptu dramatic performances. Both Masseys loved acting (as did Massey's brother, Raymond, who became internationally renowned) and supported superb amateur productions at Hart House, which helped to pioneer English-Canadian drama. In 1932, Massey had also helped found the Dominion Drama Festival.[4] In 1933, Pegi commented on the festival in prose and image for the monthly journal *Canadian Forum*.[5] She should have liked her summer sojourn, as there was much to do that suited her.

Certainly she painted a great deal – a frequent subject, cows in the neighbouring field – and she was also herself the subject of an informal portrait. Ogilvie depicted her paddling away but alongside, not in, a canoe, an impish grin on her face (Fig. 6.1). She also taught art to young Hart Massey, then about sixteen and an eager pupil. He was a willing subject as she painted or drew his portrait at least five times.[6] She reported fulsomely to Marian Scott about it all but expressed some doubts: "I have made attempts [at writing] and one was about ten pages. It got dated so I tore it and threw it over the dam at the Masseys. It fell on a space below where no water ran. It could be read from above and it disturbed the Massey order until it rained ... My experience at the Masseys ... wasn't very successful but would need more than a letter to tell why."[7]

None the less a number of her pictures from that summer found their way into the Masseys' hands. The material from their collection shown in December 1934 at the Art Gallery of Toronto included a remarkable thirteen of Pegi's works.[8] Notable was one of her rhythmic oil paintings of cows.[9] The cows – in all shapes and sizes – crowd the canvas with the directness and simple animal presence of an ancient cave painting of bison.

Pegi did not much like Toronto when she first arrived there in 1934 after her stay with the Masseys. In fact she never liked it much at any stage and seldom visited it in later life. She thought it ugly and uninteresting in comparison with Montreal. For Pegi, as for many others, every day in Toronto, known for its ubiquitous church spires, felt like Sunday. To its Ontario neighbours it was Hogtown – a small meat-packing centre grown big and grasping, with a pious and conventional populace interested primarily in making money. In Pegi's first year there the town – though founded in 1793 as York, capital of the new colony of Upper Canada – was celebrating its centenary as a city named Toronto. It was showing signs of

becoming the "no mean city" that it is today. Several dramatic new build-
ings – the Bank of Commerce headquarters on King Street West (the
tallest building in the British Empire), Eaton's College Street store (where
Pegi eventually worked), the Royal York Hotel (the empire's largest), and
the Metropolitan Life Insurance Building – were enlivening the generally
dull streetscape. Although stately homes and charming residential areas
edged the city's network of ravines and valleys, grimy railway tracks and
grubby warehouses spoiled the bustling harbour on Lake Ontario.

Toronto's inhabitants fared little better in Pegi's view. "No one here has
made up for Montreal people and I mean no one," she wrote to Marian in
December 1934. "The nicest people here are not gay even if active inter-
estingly … I feel no stimulation for art here."[10] She found that openings at
the Art Gallery of Toronto were as orderly as life with the Masseys. It was
"a very formal place," recalled Margaret Machell, later an archivist at the
gallery. "Long dresses and dinner jackets or evening clothes were worn to
openings. There would be speeches in the Walker Court and tea was
served upstairs in the Print Room … There was often a pianist or a quin-
tet to give background music. They were Social Occasions and reported in
the 'social pages' of the three papers."[11]

Pegi also found the art of her contemporaries in the city less than over-
whelming. As for the Ontario Society of Artists: "The O.S.A. is simply
terrible," she complained to H.O. McCurry of the National Gallery in
February 1935.[12] "The water-colour show is a [sic] the crime of the cen-
tury," she declared in another letter to McCurry, "worse than the O.S.A.
because it is more competent, neater and neater. So neat it makes your
hair curl. You can see them all putting on the washes through a thing like
a 'gasget' [sic] in a car, neatly & with much labour and then sighing heav-
ily & daring to call it a water-colour."[13]

Despite the modern art that they increasingly saw in the galleries of
London and New York, members of Toronto's upper middle class still
bought works by the Hague School, the Barbizon School, and Cornelius
Kreighoff, as well as marine paintings, for their sumptuous neo-Tudor and
Georgian houses. Some did hang the odd contemporary picture by a
Canadian – the market had grown in the pre-Depression years – much as
they included Native Canadian artifacts, oriental pots, and William Morris
wallpaper. This neglect did not deter Canadian artists, and some, particu-
larly the portraitists, made a living. Teaching jobs at the Ontario College
of Art, the Central Technical School, and other public and private schools

also supplemented incomes during the Depression. At Rosa and Spencer Clark's new Guild of All Arts on the bluffs in suburban Scarborough, artists and craftspeople could create and sell works in a co-operative setting. Other talented people worked in advertising and general illustrating, contributing much to the high quality of Canadian book production in the inter-war years. As in Montreal, however, there were very few commercial outlets.

Despite Pegi's criticisms, Toronto's art as well as its cultural life was no more limited than Montreal or Ottawa's, even if at times the circumstances of presentation and the subsequent reviews had their limitations. Margaret Machell recalled that when the Metropolitan Opera of New York "came to Toronto the operas were presented in the Maple Leaf Gardens because the Royal Alex[andra Theatre] stage was not big enough. The art critic was usually also the music critic."[14]

Her reservations about Toronto aside, Pegi did settle down there and found enough work to support herself. She was also stimulated by the wide range of experiences that came her way. By the autumn of 1934 she was living in a boarding-house on Grenville Street along with twenty-seven other residents. It gave her the freedom to live as she wished – something akin to her studio in Montreal. She reported to Marian in December 1934:

I'm a worker now in the social sense and of use. It costs me my social life almost entirely. I work day and night but being relieved of home pressure my mental pleasures are all day continuous. [It had been] an experience so wide that I would need to tell it in person … my artistic knowledge has spread out to something I could never have had before. My present occupations are designing and building a set for a Hart House play, The Pied Piper, also designing and executing two panels for Christmas (6-¼' × 13') for Eaton's. These are two large jobs but less one I would not make enough to live here. I manage to paint the occasional model now and then as a holiday but I have nothing to show.[15]

A highlight was her set for *The Pied Piper* – a prize-winning play of 1909 by American writer Josephine Preston Peabody that ran at Hart House from 26 December 1934 to 5 January 1935. Pegi helped to make the costumes and, in some of the twelve performances, substituted for "Five strolling actors that promised [to come] but because of Christmas did not come."[16] She painted the set on cloth – a fairly accurate rendition of a medieval

6.2 Pegi working on the set for *The Pied Piper* at Hart House, University of Toronto, 1934

town, with houses, a perspectival view down a street, and a church en-trance. The landscape through which the piper led the children was a sep-arate backdrop, painted more freely than the town scene. A photo of Pegi painting the set captures her enthusiastic, gamin qualities as she sits among the components of her design. Bright eyed, with her hair quite short, and dressed in baggy corduroy pants and wrinkled socks, she exudes the cheer-ful confidence that she brought to this serious undertaking (Fig. 6.2).[17]

Pegi started to work for the Eaton's department store chain in 1934 through meeting René Cera, its French architectural designer. Their friendship lasted throughout her life. Humphrey Carver described him as a "wonderful and improbable person to be in Toronto – round, provençale [*sic*], beret looked like Picasso."[18] The seventh-floor restaurant and audito-rium at Eaton's spectacular College Street location, designed in 1929–31 by French architect Jacques Carlu, represented the pinnacle of modernist expression in Canada.[19] (The auditorium recently reopened after sitting empty for years.) As Pegi had found in Montreal, Eaton's exhibited art: the

second-floor gallery at College Street regularly hosted shows of contemporary painting.

Cera undoubtedly introduced Pegi to new aspects of international progressive art. He also admired her accomplishments and recalled: "A friend … Charles Comfort, introduced us … I soon realized that Pegi, in her own particular way, was a highly gifted person. It was as though she were possessed by a sort of feverish daemon which transposed onto canvas the ordinary events of surrounding life – particularly the spontaneous activities of children. As a sensitive artist, she was alert to the fresh motions and expressions of street urchins … a transformer of factual events in a magical production." Pegi prepared for him "some draped floating canvasses with a colorful exuberance, which even today I remember with enthusiasm. The public liked them too … Pegi worked for me at Eatons only for special jobs which suited particularly her talent. But she did not feel attached to a steady employ, being, before anything else, jealous of her creative freedom which she devoted to the production of her own original and personal painting."[20]

In a letter of late 1934 to H.O. McCurry and his wife, Pegi describes in detail her start on the Christmas commission that she mentioned in her December 1934 letter (see above) to Marian. "It is to be 'Alice' in Eatons staring at a treasure of millions of 'Gift Suggestions' in the form of a Still-Life Pot-Pourri, (6 foot × 13') twice. Six weeks to do it. I'm going around the shop picking the things out as if presents to myself, then painting them."[21] She, like the other artists employed by Cera, worked in his vast top-floor studio at Eaton's College Street store, using commercial paint to create murals, sometimes as large as 60 × 12 feet.[22] They were subjects of much interest in their time. "When they changed the [huge, ground-floor display] windows," recalled one friend, "everybody went down to see … It was really a very important sort of visual event during the year."[23] Pegi also decorated the restaurant at the store, although there is no record as to what it looked like.[24]

In a letter to Eric Brown she confided, however, that she had not found working for Cera "interesting" or "worth it."[25] She admitted in her letter to McCurry that she was neglecting her own painting but was able to fit in some. "Please don't think I don't paint anymore. I do, at noon hour sometimes and after midnights."[26] Often she was discouraged; she knew that any work other than painting was detrimental to the quality of what she produced. The artist Caven Atkins recalled that she would throw away the

6.3 Bill Graham, undated

unsatisfactory efforts and that once he asked if he could use the back of some for his own work. Of the three sheets that he picked up, he painted only on one – a still life – on the reverse of which was a sketch of Norman MacLeod, Pegi's future husband.[27]

By the autumn of 1935, having moved several times in Toronto, Pegi was living at 506 Jarvis Street, the cheapest accommodation that she could find. There were no private washing facilities – but she was accustomed to this. She had little money and, while she now knew many people in Toronto, felt out of step and a bit lonely. "I need you and your house, friends, Frank and Montreal very much," she wrote to Marian, "I am not growing ... and no one here knows where I was even starting for [sic]. I must translate to most."[28]

She was enmeshed in another love affair – physically intense, difficult, and inspiring – again with a man some years younger – W.H. (Bill) Graham, whom she had met at Eaton's (Fig. 6.3). They shared an interest in writing, theatre, and the outdoors. Graham later went into advertising (he was a vice-president at MacLaren Advertising in the 1960s). Pegi and

Graham briefly shared the apartment on Jarvis Street with Graham's best friend, Charles Nichols, who was to marry Norman MacLeod's sister. Graham's deep admiration for Pegi's work and respect for what she could do and be mattered to her. "She really had that extraordinary visual gift of making herself something to look at," he recalled. "That is, she could pull together bits and pieces and there she was, something that you loved looking at."[29] The apartment itself may also have been inspirational. Marian described it as a "third floor cold water flat with a fireplace over a brothel," but in an interview Graham disagreed with the allusion to the occupants' profession.[30]

He remembered Pegi painting her series of self-portraits in 1935–36. In his view the apparent spontaneity of her technique belied hard work and a constant stream of changes. "She also scrubbed out an enormous amount," he revealed. "She made terrible messes and scraped it all off and scrubbed it all off and would be furious and give up painting. Then twenty minutes later, be back."[31] Pegi's writing never explained her motivation for revisiting self-portraiture over a number of years. None the less, her dual role there as both creator and subject offered unusual freedom. One can only imagine that she used it as a means to self-understanding or self-discovery. Possibly the Art Gallery of Toronto's acquisition in 1934 of Augustus John's celebrated and dramatic 1919 portrait of the Marchesa Casati had an impact on this latest reoccurrence.[32]

In one of these self-portraits, *Pegi with Cyclamens* (1936), a watercolour – and featuring her favourite houseplant – Pegi makes her naked, draped body the central subject and situates her kneeling form to the left of the composition, with the top part of her head cut off slightly by the paper's edge (Fig. 6.4). This adds to the intensity of the composition because the paper seems not large enough to hold her body. Pegi's strong, muscular right arm reaches down to encircle the cyclamen plant while her left hand hovers above a bloom, apparently about to pluck it. Her face, set at an angle, meets the viewer's gaze directly. Her technique is fluid and rhythmic, enlivening every corner of the paper with curving strokes of paint.

Pegi with Cyclamens was not her first naked self-portrait – she had painted herself regularly in Ottawa – but it exemplified her ability to incorporate personal meaning of a narrative kind and be more than just a study from life. Undoubtedly, her ongoing interest in the human figure and a now-practised technique allowed for its more exuberant depiction, but so too did her own sexual experiences. The work probably evokes the

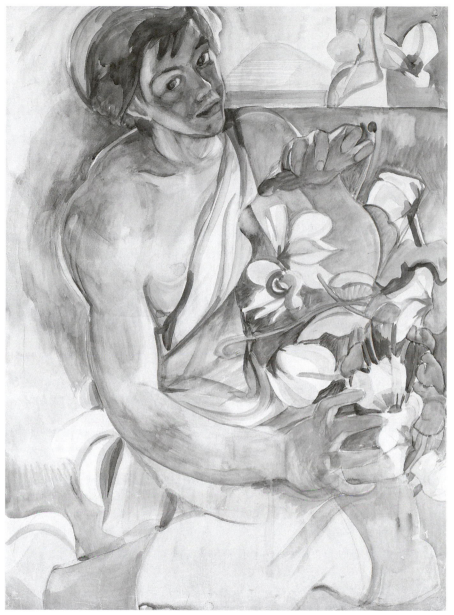

6.4 *Pegi with Cyclamens*, 1936; watercolour and graphite on paper, 76.2 × 55.9 cm (Plate 8)

consummation of a new relationship, giving a special meaning to the bloom being plucked. The painting denotes a more hedonistic dimension to the artist's life and locates the sexual element centrally in her figurative work.[33] However, the painting was not exhibited in her lifetime, being left in a huge roll of watercolours of mixed quality – perhaps as discarded as the relationship – with Charles and Louise Comfort.[34]

Such paintings were a bold, if not unique, gesture on Pegi's part. Even though liberal circles in Canada were beginning to address sexual matters, powerful taboos surrounded the subject – for example, even selling or advertising birth control was a crime (and remained so until the late 1960s).[35] Even if, as Molly Ungar argues, nudity became a potent symbol of modernism in 1930s' Canada, people did not speak about sexual activity outside marriage, even if it was taking place.[36] There were, in fact, many experiments in open marriages, with the Scotts representing one, though not entirely successfully, in that ultimately it was about permitting Frank's infidelity.[37]

While Pegi's deliberate drawing of attention to her own physical life marked her out as defiantly unconventional, she was not alone in this approach. Her friend Paraskeva Clark painted a compelling portrait of her pregnant self in 1933.[38] The nude portraits of Prudence Heward were also well known in her circle.[39] A painting of an unclothed female model by Pegi's friend Lilias Torrance Newton was refused entry in the Canadian Group of Painters' 1934 show at the Art Gallery of Toronto: her green shoes drew attention to her undressed state.[40]

Perhaps partly in reaction to this prurience, Pegi also completed two even more explicit works and exhibited them. She again combines her figure with flowers in a sexually suggestive fashion in the oil paintings *A Descent of Lilies* (1935) and – though created in a very different frame of mind, as we see below – *Torso and Plants* (1935) (Fig. 6.5 and Fig. 6.6, respectively). *A Descent of Lilies* (whose title may subtly refer to Lilias's composition) is a large, magnificent study of Pegi's own figure set in a dynamic pot-pourri of colours and forms. A naked Pegi turns her back on public opinion. Her feet tread on white lilies – traditional symbols of purity – and her arms embrace the falling, phallic blooms. Pegi's own torso stands at the centre, draped from the waist down in a red sheet. She has her back to the viewer while she looks over her shoulder out of the canvas. In front of her a dark horse and a cream-coloured horse appear to buck or kick at a lighter-coloured version of her figure, draped in a white sheet.

6.5 *A Descent of Lilies*, 1935; oil on canvas, 122 × 91.6 cm (Plate 9)

6.6 *Torso and Plants*, c. 1935; oil on canvas, 90.9 × 68.7 cm

Around the central figure, white lily blooms float and wither, and, in the lower right-hand corner, the artist's fingers, bedecked in red nail polish, hold a lily. To the left of the bloom into which the artist appears to be poking her left foot, two elegantly dressed ladies on horseback, one appearing to be sitting sidesaddle, exchange pleasantries. Above them a lily bloom appears to transform itself into the upside-down legs of a satyr. The scene has a dreamlike quality, enhanced by the way the shapes appear to emerge out of the clouds, which sometimes obscure their overall clarity. The brushwork is vigorous and controlled, and the colouring is predominantly warm – a combination of reds, ochres, pinks, and violets.

What does it all mean? Much of the sexual imagery – redness, lilies, and horses – may have surfaced in Pegi's life at 506 Jarvis Street. Pegi liked painting her own sexuality, as we saw in *Pegi with Cyclamens*. In *A Descent of Lilies*, red is the predominant colour, associated in Western culture with both passion and violence. Pegi dresses the central figure of the artist partially in red and makes her flesh tones reddish.

The lilies quite clearly have some special significance: a hand gently holds one at the lower right of the painting – a pre-eminent position in the composition. The artist emphasizes the lilies' phallic form, depicting them in a fleshy way. Pegi was perhaps thinking here of American painter Georgia O'Keeffe and her recent flower paintings, commonly viewed as evoking female genitalia.[41] She was aware of O'Keeffe's work, writing about her to Marian Scott at least once.[42]

The precedents for the horse-imagery may well be Renaissance allegories, which often used horses as symbols of lust.[43] In Classical literature, dark and light horses sometimes represent the two sides of passion.[44] In *The Meaning of Dreams*, based on Freudian theories, Calvin S. Hall specifies the horse as signifying masculine sexuality and as appearing in women's dreams in this denotative role twice as often as in men's.[45] In Pegi's time, Freud was popular reading.

Colours and motifs relating to sexuality also appear to the left of the canvas in a falling, but only partially complete, satyr. In Renaissance imagery the satyr personifies lust.[46] The one depicted here has metamorphosed out of a withered lily bloom. This albeit-limited use of metamorphic imagery indicates that Pegi was probably aware of its evocative use by the Surrealists. Indeed, the painting as a whole, with its objects floating and falling in space, is rather dream-like and hallucinatory, like much Surrealist painting of Pegi's era, which one could see at least in books and

magazines.[47] Though not documented, other influences may have includ-
ed the sexual aspects of the modernist British paintings and German
Expressionist works at the Art Gallery of Toronto and in journals.

Pegi considered A Descent of Lilies a major composition. When first
exhibited in Toronto in 1935, in a group show by young local artists, its
price of $300 was her highest to date.[48] Art critic Graham McInnes wrote
a full-page formal interpretation in Canadian Forum but neglected the
work's meaning.[49] "The emphasis is on form; subject matter acting simply
as the inspiration for the work," McInnes writes. "The artist's task, taking
his subject matter as the initial inspiration perhaps, is to abstract, to syn-
thesize and understate, to re-form and fuse in the fire of his creative imag-
ination, under the stress of powerful feeling, the original impact of the
external world."

The painting was offered to Vincent Massey, who also then owned the
Newton nude. Usually enthusiastic about Pegi's work, he probably
declined it as he was about to move to Britain as Canada's high commis-
sioner there. It hung for a time in the dining room of architect Humphrey
Carver and was finally purchased in the late 1930s by Charles Nichols's
brother T.E. Nichols, publisher of the Hamilton Spectator. It is now part
of the collection of the National Gallery of Canada.

Pegi painted Torso and Plants probably in 1935. She first exhibited it early
in 1936, and Bertram Brooker included it that year as an illustration in his
influential Yearbook of the Arts in Canada.[50] Compositionally, the work is
much like Pegi with Cyclamens. Here she juxtaposes her naked torso with
daffodils, hyacinths, and rhubarb stems. Her arms encircle this eclectic
spring bouquet, which rests on her draped lap. Her right hand clutches a
few blooms of blue hyacinth, the symbol of constancy. It may have also
recalled for her the lines from T.S. Eliot's The Waste Land: "You gave me
hyacinths first a year ago; / They called me the hyacinth girl." While her
torso has a certain monumentality, the flowers and rhubarb stems writhe
and coil before it with unusual vigour and life. It seems from her letters
that Pegi was pregnant in 1935 and had an abortion: rhubarb was a tradi-
tional purgative and remedy for unwanted pregnancy.[51]

There is no suggestion that she considered continuing the pregnancy.
Marriage to the father – possibly Graham – was quite clearly out of the
question, and she could hardly support herself, let alone a baby. Returning
to Ottawa and her parents' home seems not to have been a viable alterna-

tive either. She wrote in an undated letter probably of 1935 to Marian: "I guess the worst is true because although I have walked and paddled with pack through six hours of bush and all kinds of things one *would think* might affect ... I think I shall go to Montreal some time next week ... I feel I'm being mocked," she confided. "Motherhood has become a topic of conversation. At tea yesterday I heard all about twilight sleep."[52] In October 1935 she informed Marian: "I've been dying to tell you – a joke indeed – I had my appendix out. I laughed all the time in the hospital – speaking of [the] operation – and thinking how respectable it was, which only you would share ... all open and above board."[53]

Marian was the only person with whom Pegi could share this information. Marian had personal troubles of her own, as Frank was pursuing extramarital affairs, and Pegi's jocular account of her trials was probably her way of helping them both cope with significant stress and loss.

The emotional toll of 1935 profoundly affected Pegi's view of herself and the world, and she produced paintings that seem to reflect on life and death. *Cold Window* (c. 1935), for example, contrasts a vibrant pot of flowers in front of a window with the lifeless winter landscape outside (Fig. 6.7). Pegi never explained why the view through a window was to become a common device of hers, but her ongoing use of it suggests that it was important. *Pavement People* (undated) renders a street scene observed – again though a window.[54] The still-life element on the windowsill consists of two stems of rhubarb in a glass jar. Two shadowy figures, a man and a woman, emerge from the gauzy drapes and bow their heads as though in prayer before it. (It is feasible that Pegi was familiar with Käthe Kollwitz's uncannily similar *The Mourning Parents* of 1932 – a memorial sculpture to Kollwitz's own son, killed in the First World War.) Pegi's painting also emanates an atmosphere of mourning and bears witness to an experience that was deeply felt.

Self-Portrait with Begonia (c. 1935) positions Pegi against two huge windows that frame her head (Fig. 6.8). A few leaves and blooms of begonia partially circle her face, which dominates the image. Begonias grow well in shade – unlike cyclamens, which need sun – and symbolize dark thoughts; Pegi, with her face set away from the view outside, has retreated from the joy of only a few months earlier in favour of darker climes. The colours in the painting are also cold, with light blues and violets predominating, in contrast to the hot, exuberant Mediterranean colours of

6.7 *Cold Window*, c. 1935; oil on canvas, 122.4 × 69.2 cm (Plate 10)

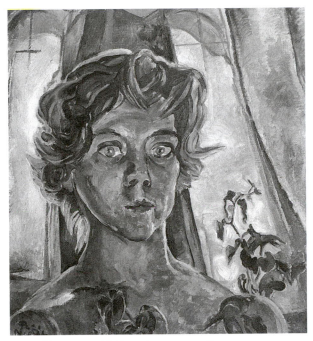

6.8 *Self-Portrait with Begonia*, c. 1935; oil on canvas, 55.8 × 51 cm

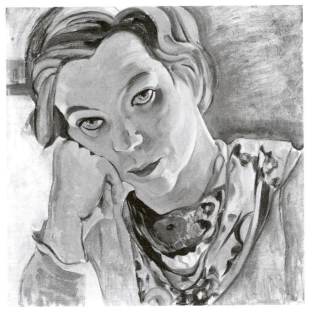

6.9 *Self-Portrait*, c. 1935; oil on plywood, 40.3 × 40.2 cm

A *Descent of Lilies* and *Torso and Plants*. This is the Pegi that Norman MacLeod met and then married in 1936 – when she was perhaps on the rebound from Bill Graham (when Graham moved out of the apartment, Norman moved in). The portrait remains with Jane, their daughter. The emerging, more world-weary Pegi is also the subject of a self-portrait in the Art Gallery of Ontario (Fig. 6.9). There the flowers that characterized the other self-portraits become merely patterns on the scarf encircling her neck.

7

A Wider Circle and a Wedding

1936

AS IMPORTANT TO PEGI AS HER PERSONAL LIFE WAS, her career as an artist was even more so, and her first two years in Toronto had advanced it only somewhat. As the Depression started to ease, conditions remained harsh, and any settled life eluded her. She bounced around from occupation, to project, to crisis. She knew many people, and she was as well known and admired as many of her peers there such as Paraskeva Clark and Will Ogilvie. She painted industriously and well, exhibited, and earned a little by doing portraits of children. Producing the sort of landscapes that she had done earlier might have been profitable, but her own, very individual approach and choice of subject were supplanting them, and she could go no other way.

Her current watercolour style was breezy. The paint application is light, at times transparent, and at most opaque. In her crowded surfaces, foreground and background details compete – at times eliminating any perspective. The washes appear to have been applied quickly, and some lines look nervous and jittery. Many compositions seem unfinished and probably were. All too often it appeared – reviewers noted – as if she was not giving herself time to resolve her ideas and subjects.

Her oil paintings share this unfinished quality, but the lightness is absent. Instead, the paint swirls around and the lines are rarely straight. The crowdedness of subject and background at times becomes claustrophobic, as we see in an exuberant street scene entitled *Chinatown* (c. 1936) (Fig. 7.1).

7.1 *Chinatown, Toronto*, c. 1936; oil on canvas, 68.6 × 63.5 cm

The confusion apparent in her paintings also shaped her personal life. Pegi always had difficulties with practical matters. She did not really know how to dress appropriately, for example, and friends often provided a suitable garment or advice. "She never admitted they were outrageous costumes," noted Bill Graham. "When she made something to wear in the evening out of an old double damask tablecloth, and dyed, it wasn't just a great idea or a great piece, it was better than anything that could be bought at Creed's or anywhere else, and you had better agree."[1] And she was a lamentable housekeeper and a quixotic cook. Later, many of her submis-

sions reached exhibitions only because someone else delivered them. These limiting organizational skills were perhaps one of the reasons why she never established herself in the United States.

But she was much admired and loved all the same. Her good friend critic Graham McInnes, who may have been in love with her, observed perceptively:

The conscious cuteness which turned Margaret Nichol into Pegi Nicol gives only one clue to her vivid personality. She was cute of course, cute as a button, wayward and exasperating, and also a bit of a tease. But she had a wonderful way of seeing the world without eyelids. She could take a group of children playing in a slum street, a tangle of narcissus bulbs in a flower pot, a view of smoky steaming winter Montreal from St. Helen's Island in mid-St. Lawrence, and put on them all the stamp of her own personality; a series of disjointed writhing images, never at ease, full of bubbling enthusiasm; a brilliant and cascading profusion of figures like the endless talk of an Irishman over whisky. A Pegi Nicol in a gallery proclaimed itself immediately because of its completely individual quality; much as one knows after a bar or two, that it is Chopin's music because it is so personal that it can be by no one but him.[2]

Although her colleagues admired her work, purchases were few and far between in these Depression years. She nevertheless continued to produce and to exhibit. In April 1936, at the ninth exhibition of the Canadian Society of Painters in Watercolour at the Art Gallery of Toronto, she showed four works. *Gardening Children* (undated) depicts the school garden in Ottawa that she loved, and three compositions are views of Toronto – *Bay and College Streets* (undated), *Dundas and Yonge Streets* (undated), and *Kosher Fowl Market* (undated). These pictures show the influence of David Milne, whom Pegi had met through the Masseys, who were early purchasers of his art. His light touch, disciplined use of space, and palette of a few colours show in these airier and less cluttered offerings. Her friend McInnes praised Pegi's exhibited works highly in *Saturday Night*. He said that she was at the top of her form. "The chief feature of Miss Nicol's painting apart from its colour, is its immediacy, and when her medium does not allow her to think or to feel twice, or to chop logic with herself and dissipate her strength, she produces excellent work."[3]

In Toronto, even without the dances, lunchtime meetings, and academic stimulation that she had known in Montreal, Pegi had gradually found people of her own age with whom she felt almost as comfortable as with her Montreal friends. She had complained to Marian Scott and to Eric Brown that her work left her little time for social life, yet within a year she had lost one lover and acquired another and circulated widely in the city's diffused artistic circles. Humphrey Carver described the life of Pegi's and his circle then as "a strange dreamlike period of suspended animation. Because there were no opportunities and no pressures towards successful careers, we were very intermingled and we had plenty of time to enjoy each other's company in a relaxed and easy-going way. Artists, oddballs, professionals, and political people ... we were all drop-outs of a kind, not by choice but by the inescapable circumstances."[4] Pegi often painted them (Fig. 7.2). Carver was a central figure for her. He found her "fey, gipsy, funny, delightful."[5] For him she was "a highly sexy person, no self-consciousness, loved the fruity aspects of life ... [had] latent affairs with everyone she met."[6]

Pegi also maintained her contacts with the older establishment élite with whom she associated through her Massey connections. Maude Grant, widow of W.L. Grant, principal of Toronto's largest private school, Upper Canada College, was a good friend. Maude was a sister of Alice Massey and Raleigh Parkin. Her daughter, Alison, a teenaged student of art at the Central Technical School, received warm encouragement from Pegi.[7] So did Jane Smart from Ottawa, then a student at the University of Toronto and later a director of documentaries at the National Film Board and the talented sister of the novelist Elizabeth Smart.[8] Jane also shared Pegi's left-wing sympathies, for it was she who paid for Dr Norman Bethune's passage to Spain.[9] Pegi also had connections with the university through instructors there such as Barker Fairley and Victor Lange of the German Department and Felix Walter, then teaching French. Fairley, a good friend, became a gifted portraitist. Pegi thought highly of him, describing him to Marian as "The Great man."[10]

Pegi had good connections within Toronto art circles. She knew several local members of the Group of Seven – A.Y. Jackson was a friend and an important link between his and her Montreal friends. She saw Arthur Lismer and probably other artists working in the Studio Building at the edge of the Rosedale Ravine off Yonge Street; Lawren Harris had built the structure in the 1920s for his colleagues and they remained close. A photo-

7.2 *Figures Sunning*, c. 1934;
watercolour and charcoal
on paper, 72.7 × 50.5 cm

graph of members of the group and their circle from 1936 confirms that
the ties were strong (Fig. 7.3). As before, Pegi went on sketching expedi-
tions with Charles Comfort and Will Ogilvie and regularly saw other con-
temporaries such as Carl Schaefer and Charles Goldhamer. She was in
touch with several able women artists as well: painters Paraskeva Clark and
Isabel McLaughlin and the sculptor Elizabeth Wyn Wood, the much
younger wife of another sculptor, Emmanuel Hahn. She also knew sculp-
tors Frances Loring and Florence Wyle. With some of her artist friends she
helped set up the Picture Loan Society, the brainchild of H.G. (Rik) Kettle
and Douglas Duncan, who became its first director. This non-commercial
body provided facilities for the display, sale, and rental of contemporary
works of art. In due course, the idea spread across Canada.[11]

On and off Pegi wrote. Throughout her correspondence there are refer-
ences to novels begun, poems completed, and plays commenced. In an

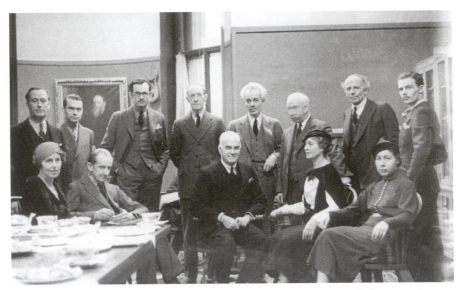

7.3 Tea party in the director's office celebrating the Group of Seven exhibition at the
National Gallery of Canada, 22 Feb. 1936: seated left to right: Maud Brown, Eric Brown,
H.S. Southam, Bess Harris, Dorothy McCurry; standing, left to right: H.O. McCurry,
Donald Buchanan, Graham McInnes, Duncan Campbell Scott, Lawren Harris, A.Y.
Jackson, Arthur Lismer, Lawren Harris, Jr

undated letter of 1935 to Eric Brown she commented: "I am in the middle
of writing the usual spring novel. It incorporates last spring's so it really isn't
[a] waste and very absorbing."[12] She published reviews on an occasional
basis, as we see below. Yet even though she produced passages of notable
beauty and insight, the same sort of slapdash quality that could both help
and hurt her paintings could also affect her writing.

In the summer of 1935 she began to write and illustrate for *Canadian
Forum*, a left-wing journal founded in 1920. In time she became its art edi-
tor, a notable achievement.[13] *Canadian Forum*, revamped in 1933 after the
last of Thoreau MacDonald's decorative black-and-white covers appeared,
was primarily a mouthpiece for the left-leaning League for Social Recon-
struction (LSR), whose birth, under the leadership of Frank Scott, Pegi had
observed in Montreal. The broadcaster Graham Spry, an old Ottawa
friend of hers, had bought the magazine for $1 in the summer of 1935, sell-
ing it to the LSR a year later.[14] It had a small readership, and it steadily lost
money during the 1930s. Its message, however, was potent, especially in
university circles. Many of its contributors were single-minded and anti-

establishment. They met at the home of Frank Underhill, a contumacious historian at the university whose provocative teachings filled the classrooms. Pegi would have received little money for her offerings but would have enjoyed the discussion and debate as well as the company that kept her linked to her beloved Montreal friends.

Her sparse contributions reflect her interests and friendships. Her first was a description of the opening exhibition in the Margaret Eaton Gallery at the Art Gallery of Toronto.[15] She makes clear the ongoing British influence on Canadian art. Until the outbreak of the Second World War two-thirds of the work on display at the Art Gallery of Toronto was by foreigners, the majority of them British.[16] Many Canadian artists still looked up to their British counterparts who painted for the Canadian War Memorials Fund, initiated by newspaper magnate Sir Max Aitken from Newcastle, New Brunswick, who became Lord Beaverbrook. "The Paul Nash from the Canadian War Memorial collection is still his greatest work; the material of war as still life – devoid of emotion," Pegi notes in her review.[17] In another contribution, in August 1936, she reviewed Marius Barbeau's *The Kingdom of the Saguenay*, describing the author in dramatic terms as "its very priest and discoverer."[18]

Pegi's less than half-a-dozen literary efforts for *Canadian Forum* are transparently by an artist for artists. Her prose, albeit breathless, has the same sort of immediacy as her painting. In 1936, she titled a piece about a show by the new Canadian Group of Painters "The Passionate Snow of Yesteryear."[19] "Where is the burning snow, the passionate hill of the earlier day of Canadian art?" she asked. "This ... is a remarkable summery green. Through the latter day group of artists budding from the group [sic] of Seven comes maturity to our national art movement. The life of a school of art fades from the vigorous primitive to refinement and subtlety ... the empty patterns like gaskets have relaxed and the cliches [sic] for spruce, barn, drift shapes, have given place to shapes actually experienced."[20] This is a real splash of observation. It also reflects her friends' attitudes in its rejection of romanticism for real life. Taken in conjunction with her earlier, opinionated letter to H.O. McCurry about Toronto watercolourists, her criticism suggests a more sombre, judicious attitude, not necessarily evident in her own paintings.

If Pegi readily supported the left-wing line in political matters, she did not think deeply about such things, being essentially a follower rather than an initiator. None the less, she made every effort to expand her knowledge

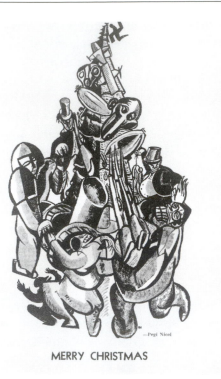

MERRY CHRISTMAS

in such areas. She read Karl Marx and designed an anti-fascist cartoon for
Canadian Forum's Christmas number in December 1936 (Fig. 7.4). She
was proud to be acquainted with Dr Norman Bethune, who went to Spain
to fight with the International Brigade; she apparently painted a frieze in
his Montreal living-room.[21] "Arms for Spain means arms for peace" was a
popular slogan. For Pegi, as it was for many in her circles, it was easy to see
the left as good and brave and as wanting only peace and justice.

Nevertheless, Pegi's involvement in left-wing circles did contribute to her
art and to her life. It is unlikely that she would have had the courage to
exhibit her nude self-portraits without the supporting environment around
Canadian Forum. And it was from within that circle that, on the rebound
from Bill Graham, she met, loved, and married Norman MacLeod.

Pegi met Norman MacLeod in 1935 on a bench in Toronto's Allen
Gardens, put in touch probably by Bill Graham's friend Charles Nichols,

who was soon to marry Norman's sister, Jean. Norman came from upright, conformist, Loyalist, Protestant stock, a sort that Pegi knew well. He was a big man, seven years her junior, who had recently moved to Toronto to find engineering work following his graduation from the University of New Brunswick. He claimed to be a communist. His political attitudes appealed to Pegi, but probably not his forthright, aggressive manner of expression. Graham McInnes described them: "This wayward teasing elfin creature married a great big wrestler of a man … He calmed her by force … This was widely regarded as the Taming of the Shrew. But no one could ever subdue her painting."[22]

Norman was the only surviving son of the late Colonel Harry Fulton MacLeod, a respected citizen of Fredericton, who had served as mayor of the New Brunswick capital, member of the provincial and federal parliaments, and solicitor-general of the province. Born in 1870, he had had distinguished service in the First World War in an infantry battalion and died in 1921, when his son was about twelve.[23] His widow, Ina Mersereau, brought up Norman and his older sisters, Mary and Jean.[24] Ina was able, active, extremely well educated, and very much part of the community. She was especially proud of her Loyalist background, being descended from one of the first families to arrive in New Brunswick after the American Revolution.[25]

Norman did not altogether conform to the family mould. There was a rowdy, rebellious streak in him that Pegi found attractive. Fredericton acquaintances remembered him in his younger days as a bit wild.[26] A neighbour, Horace Block, recalled "an extremely handsome youth who grew into a handsome man. He was of better than average height, had a round face, ruddy complexion, black curly hair, twinkling eyes and a ready smile which exposed gleaming white teeth."[27] As he matured, Norman determined to make a successful business career, despite his seeming iconoclasm.

He and Pegi lived together openly in Toronto when this still raised eyebrows in a majority of circles. He was interested in her painting and writing, even trying brush and pen himself. Undoubtedly some of Pegi's friends patronized him because he was arrogant, especially when he drank. He found many of her friends distasteful and registered his disapproval by arguing or by glowering silently.

For a time after Norman's arrival, Pegi painted little. She wrote to Marian, "I am working like mad and Norman goes out at six to bend rods all day in an unheated warehouse."[28] "I have finished with the Cera work

7.5 Pegi and Norman, c. 1936 7.6 Pegi on her wedding day, 1936

and have fears that Norman has come to the end of his job," she reported somewhat later. "The difference is that I have sixty dollars, he got twenty … his was 1,000 x harder … he is very discouraged."[29] A photograph shows them sitting on the grass on a summer's day, content and comfortable together. Pegi looks tiny but sturdy, almost child-like beside Norman's bulk; something that we cannot see on her right has attracted her attention (Fig. 7.5).

Despite their happiness together, some of their older friends such as Maude Grant thought the arrangement untidy and felt that they should regularize it, especially if they planned children. In due course, they decided to marry on 10 December 1936. Pegi travelled to Ottawa to bring her parents for the event. Norman's handsome looks and charm dazzled her mother.[30] Pegi had feared that she herself might alarm his imposing and accomplished mother, but this proved not to be the case.[31]

The wedding took place at Port Credit, outside Toronto, in Anthony Adamson's home. Humphrey and Mary Carver had borrowed it from the notable architect, who was away, and Mary's father, the Rev. Charles W. Gordon, performed the ceremony. Pegi was thirty-two, and Norman,

twenty-five, although she gave her age on the wedding certificate as twenty-nine and looked it (Fig. 7.6). A party followed at the MacLeods' apartment near the university at 14 St Mary Street, freshly painted by Pegi. Maude Grant managed the affair with grace, loaning them suitable silver and china.[32] Charles Comfort took a photo of the reception, showing glasses, flowers, candles, and Pegi looking young and pretty in a dark dress.[33] It was the day that King Edward VIII signed his instrument of abdication. The guests went home, the bride and groom went off to a movie, *Midsummer's Night's Dream*, and the bridegroom's siblings and friends, according to reports that Bill Graham received (he was not invited), got drunk.[34]

Before she married, Pegi had planned to make a will, and she told Marian what it would have contained. The Scotts' son, the Parkins' daughter, and the two daughters of the Charles Comforts should have a certain number of her paintings, partly because she knew that they were "going to grow up knowing that pictures have some importance."[35] What is certain is that these children all grew up knowing Pegi and remembered her – as did the offspring of so many of her friends. It was, after all, a Comfort daughter who chose to begin to write Pegi's life. And she was not the only one.

Greenwich Village Vistas

1937–1939

EARLY IN 1937, PEGI AND NORMAN MOVED FROM TORONTO TO New York. Pegi was pregnant, and Norman was desperate for permanent work that would support a family. The improving Canadian economy made them think that U.S. conditions should be even better. Yet even though Franklin Roosevelt's New Deal had helped some of the hardest-hit areas of the United States, unemployment generally remained stubbornly high until war started in Europe and French and British orders for supplies began to reinvigorate the American economy.

The New York that they discovered was beautiful and full of exciting architecture, music, and culture – a beehive of activity. It met their expectations, perhaps shaped by the visions of the metropolis evoked by the *New Yorker* magazine and its talented journalists.[1] Norman and Pegi each enjoyed the city immensely, but in very different ways. Norman found professional challenge. Although success came slowly, the range of possibilities was always stimulating, and he never seriously considered returning to Canada. He and Pegi lived in Greenwich Village, long a bohemian Mecca. The bustling streets, the lively ethnic neighbourhoods, and the elevated railway energized and inspired Pegi. And the city's grand sites – especially the galleries and museums – filled her with awe. She was free to paint as she liked and to visit the great collections, which she already knew through reproductions and the talk of her peers. New York had great art treasures – modern and classical – and exciting contemporary painters. The Museum of Modern Art, formed only in 1929, provided a splendid

selection and was near many small galleries. The ride there on the top of a bus, uptown on Fifth Avenue from Washington Square in the Village, offered a delightful excursion. More traditional fare was on view further up at the Metropolitan Museum, and smaller venues nearby included the splendid Frick Collection.

The American painting that Pegi saw was fervently nationalistic and bred in isolation. Millions of immigrants from Europe had sought a life of peace and prosperity in the United States and had proceeded to give their new land a larger-than-life history, of imagination as well as fact. Some groups, such as the Irish and the Germans, both very numerous in New York, added strongly anti-British sentiments to the standard-issue U.S. isolationism, pacifism, and nationalism. The United States' late entry (April 1917) into the First World War reflected this strong pacifism, exemplified by President Woodrow Wilson's dictum, "Too Proud to Fight." And afterwards the U.S. Senate, unsympathetic to Wilson's dreams, refused to ratify the Treaty of Versailles and to enter the new League of Nations.

In the 1930s, American painters such as Thomas Hart Benton were producing patriotic pieces, often very large murals that became immensely popular. The New Deal's encouragement of the arts generated a deluge of such pictures, many of them propagandistic. Fortunately, the many freer-thinking figurative and abstract artists provided a counter-balance. Pegi herself liked the realism of the Ash Can School, and Georgia O'Keeffe's disciplined, detailed, close-up paintings, often of flowers, were enigmatic, cerebral, and subtly sexual. Pegi admired them, as we saw in chapter 6, partly because Marian Scott did so and partly because they were so different from her own similar themes and subjects and a refreshing antidote to glorious landscapes and stirring history.

According to Pegi's friends, the photographers whose work she saw in New York excited her too – for example, Man Ray, Charles Sheeler, Alfred Stieglitz (O'Keeffe's husband), and Paul Strand. She learned much from the immediacy and the multi-layered images that a photographer could achieve. She also loved films and was a regular visitor to Saturday-afternoon showings at the Museum of Modern Art. The multiple views of the same scene and the sense of movement in a watercolour of hers such as *New York Street Scene* (1945) show her indebtedness to film and photographic techniques (Fig. 13.3, p. 168).

In this work Pegi paints a woman seven times as she apparently sweeps the steps below the artist's window viewpoint. The woman's bright red blouse or jacket and orange scarf punctuate the paper's surface the same

number of times. The four largest views of her figure take up almost the entire picture, but in the background one can see three further, much smaller depictions that provide some sense of perspective to the overall composition. Interspersed among the seven figures are the people who passed by the woman as she completed her task of sweeping. These include a couple with a pram, a man holding onto his hat, and at least two other female figures. Pegi filled the surface of the paper between the figures with squiggled lines and rough washes. She painted these areas in various shades of green – the complementary colour to red in the colour wheel – and the effect is to enliven the composition overall. What the woman is actually sweeping is not clear, nor is the relationship between street, sidewalk, and steps. The viewer gains an overall impression of people, activity, movement, and energy.

Pegi's Greenwich Village neighbour sculptor Winifred Lansing became a close friend. This intense and flamboyant personality, who had produced sculptures under the Works Progress Administration in the 1930s, introduced her to contemporary American art. It was she who made Pegi aware of the wealth of art coming in to New York through practitioners such as Marc Chagall, Max Ernst, Fernand Léger, Roberto Matta, Piet Mondrian, and Yves Tanguy and confirmed Pegi's growing feeling that being a wife and mother was not enough to make her life complete. Lansing had studied in Rochester, New York, at the University of Rochester's Memorial Art Gallery and in New York City at the Brooklyn Museum of Art and the Art Students' League. She moved in Manhattan art circles, counting among her friends sculptors such as Ossip Zadkine (whom Donald Buchanan also admired).[2] Some of her watercolour sketches of children and nudes at the Memorial Art Gallery in Rochester resemble Pegi's work in the same medium. Lansing taught underprivileged youngsters, and Pegi's later paintings of slum children undoubtedly followed her example.[3]

In December 1937, Pegi gave birth to Jane at St Vincent's Hospital in Greenwich Village. On the night of the birth she painted a large watercolour.[4] She spent a happy ten days at St Vincent's and later claimed to have written there most of one of her instant novels about hospital life; she said that Norman intended to make a play out of the material.

Early baby days were delightful; mother was enraptured, and father adoring. Living conditions, however, were precarious. In the spring of 1938 they were passing on their Village abode to King Gordon, who moved to

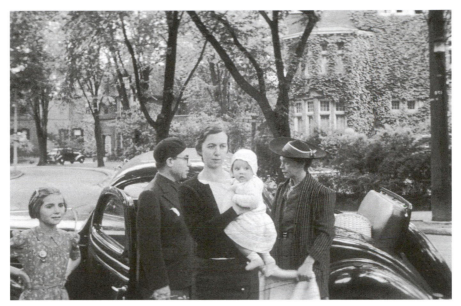

8.1 Pegi, Jane, Louise Comfort and daughter, and René Cera in Toronto, June 1938

New York to a publishing job in May.[5] Norman had still not found a permanent job, and so, to save the expense of another move that might prove temporary, Pegi took Jane with her to her parents' home in Ottawa, which she now found pleasant and serene. "Time stands still. The children's garden is the same. Jane has produced neutrality," she wrote to Marian.[6] During the summer Norman continued his job hunt in sweltering New York, while Pegi in Ottawa and Toronto saw old friends like the Comforts and René Cera and, as ever, made new ones (Fig. 8.1). Kathleen Fenwick, curator of prints and drawings at the National Gallery of Canada since 1928, became a close associate. Pegi also saw a good deal of Donald Buchanan, who had founded the National Film Society in 1935–36 and worked as supervisor of talks at the new Canadian Broadcasting Corporation. Pegi frequently visited H.O. McCurry and the Browns.

Eric Brown was putting the finishing touches to a major show of Canadian art at the Tate Gallery in London, *A Century of Canadian Art*, arranged by Vincent Massey, now high commissioner to Britain. Brown selected two of Pegi's pictures for this exhibition, and Massey later, for $175, bought one of them – *School in a Garden* (c. 1934) (now in the National Gallery of Canada) (Plate 7). Pegi wrote Brown in 1938 about the

sale: "I can't tell you of course of the joyous disturbance caused in my soul
… I could not hope for anything so wonderful … I could scarcely sleep
when your letter arrived and kept spending the money all night long, on
paints and canvas and Jane. When morning came I had a pile of toys a
mile high and roll after roll of canvas, all hand-prepared … you know my
ambition has never flagged and more and more it burns and I can't paint
enough."[7]

Early in 1939, Eric Brown died. Back in New York, Pegi wrote to Maud
of "the good structures you've made in my life." The two of them were, she
said, "more nearly parents as any."[8] Critics such as Graham McInnes
remembered Brown as a pioneer in Canadian art but also as the founder
of the country's national collection.

Brownie's intimate knowledge of artists, art dealers, and art galleries, especially in
Britain was such that, over a period of twenty odd years, on an annual budget …
sometimes as low as $25,000, he built up one of the finest small public collections
in North America … all these treasures were housed in the tail end of the
National Museum, in poorly lit, un-air-conditioned rooms, backed by dirty
monkscloth and shielded from glare by pieces of hanging canvas. In these primi-
tive conditions he built up not only the collection but the catalogues, the work-
shops for restoring, and the shipping facilities for innumerable travelling
exhibitions across continental distances.[9]

Pegi had remained in Ottawa until the late autumn of 1938. On her return
to New York, the family lived for a time in Belleville, New Jersey, at 268
East Graylock Parkway; from the foot of the street one could see the new
Empire State Building across the Hudson River. Jane was now a little
older, with more predictable habits, so Pegi could work constantly, though
with a limited range of subjects. She painted mostly Jane or other chil-
dren, scenes from her window, building sites nearby, and a few portraits
and still lifes. Often she left the works unfinished or completed them
quickly and imperfectly. Until Jane grew older, Pegi could not get out into
the streets to paint the passing life. In retrospect, however, her paintings of
Jane form a remarkable sequence of interesting and varied interpretations,
unique in terms of their number – many hundreds – in Canadian art.

Her materials, however, were not first class. She bought old sheets from
thrift shops and tore them up, sized them, and reused them as canvas.
Eventually she found that Norman's former classmate Harold Kirkpatrick,

8.2 *Children in Pliofilm*, 1939; oil on canvas, 80.5 × 106.7 cm (Plate 11)

who worked in the paint business at Reichhold Chemicals, could supply her with industrial powdered pigment. While she never described what process she used, it is probable that Pegi mixed the pigments with linseed oil and turpentine to the desired consistency for painting, and she may have added a lead oxide called Litharge to the oil to hasten the paint's drying capability.[10] André Biéler remembered her giving him a bottle of "vicious" green paint that had emerged as a result of a chemical accident.[11] She needed better materials and wrote to H.O. McCurry in 1938 to ask if he knew of any "scholarships or such that provide people with paint."[12]

One of her most interesting pictures from this period, *Children in Pliofilm* (1939), showed in the art exhibition at the Canadian pavilion in the New York World's Fair of 1939, a major achievement (Fig. 8.2). The painting's suggestion of flight and its use of a newly developed protective plastic fabric may have echoed the advanced technology that the fair promoted.[13] In June, Pegi wrote to McCurry:

In regards to World's Fair Show, I'm delighted to be invited. I've sweated blood over a picture which succeeds in looking over light-hearted. Oh, the aching dreary canvasses (3) discarded in its wake (I guess I was over-thrilled at the invitation) … The picture is called 'Children in Pliofilm' and I do hope you will like it. It is my baby in a pliofilm rain cape flying over the street full of similarly coated kids. I was working on a big one of it (69x59') when the notice came so I did it again on a smaller canvas. The material pliofilm is endlessly lovely, I think.[14]

Although she was finding time to paint and Jane was a flourishing and beautiful child, Norman and Pegi were beginning to find married life testing. They were poor and had no base and no firm direction. Pegi had no aptitude for housekeeping, and chronically chaotic domestic conditions must have affected Norman. He needed an order that she could not provide, and he could not offer the stability of better accommodation and a bit of money. As Norman changed gradually from a malleable young husband into one determined on a career, Pegi's hitherto-dominant role lessened, as did her self-confidence. Both Pegi and Norman wanted their own way and were self-centred.

It was her continuing moderate success in Canada that kept Pegi going. She needed every scrap of recognition (and money) that came to her. She had enough friends and connections in her homeland to keep her work circulating, but the logistics were growing ever more difficult. The National Gallery of Canada was a significant patron. It stored her work, dispatched it, entered it for exhibitions, and often sold it for her too and then deposited the proceeds in her bank account.[15] The help H.O. McCurry and Kathleen Fenwick provided her with was remarkable and a testament to their high regard for her and her work. For a national institution to assist an artist in this way was nothing short of astonishing.

In New York, however, Pegi – in part swamped by daily life and work – made virtually no attempt to make herself known to dealers and galleries and did not offer works to small shows. Perhaps what she was achieving in Canada satisfied her. Certainly, until war broke out and transporting paintings across the border became a problem, this was probably the case. When something sold, however, she was elated. In 1939, she made a good sale to the Art Gallery of Toronto – a watercolour entitled *Jarvis Street Sidewalk* (c. 1935–36) – and wrote to Martin Baldwin, the gallery's director: "I am very grateful and excited about it and also glad it was that particular watercolour. It was one of those (of a series) where everything felt right as

8.3 *Self-Portrait with Jane*, c. 1939; oil on canvas, 84.8 × 69.5 cm

I painted. If I could only always paint so!"[16] Dating from her Toronto years (she had lived on Jarvis Street) it is a view from above, lightly painted, the walking figures full of movement, the effect, almost breathless.

Her last major study of herself – *Self-Portrait with Jane* – dates from about 1939, if we judge by Jane's appearance (Fig. 8.3). The composition is close to that of *Torso and Plants* (Fig. 6.6, p. 84), her daughter replacing the plants, but with radically different symbolism – she now presents her baby to the world. The painting is about life, not death. Later, in 1944, Pegi used this image as a Christmas card, clearly seeing something of the Virgin and

Child in it.[17] The grouping of mother and child clearly remained a powerful image for her. In none of her correspondence does she explain why, but in *The Peace Bird* (c. 1946), a mother and her child float above the street in Manhattan where Pegi then lived, while a pigeon (denoting a dove) descends to the street below (Plate 15). One could argue that Pegi had reworked *Self-Portrait with Jane*, with its image of a mother presenting her young child to the world, in a new and tragic way to evoke the aftermath of world war. In the Chagall-like *The Peace Bird* the child surveys a world now facing an ambivalent tranquility – one in which her mother is to be largely absent. These two paintings (1939 and 1946) frame Pegi's experience of the Second World War – a period in which, as parts IV and V explore, she lived three parallel lives in three cities: Ottawa, Fredericton, and New York.

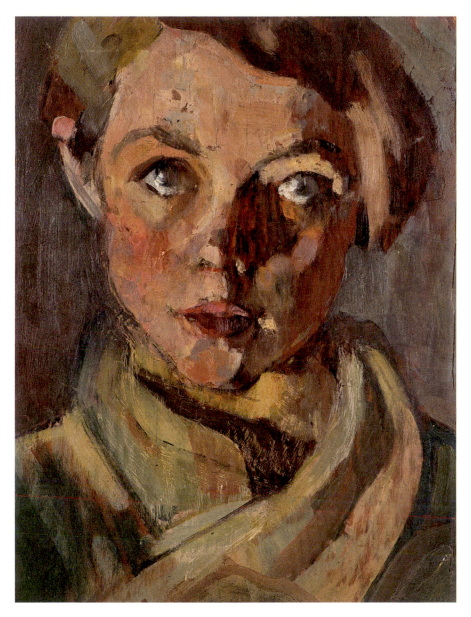

Plate 1 *Self-Portrait*, c. 1928; oil on plywood, 30 × 23 cm

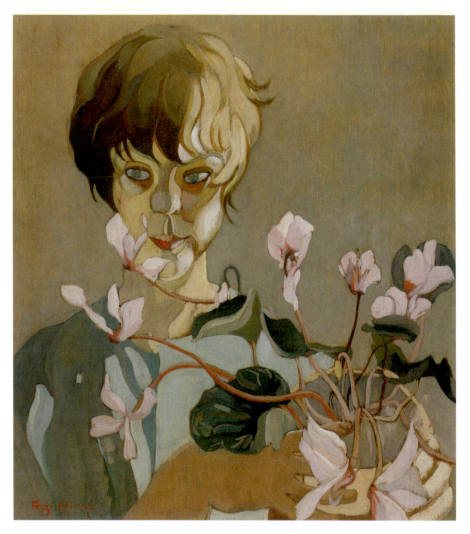

Plate 3 *The Slough* (recto), 1928; oil on board, 61 × 54.7 cm

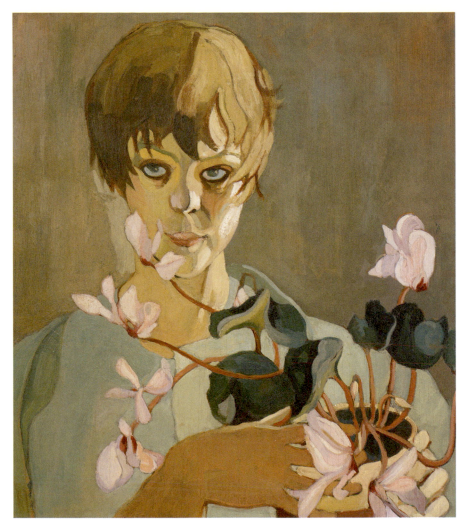

Plate 4 *The Slough* (verso), 1928; oil on board, 61 × 54.7 cm

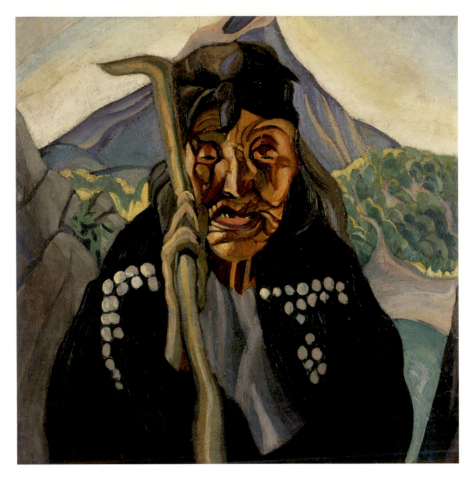

Plate 2 *Bianinetnan, Aged Indian Woman of Hagwelget Canyon*, c. 1928; oil on board, 61 × 61 cm

Plate 5 *The Log Run*, c. 1930; oil on board, 59.7 × 59.7 cm

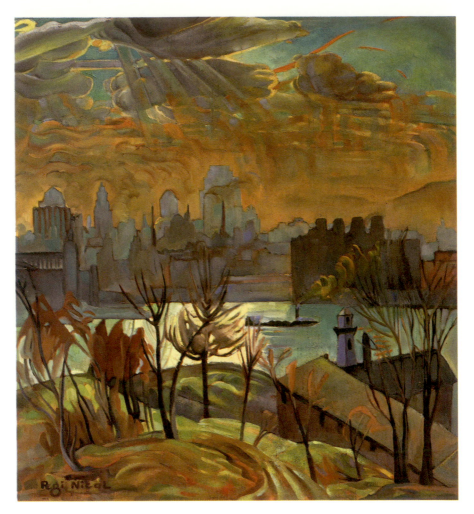

Plate 6 *Montreal Harbour from St Helen's Island*, 1933; oil on plywood, 65.8 × 60.4 cm

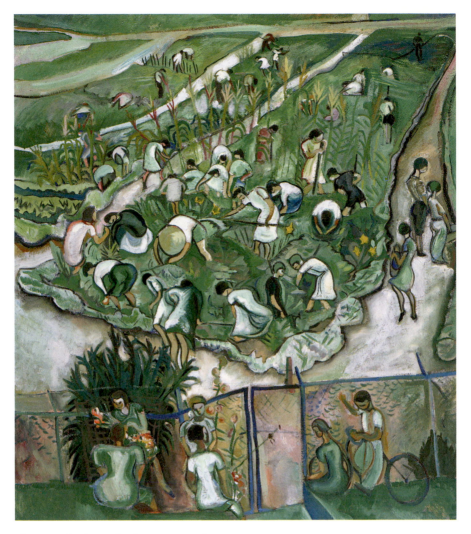

Plate 7 *School in a Garden*, c. 1934; oil on canvas, 112.4 × 99 cm

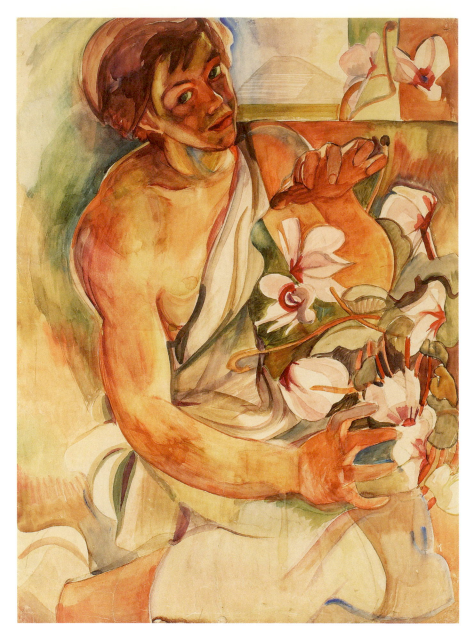

Plate 8 *Pegi with Cyclamens*, 1936; watercolour and graphite on paper, 76.2 × 55.9 cm

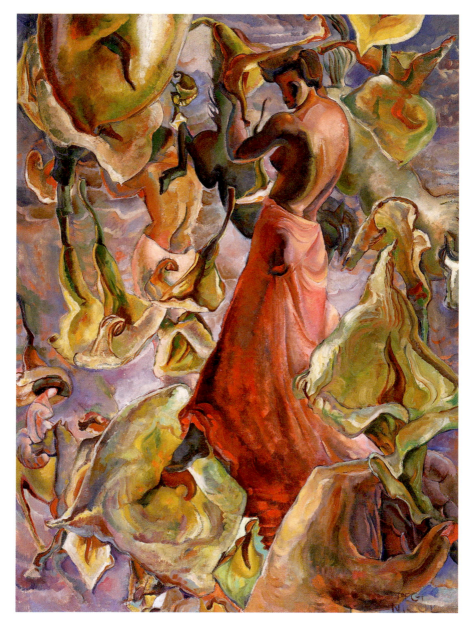

Plate 9 *A Descent of Lilies*, 1935; oil on canvas, 122 × 91.6 cm

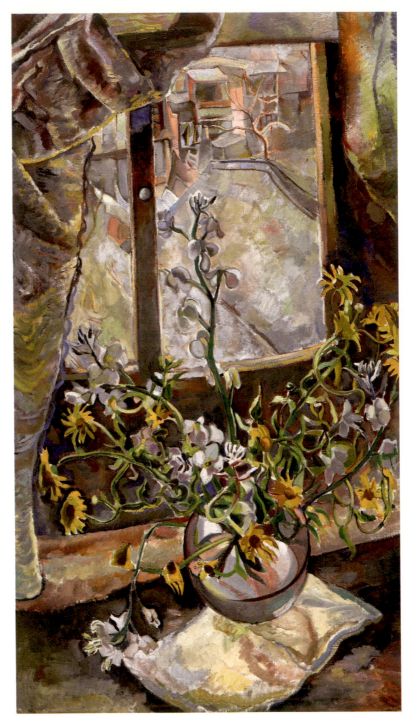

Plate 10 *Cold Window*, c. 1935; oil on canvas, 122.4 × 69.2 cm

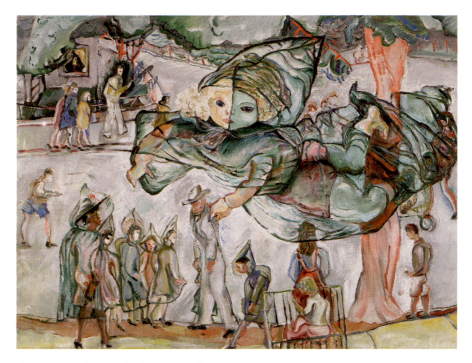

Plate 11 *Children in Pliofilm*, 1939; oil on canvas, 80.5 × 106.7 cm

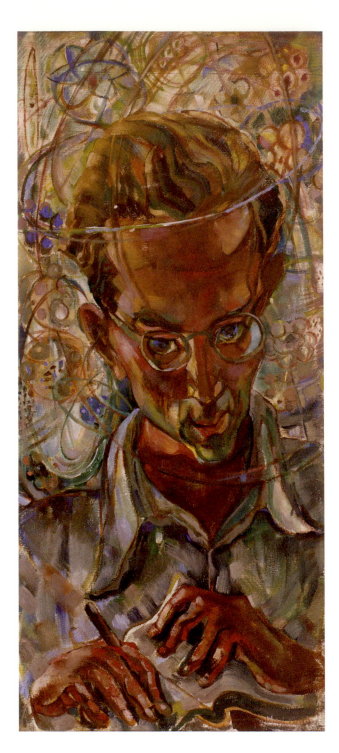

Plate 12 *Molecular
Physicist*, 1945; oil on
canvas, 91.5 × 40.7 cm

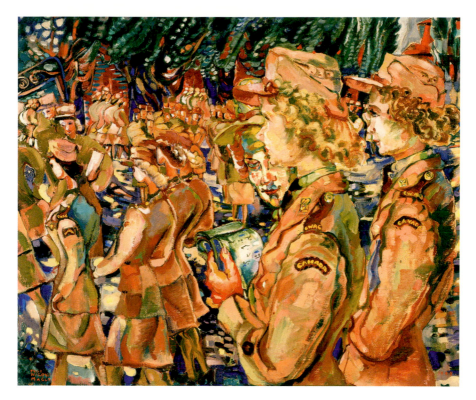

Plate 13 *Morning Parade*, 1944; oil on canvas, 76.5 × 91.8 cm

Plate 14 *When Johnnie Comes Marching Home*, c. 1946; oil on canvas, 122 × 112 cm

Plate 15 *The Peace Bird*, c. 1946; oil on canvas, 119.7 × 101.5 cm

Plate 16 *Good Friday*, undated; oil on canvas, 98.4 × 55.7 cm

PART FOUR

Ottawa and Fredericton

1939–1948

A New Brunswick Renaissance

1939–1940

CANADA DECLARED WAR ON GERMANY on 10 September 1939. In downtown Manhattan, Pegi, Norman, and Jane were settling into their new apartment at 345 West 12th Street in Greenwich Village. New Jersey was now in their past. In practical terms, the war had little effect on their lives or environment. The United States was for now resolutely a non-participant, secure in its myths of innocence and exceptionalism. From the Nazi occupation of Poland until the fall of France in June 1940, New Yorkers remained disconnected: interested more in the World's Fair at Flushing Meadows in Queens than in the "phoney" war. At the fair, innovative creature comforts dominated the attractive, progressive, and technologically advanced, futuristic architecture. The RCA building, for example, introduced television to visitors, who received "I was televised" cards as souvenirs.[1]

Emotionally, the story was different for Pegi. Writing on 13 September to H.O. McCurry, now director of the National Gallery of Canada, she began: "A fireplace added to Kingsmere [H.O. McCurry's home in the Gatineau Hills] sounds more than something today." Clearly she missed her country, particularly now that it was at war.[2] She had only recently returned from her summer visit with Jane to her parents in Ottawa and had spent time at McCurry's cottage, and she was undoubtedly homesick. The declaration of war had only served to emphasize her feelings. "I enjoyed the Gallery and Kingsmere. Everything seems so precious now.

Yours unsatisfactorily, I'm afraid, Pegi MacLeod." She added a postscript: "In spite of black outside world I sold 1 large [and] 1 small pictures [*sic*] since my return." The rest of the brief letter made clear that the war did not dampen her enthusiasm for painting.

It would be fascinating to know what Pegi and Norman thought of events in Europe during the first year of the war, but Pegi's regular correspondence with Marian Scott in Montreal had lapsed somewhat. We know only that Norman thought highly of Winston Churchill.[3] The Nazi–Soviet pact of August 1939, which demonstrated the realities of world politics to many fellow travellers, must have shaken some of their left-leaning friends. However, we have no clue about what the MacLeods thought of Germany's swift and devastating advance into Norway, the Lowlands, and France in the spring of 1940. American ambivalence had insulated New Yorkers, but Franklin Roosevelt intended from the start to help the Allies, and U.S. industrial capacity expanded at an astonishing pace. Roosevelt sent Harry Hopkins to Britain while it alone in Europe faced the Nazis, determined to find out what supplies it most needed.

Pegi's principal contacts in New York remained Canadian expatriates, such as Norman's friend Harold Kirkpatrick. She saw a good deal of Letitia Echlin, whom she had taught at Elmwood School. Letitia, married to a Canadian neurological surgeon, lived near New York and had introduced her to the sculptor Winifred Lansing. King Gordon was also around and in constant touch. Donald Buchanan visited New York regularly, as did Raleigh Parkin. Occasionally she crossed paths with others such as her classmate Lillian Freiman from the École des Beaux-Arts, a cousin of her Ottawa friend Lawrence Freiman.

Pegi – seemingly keen to help in the war effort – visited Ottawa with Jane again briefly in the summer of 1940, en route from disposing of their second Greenwich Village apartment. Norman was looking for a war job in Canada and was sensitive to Pegi's need to be in that country.[4] In an interview with the Ottawa *Citizen*, Pegi spoke earnestly of the role that artists could play in recording the war.[5] Her remarks reflected her current interests. She recommended mural painting, little practised or studied in Canada, for recording war activities. The fact that an exhibition of mural designs for American federal buildings had just been on view at the National Gallery may have had some influence as well.[6] Furthermore, the propaganda value of the genre in the United States and earlier in Mexico had obviously impressed her as much as it had other Canadian artists. She

does not appear to have realized its dangers in the hands of totalitarian governments. All this notwithstanding, the interview revealed that her attitude to war had clearly changed. It had only been a few years earlier that she had drawn for the anti-war *Canadian Forum* a "peace" picture composed of gas masks, cannon, skulls, rifles, grenades, soldiers, and top-hatted arms manufacturers (Fig. 7.4, p. 98). But pacifism was now passé.

From Ottawa, Pegi and Jane went on to Fredericton in New Brunswick, to stay with Norman's mother. It was Pegi's first visit there, and she found it delightful. Small and pleasantly positioned on the Saint John River, it is the provincial capital, its small, old cathedral one of the most beautifully situated in Canada. Many of its early settlers had come from educated New England families who followed the flag to British land. They were a conservative lot who built churches, founded a university, and carefully watched the education of their children.

Today, with its leafy old streets and white clapboard houses, it is still, despite concrete, car parks, and industry, very much like the agreeable place that Pegi found in 1940. She sensed that it was – like Toronto and Ottawa – stuffy, conventional, and a bit sleepy, but successive waves of immigrants had nourished a tough, robust, independent citizenry. It and the region were undergoing an explosion in artistic creativity, and Pegi was to play a substantial role in that renaissance in the summer and autumn of 1940, and for the rest of her life.

Pegi and Jane stayed a long while in Fredericton – well into the winter. They had no accommodation arranged in New York, but Norman, temporarily employed there and without a job in Canada, was probably managing well enough, surviving uncertainties better alone. At first Jane and Pegi stayed with Ina MacLeod, Norman's clever, if rather formidable mother (Fig. 9.1). Mrs MacLeod found out that her pretty, talented little daughter-in-law had a strong personality and was no more pliant than she or her son. None the less, their bonds were firm, and Pegi found support in the city where Norman's family had long lived.

Pegi's often-bohemian appearance may well have rattled some of Fredericton's teacups. One of her students, Helen Beals – then the assistant editor of *Maritime Art* – recalled: "I remember especially one week, Mrs. Clark … decided to have an afternoon tea for the town ladies to meet the painters. Pegi usually dressed very informally," she continued, "with skirt buttoned in the back or a safety pin and old blouse on. She came to

9.1 Ina Mersereau MacLeod, undated

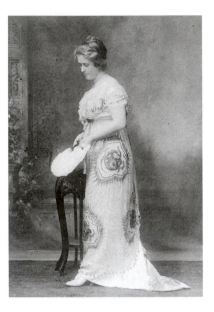

tea just like that and the contrast between her and the fashionable
Fredericton ladies was quite fun."[7] Pegi in her thirties dressed as uncon-
ventionally as ever. She increasingly worked into her wardrobe odd bits of
fabric, handiwork, or curiously coloured items from New York's thrift
shops. Often the effect was successful, but sometimes she looked a bit of a
Raggedy Ann. Many of her friends remembered her clothes and her pas-
sion for bits of contrasting material. Kathleen Fenwick, of the National
Gallery, recalled going for the first swim of the season one year with Pegi.
Pegi's swimsuit had a number of moth holes in it and she covered the
holes up with freshly picked daisies.[8] Her choice of dress was no pose,
although she knew that its oddness added interest.

During her 1940 sojourn in Fredericton Pegi met a local artist and teacher,
Lucy Jarvis. On a whim, one day, the two of them decided to go and see
Margaret MacKenzie, wife of an old acquaintance of Pegi's from Toronto
– the new president of the University of New Brunswick (UNB), Norman
MacKenzie. Out of this visit emerged the Observatory Summer School for
the Arts. The university loaned the Observatory – a tiny, early-nineteenth-
century wooden building on the campus – for Pegi and Lucy to arrange as
a centre for studying and teaching art and for displaying paintings and
drawings and holding concerts.

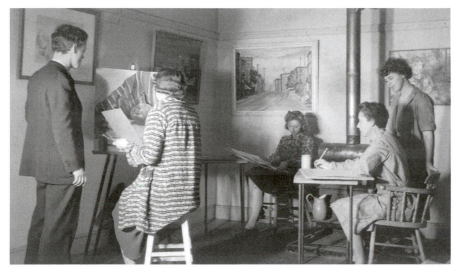

9.2 Inside the Observatory, undated. Lucy Jarvis is on the right.

With her customary zest, Pegi proceeded to restore and paint the Observatory with Lucy's assistance. To furnish it with pictures and teaching materials, she asked H.O. McCurry for ideas, prints, and general help. He responded characteristically, advising her to "occupy the observatory without delay" and assuring her a comprehensive set of materials – lectures with slides, a complete history of art in colour reproductions (about one thousand in all), as well as a dozen pictures by Canadian artists, adequate for teaching purposes.[9] On opening night she gave a lecture on Cézanne and then put Bach on the gramophone and supervised an impromptu life-drawing class.[10]

Lucy and Pegi were very different, a puzzle to each other, but they worked together well enough. Lucy was older and eccentric – a doughty Nova Scotian with little of Pegi's talent or élan. Lucy wrote just before her own death, "To me Pegi was a real adventure – an artist who I felt was growing (and always would) while most became static."[11] The first classes that the two organized were small and informal (Fig. 9.2). Pegi had not taught for many years and needed to accustom herself to her pupils and their needs. Supplies would have posed a problem in a community unaccustomed to an art school of any kind, but Pegi would have been good at improvisation. The bustling activity would have attracted the arts-minded and curious for visits and resulted in lots of talk and pleasant meals. Pegi

would not have thought about the long term – she rarely did. The excitement of setting up an art school would have been what drove her.

After the first summer, Lucy kept the school going throughout the rest of the year, and until 1948 Pegi came every summer to teach and to stimulate all sorts of groups and individuals. In 1975, Lucy wrote about it all. "We were working at a time when the arts were unconscious of their part in the general upheaval and often we were quite naive in our reactions. For instance, we really thought we were doing 'war work' in that old Observatory. We were not trying to make U.N.B. a cultural centre ... it already was that and we were servants to its needs."[12]

That summer of 1940 exposed Pegi to a good deal of talent in New Brunswick that could be focused at the centre. To McCurry she mentioned potters, weavers, photographers, all doing interesting work. "This is a very good hen without a head, and in a way, I could be head for a time perhaps ... there is a nucleus of interest in art."[13] There were enthusiastic artists. Painters of Saint John – Miller Brittain, Daniel Edwin (Ted) Campbell, and Jack Humphrey – were often in Fredericton to participate at the centre and to show their work. Pegi's presence coincided with and certainly may have helped galvanize a little artistic renaissance in the two communities.

McCurry had told Pegi to beware any clash with the Maritime Art Association, formed in 1935, but with her inaugural event she had already begun to win over the local art club, formed only in 1936, and to generate the enthusiasm for which Fredericton and New Brunswick still remember her. The Observatory centre was intended for both town and gown, and so it became, fully integrated with both. Pegi soon discovered that there were vibrant art clubs in all the main centres of New Brunswick – Moncton, Newcastle, and St Andrews, in addition to Fredericton, Sackville, Saint John, and Wolfville. Interested people had formed these before or at the instigation of the Maritime Art Association.

The redoubtable Elizabeth Russell Holt, at the Saint John Art Club (founded in the late nineteenth century but regrouped in 1908), had taught several area artists, including Miller Brittain. She would tantalize her pupils with the possibility of a life in art, despite the region's chronic economic difficulties. Her solid teaching of draughtsmanship and of the accurate rendering of form, texture, tone, and light gave her pupils an exceptionally good grounding. At the Saint John Vocational School (opened in 1926), both Brittain and Jack Humphrey taught, and Ted

Campbell, also a pupil of Holt's, became its art instructor and later ran the art department. Avery Shaw, art curator of the city's New Brunswick Museum, made a major contribution to the arts in the province. By the late 1930s, Mount Allison University in Sackville was offering good courses in the fine arts and granting degrees in the subject.

In Nova Scotia, Walter Abell was teaching art history and aesthetics in the art department that he had formed at Acadia University.[14] He had been a founder of the Maritime Art Association and, in 1940, of *Maritime Art* – then the only art magazine in Canada and precursor of *Canadian Art*, for which he edited the first volume after its establishment in Ottawa. Donald Buchanan and Robert Ayre subsequently co-edited the magazine. Abell's anti-elitist views – that art was not merely a source of pleasure for the rich but should be accessible to everyone – would have appealed to Pegi, who knew his work from her *Canadian Forum* days.[15] Her avid supporter H.O. McCurry was similarly sympathetic.[16]

There were many people in and around Fredericton and Saint John that summer and autumn of 1940 who found Pegi an adventure and appreciated her enthusiasm for the arts and crafts of New Brunswick. Some of the artisans and artists whom she had mentioned to McCurry congregated at the shop of Madge Smith, in a little cubbyhole at 610 Queen Street. Madge, who had emigrated with her family from England as a child, was a photographer and made quite a good living out of images that she had taken of the King and Queen's visit in 1939.[17] She presided over her small emporium, showing and selling local crafts and pictures and entertaining visitors over tea and coffee.

Madge and Pegi took an instant liking to one another that developed into a deep and lasting friendship (Fig. 9.3). Madge was a perceptive judge of quality in the products that she purveyed and a warm, practical friend to craftspeople and artists. A tall, dignified, rather taciturn woman, she gave the Observatory school a push in the right direction. Calm and diplomatic as well, she could smooth ruffled feelings and steer dissatisfaction into more positive channels. Her need to sell always tempered her own enthusiasms. Pegi's association opened new doors for Madge. Pegi knew many of the artists in Canada and – through her connections, particularly with the National Gallery – could help make known the considerable talents of New Brunswick artists and craftspeople.

From 1940 onwards, Pegi publicized the products of the province in a score of ways. She bought as much art and craft as she could, sending

9.3 Madge Smith and Pegi in front
of Madge's shop, Fredericton, undated

Madge's wares to her friends and relatives, repeatedly and often excessive-
ly. She overwhelmed her mother and aunts with woven scarves, and
McCurry received three-dozen wooden eggcups inadvertently, for Pegi
often ordered carelessly.[18] Over the years Pegi also brought from New York
many objects to add variety to Madge's stock.

　　At Madge's shop Pegi met the potters Kjeld Deichmann and his wife,
Erica, and they became close friends. Madge was the first person to sell
Deichmann work, which the Canadian Handicrafts Association later dis-
tributed across the country.[19] It was some of the earliest Canadian pottery
of good quality – albeit produced by a Danish-trained immigrant.

　　In late 1940, Pegi visited the Deichmanns at their home at Moss Glen
on an island in the Saint John River, and she returned there many times.
Moss Glen had a connection to the mainland in summer by ferry and in
winter only by ice. There Pegi painted, often choosing for her oils the
colours of the glazes that her hosts used on their pottery.[20] Erica recalled,
"It was stimulating to be near Pegi. She was unusually gifted not only artis-
tically but musically, (she played the piano well and had a charming flexi-

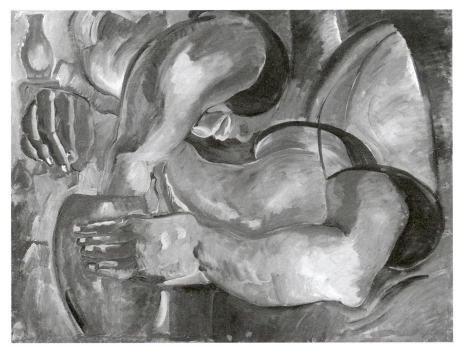

9.4 *Kjeld Modelling*, undated; oil on plywood board, 61 × 81 cm

ble voice) but she could also design and sew, and made all kinds of ex[c]iting wearing apparel."[21] Pegi shared with these friends a fascination with natural surroundings and with the explosive and subtle actions of the natural world – elements that she missed in New York. In her portraits of both Kjeld and Erica – she also painted their children – she tried to capture the motion of their arms and hands as they shaped the clay on their wheels and modelled. Her portrait of Kjeld deep in concentration as he throws a pot is particularly striking (Fig. 9.4).

The academic side of life in Fredericton also appealed to Pegi, and she to it. It was a remarkably rich and innovative environment for the arts, and she made many friends in its circles. Without it, Pegi would not have been able to achieve what she did. One of the new friends was Alfred Bailey, head of the fledgling history department, who had been to school with Norman and remembered him as a "young buck."[22] He and Pegi shared a common interest in poetry and Canada's First Peoples. He was an expert on Algonkian society.[23] He was also involved in the New Brunswick art community and the New Brunswick Museum.

Pegi and Jane lingered in Fredericton until the late autumn of 1940. Norman joined them there for a holiday. He had sweltered through the New York summer in cramped accommodation, while Pegi had spent her time comfortably and profitably. The art centre had been well started, though not formally opened. And Pegi had painted extensively – the streets and sidewalks of Fredericton; meadows, flowers, and horses at the experimental farm outside the city; the harbour and oddly angular corners of Saint John; and portraits of adults and, as always, children. Erica Deichmann-Gregg recalled:

Pegi worked spontaneously and very, very quickly. Rarely did she make corrections by over painting. If she wanted to change her concept she altered the pattern and even the main structure while she was working – transforming a head into a bowl of flowers … She never wasted time. She would paint any subject on any background within reach – sections of plywood and wall board, blueprints from her husband Norman's office, canvas and paper given to her by Madge Smith, wrapping paper from anywhere. And she would settle down in any kind of light … sometimes in the half-dark.[24]

At the end of this summer Pegi felt restored and ready to face New York again. She had provided Jane with family and the sort of rural environment that she had known in her own childhood. She had made new friends, met like-minded artists, and painted. Above all, in the Observatory summer school, she had found something challenging that suited her talents. As she had with her young Elmwood pupils more than a decade earlier, she could share her thoughts on art and engender interest in painting. She could also develop some measure of independence for herself. Significantly, she had also found a way to ensure a regular return to Canada.

Six Weeks in Summer

1941–1948

BUOYED BY HER SEVERAL EXCITING MONTHS in New Brunswick and memories of an excellent class, Pegi was quite happy to return to Manhattan at the end of 1940. Norman had not found a suitable job in Canada but had located something in New York. They now accepted the city as home and took a long lease on an apartment, so that Jane could begin infant schooling. They took a top-floor apartment – the cheapest centrally located one available – at 509 East 88th Street in an area known as Germantown. Pegi wrote to Madge Smith, "This is ... a contrast to the Village – prosperous, domestic, an orgy of shops, restaurants, lots of sausage & beer and faces older than Methuselah, early German paintings, Memling, Cranach, old, old, old. After Canada where children are just bland healthy lumps, these over-civilized crones of seven are amusing." Recalling all the excitement of Fredericton, she laments, "I'm a hausfrau again."[1]

The MacLeods' new neighbourhood seemed seedy and dreary to many of their friends. Their narrow red terrace tenement building had steep stairs. The inside rooms ran the depth of the structure, with entrances at each end, like a train carriage – hence the name railroad apartments. Front and rear rooms were spacious enough, but the two intervening ones were virtually part of a corridor and extremely cramped. One could see the distant East River from the back room, which served as kitchen and general all-work room. There was a bathroom off it. Soon buildings blocked the view. In the back room Pegi cooked, washed, ironed, ate, painted,

wrote, and grew plants in abundance: pips, seeds, galloping cabbages, all rampaging about the large back window. She kept her brushes in a silver mug and used a Limoges platter as her palette.[2] Some nervous visitors feared that paint might mingle with food and that the Deichmann mugs might retain the candle wax that often filled them. "Pegi had innumerable paint pots making one suspect of the lima beans and pork chops simmering away in, hopefully, another kind of pot," recalled her friend Margaret (Allen) Baerman.[3] Pegi in fact kept everything scrupulously clean.

Many friends visited the MacLeods and retained vivid memories. Pegi had painted her front room a blue-green, like one of the Deichmanns' favourite glazes. The kitchen was apple green. She painted the floors of the apartment too and in time dressed them with rag rugs – some her own creations and some purchased from farming women around Fredericton who took their handiwork to the weekly market. Her own were always colourful but a little crooked and lop-sided. There were no wall fixtures, so all the lights hung from the ceilings, with wooden glove stretchers attached to their cords as pulls. The place had little furniture, and little room for any. Bed covers consisted of miscellaneous fabrics from thrift shops. A rich, poison-green plush throw covered the largest bed. "Trips to the local thrift shop provided such items as velour draperies to be converted to evening attire," according to Margaret Baerman.[4] Norman tended to live in the front room, which had a large bed, a couple of chairs, and orange boxes for tables.

The early months of 1941 were good for the MacLeods. They were getting on better together after a considerable separation and enjoying their new apartment and district. Jane was now mobile, so Pegi was able to roam the streets and paint, to visit the Central Park Zoo regularly, and generally to enjoy New York. To Madge Smith in Fredericton she wrote, "I have attacked my view from the window. Its [sic] a little beyond one who has neglected landscape for years. Yesterday I was below in the street just painting up and down it whatever happened by, but this morning in the same place, I managed to catch cold – I'm terrified of arthritis, lady-artist's disease from living in unheated studios so I've a hot water bottle in the back of my slacks and Jane is alarmed by my fat back-tummy!"[5] She could not "get used to having acquired a whole new world. It gives me endless pleasure."

During the winter, Pegi designed posters for the Deichmanns and wrote, under her maiden name, an article on Miller Brittain for the fourth

issue of *Maritime Art* (April 1941).[6] She was also preparing an application for a Guggenheim Fellowship.[7] In January 1941, she shared a show at the Art Gallery of Toronto with Mabel Lockerby, Kathleen Morris, and Marian Scott. The ever-supportive National Gallery had submitted fourteen of her pictures – four titled *Jane Asleep*; three featuring Jane awake; and four street scenes, one garden subject, and one painting of her bathroom. Graham McInnes in *Saturday Night* thought her studies of Jane charming. However, "[she] will never be a popular painter," he noted, "because she distorts for emotional ends, a type of unorthodoxy frowned on in this country" – surely a journalistic exaggeration. "But nothing will ever stop her being a good one."[8] In the Montreal *Standard*, Robert Ayre's more considered review contrasted Marian Scott's recent cell abstractions with Pegi's "vigorous, splashy, untidy pictures," finding a common ground in their focus on growth.[9]

Pegi was choosing pieces for the Eleventh Biennial Show of Water Color Painting, to take place at the Brooklyn Museum from March to May 1941. War kept the Europeans away, and sixteen Canadian painters constituted the only international element in the exhibition. The National Gallery of Canada again sent some of Pegi's pictures, and two were hung – *Planting the School Garden* (undated) and *Tenth Street* (undated). Reviews were mixed: critics writing perhaps for Canadian readers commended the show; in the *New York Times* Edwin Alden Jewell found Canadians "less adventurous and less exhilarating."[10]

En route to another summer in New Brunswick, Pegi attended a June 1941 conference of Canadian artists in Kingston, Ontario, arranged by her friend André Biéler.[11] This ambitious event had as its theme the artist's role in society and brought together for the first time practitioners from across the country. It introduced them, through a workshop format, to new ways and techniques for circulating and promoting their work. It presented speakers on general topics and specialized seminars and talks by American visitors. Thomas Hart Benton spoke, and Edward Rowan described the (U.S.) Public Works of Art Project, which Franklin Roosevelt had introduced and that had employed thousands of artists to decorate civic buildings in the depths of the Depression.[12] Pegi talked about making pictures available in schools, either by direct loan from the artists or from the government. She believed that public schools did not receive enough exposure to artistic resources and did not gear instruction to their use. In general, the conference did generate healthy enthusiasm.

10.1 Class photo, 1941. Lucy Jarvis on the upper left and Pegi on the upper right

In 1972, Jack Shadbolt, the Vancouver artist, commented, "it was the first time that Canadian artists right across the country achieved a sense of political identity."[13]

By early summer 1941 Pegi and Jane had moved back to Fredericton. Pegi had discovered the previous year that she was a rather good teacher. She returned to the city as a strong personality, with an established reputation as a painter. The University of New Brunswick (UNB) was willing to let her run the Observatory in any way that she wished, subject to budgetary limits. To her delight, her Canadian friends had been pleased to learn of her continuing new venture. H.O. McCurry wrote to her in May 1941, "I am glad to hear that you are going back to teach at the Observatory. You have set something going there that will never stop I am sure."[14]

Her pupils were a motley ensemble of the interested and only vaguely interested of all ages. Some had limited experience in painting, others none. All had to be catered to by one or, initially, two individuals and in a very small space. Pegi varied her painting classes according to demand and circumstances. She seems to have structured them well, with lectures on form, colour, composition, and some art history, interspersed with practical lessons on drawing, mixing pigments, preparing canvas or panel, and making frames. The rest of the time was for painting.

Initially, the classes occupied six weeks of summer, with Pegi and Lucy Jarvis alternating afternoons. However, during the 1941 session the inherent personality conflict between the two women came to a head. Their natures, skills, and methods differed radically. The parting was, however, easy, and both women were magnanimous. Lucy withdrew from the summer school altogether, which must have been hard for her, as she had enjoyed it and sharing the work. She kept a photograph in which she, Pegi, and some of their pupils peer through picture frames that they had had specially made (Fig. 10.1).[15]

In August 1941, Pegi wrote to McCurry, "The most exciting thing I know is that I went to a tea for summer teachers at Woodstock Vocational School. There I met a Miss Grace Coglan [Caughlin], Principal. She wants a *mural*."[16] A clearly delighted Pegi had extolled mural painting only the year before in the Ottawa *Citizen* and had experience in the genre, as her work for Cera at Eaton's had proved. She took her mural project seriously and first drew a design on paper. She also researched the content. Mrs Nelson Adams recalled her sketching plants at the experimental farm in Fredericton, and Pegi even included Adams in a white lab coat in the finished work.[17] Miller Brittain had been working on a mural in Saint John, which perhaps inspired and influenced Pegi as well.[18]

Full of symbolism, Pegi's massive composition extolled the virtues of vocational training as it related to the rural way of life. Marylin McKay describes it as representing "the material progress of Western culture's modern age."[19] Figures digging, delving, spinning, and weaving in traditional and modern ways peopled the wall. She painted her mural largely in earth colours on white, lead-primed canvas that she cut and glued to the wall. A student, Marjorie (Rogers) Donaldson – later curator of the UNB Art Centre – painted in the uncovered pieces of wall. Photos of Pegi at work make clear the scale of the undertaking. Almost buried in canvas, her small, sturdy figure points out one of her subjects (Fig. 10.2).[20]

Pegi was paid in hand-woven cloth that thrilled her. In 1941, she detailed the creative process for *Maritime Art* and concluded: "So altogether I have my cloth, the new friendships which I established during the course of my work and the opportunity which I had to get a lot of painting out of my system."[21] She may also have taken dangerous amounts of lead into her body from the canvas primer.

Margaret MacKenzie apparently wanted a mural for UNB, but Pegi never completed another such work. Sadly, the mural in Woodstock did

10.2 Pegi and her Woodstock
mural, 1941

not survive intact, but pieces were rescued and framed in 1976 and hang
in the school still.[22]

For the rest of her life Pegi returned to Fredericton each summer. She had
no car, so she did the journey in a series of trains with a young child,
paints, baggage, canvases, and much paraphernalia. It took a long time,
particularly since she invariably included Ottawa and Montreal in her
itinerary. There was good overnight service from New York to Montreal or
Toronto and also to Fredericton.

 Pegi left her husband for months at a time in order to do this. The mar-
riage was rocky, and being apart for a while each year suited both parties.
New York can be witheringly hot and humid in summer, and Pegi wanted
Jane to have some fresh air and a change of environment. She had
expressed to friends some reservations about the company available to Jane

10.3 A class outside the Observatory, undated

on East 88th Street.[23] The area was mixed, very rough, and very anti-British. Above all, however, she returned to Fredericton because she loved what she was doing there. In a 1942 letter to Madge after her third summer of teaching, she wrote: "I am afraid you are forever caught in the mesh. Once it happens art has you for good."[24]

Beginning in summer 1942, Pegi introduced intensive two-week courses (Fig. 10.3). In these, the day began with a fifteen-minute talk, more often than not on colour. Pegi liked to have her students begin with one colour at a time, working their way through the six primary and secondary colours and then combining them. One student, Donald Gammon, recalled listening to Pegi discourse on the evils of cobalt blue paint, only to discover that it was the only colour available to her class that day.[25] He also recollected Pegi's clear, precise voice telling people to hide behind bushes and then flit between them, thus challenging her pupils to sketch a fleeting pose. One participant remembered times when the model danced around to music and the observers had to swiftly capture her motions on paper.[26]

Pegi also found subject matter in the neighbouring countryside, in the university's collection of stuffed birds, and among the flora and fauna of the experimental farm. From her friends at the National Gallery, she was

always able to borrow slides, lectures, and prints featuring works by the old masters. She also worked at developing a solid reference library for her students. She encouraged local artists, including Miller Brittain and Jack Humphrey, to lend pieces to display both in the Observatory and else-where on campus. Madge willingly hung and sold students' work in her shop and arranged end-of-session shows there for them. Pegi appreciated her pupils' response to her efforts, writing to Madge in the spring of 1942, after her second summer of teaching, "it is *very, very* amazing about all those people painting and being eager."[27]

Pegi gave unstinting service, often returning to New York at summer's end drained of energy. For the most part the summer school attracted nuns, housewives, and students. The war effort absorbed the time and energy of many people, although sometimes teen-aged and female service people attended classes when they were off duty. If Pegi recognized the limitations of the situation, she seems never to have lost faith in her students, whom she thought as good as any. After viewing the Contemporary Arts Society (CAS) Show in Montreal in 1944, she wrote to Kathleen Fenwick quite strongly, "I would not care to be sponsor of broadcast of amateurishness of C.A.S. as I believe they have a right to be amateurs! But not to talk so much. One of my pupils in Fred. would knock spots off some of them – and I mean *spots*."[28] "Spots" was probably a reference to the abstract paintings of the francophone artists.[29]

Letters to or from several of Pegi's friends record something of what she offered as a teacher. Will Ogilvie commented years after her death on her "extraordinary gift of communication" and her ability "in conveying her own sensitive awareness as to what goes into the making of a work of art."[30] Ogilvie also remarked on Pegi's ability to find qualities of beauty in the prosaic and seemingly unlovely. He suggested that Pegi was able to convey to her students the difference between "looking" and "seeing" in this con-text. Madge had attended a 1940 class of hers, and Pegi asked her in 1941: "Did I ever tell you I liked your apples that night and cruelly made an example of you because I knew you and knew you wouldn't mind. The apples had a touch and all the cold approach 'by plane' or otherwise is no good without. I sometimes think nothing matters but the communication from a certain kind of person thro his hand and his brush. Expression by planes alone *is* not. Only by his tenderness and infinite pleasure stroke by stroke, he *is*."[31] A Fredericton artist and erstwhile pupil, Dorothy Sleep, said that Pegi could make one see beauty in things as common as bur-

docks. Never pedantic, Pegi encouraged her students to experiment and to break away from rules. Sleep remembered asking her what colours to use when painting distance, and the teacher replied that there were "no rules for art."[32]

Above all, her own joy in painting seems to have been her strongest influence on her pupils. Evelyn Wright, a local amateur artist, was one of her first: "Pegi inspired her students to paint in a creative manner, not perhaps by her lectures so much as by her innate enthusiasm for the art of painting."[33] Wright's paintings still hanging in Fredericton possess a richly and fully drawn vivacity of line combined with form that owes much to Pegi's example. Another student recalled Pegi's admonishing them to "sketch, sketch, each and every day and eventually the hand will become fluid and the eye sharp."[34]

As a teacher Pegi was simply herself, and her classes saw the complex mix of emotions and the volatile nature that made her charismatic. She was certainly a memorable figure on the campus as she moved swiftly and purposefully around, her slight but sturdy figure often dressed in brightly coloured swinging skirts and neat blouses, a Maliseet basket slung over one arm, Jane frequently in tow. When painting, she usually wore baggy trousers and smocks in scruffy condition and bespattered with paint. Madge photographed her in her shop, colour-besprinkled, surrounded by the work of her friends and students (Fig. 10.4). Pegi's paintings could be chaotic too, as in the colourful exuberance of her depiction of Fredericton's market (Fig. 10.5).

Pegi was able to live on what she earned in Fredericton while there but often added to her planned workload – for example, at one point teaching visiting CWACs (Canadian Women's Army Corps) – to earn more. There was never much money for the school, as the fees were always reasonable. The course cost fifteen dollars in 1942.[35] Pegi and her students improved the Observatory as needed, once in 1943 painting zodiac signs around the dome. As late as 1946, she told a journalist from the *Christian Science Monitor* that they turned chairs upside-down to use as easels and that the pigments that students mixed were gifts.[36]

1944 was Pegi's fifth summer in Fredericton, and she wrote to Kathleen Fenwick of her latest plans (somewhat discounting the vibrant professional art scene), "As to art this spot is barren, tho[ugh] so lovely to see … I've inaugurated tea at 4 in the studio and with such can influence a good fifty teachers who haven't seemed to meet much painting."[37] She sought

10.4 Pegi in Madge's shop, 1945

10.5 *Square, Fredericton*, c. 1943; watercolour, gouache, and graphite on paper, mounted on paper board, 64.6 × 99.7 cm

constantly to improve her courses, in one 1946 letter imploring Madge: "Are you coming yourself this year? I am open to suggestion. How would two nights per week suit you? I want you to consult yourself, your own memory – were you fatigued – could you considering the hill, take more work? Less? Did you like the creative part? the lecture? Would you like more discussion – modern? history? technics [sic]? Would you like to examine more pictures – bigger – better? Would you like more book study? I will consult no one else as I am sure you know your feelings and they would be lucid."[38]

Pegi's accommodation was always unsettled. The first summer she and Jane camped in an old woodshed on the side of the hill behind the Arts Building where the MacKenzies lived. The structure had two floors; the top section had been an ice-house and was reached by a ramp. This was the location that they chose. Pegi liked the informality that was missing at her mother-in-law's. In 1943 and 1944, she boarded with the Saunders family. John Saunders, then a boy, recalls how, after Pegi left, his family would clear out armloads of sketches from her room and burn them.[39] She lived later in the university's Lady Beaverbrook residence, and one summer on the experimental farm.

While in Fredericton, Pegi managed to paint continuously if erratically. Portraiture was one genre that she pursued, and she had planned to paint everyone in UNB's Chemistry Department. She completed two of her planned portraits, and one of them, *Molecular Physicist* (1945), is a striking and innovative study of a man, his head surrounded by circling atoms (Fig. 10.6). In 1950, David Leonard Garmaise, an associate professor of chemistry at UNB, wrote to Donald Buchanan about the work in connection with Pegi's memorial exhibition. While making it clear that he was not an atomic physicist but merely the model for the portrait, he noted that "her intention was to portray the dilemma of the modern scientist (primarily the atomic physicist) ... [I]n the face of mankind's apparent inability to control properly the new sources of power which the scientist discovers; the scientist wonders whether or not to dodge the knowledge he has obtained."[40] Marian Scott's celebrated endocrinology mural commission for the Department of Histology at McGill University, completed in 1942, may have influenced Pegi's execution of this piece.

Pegi had a deep-seated need to spend time in Canada because she still considered it her home, but, as Jane grew older and life in New York

10.6 *Molecular Physicist*,
1945; oil on canvas,
91.5 × 40.7 cm (Plate 12)

became slightly easier financially, she began to reconsider her commitment to Fredericton. While she had always very much liked the people with whom she worked there, she had never reconciled herself to life as a teacher. She was an artist. More ominously, she was often ill at the end of the summer sessions. Perhaps the disease that finally killed her had already started, although she had no inkling of it.

In 1945, she wrote to Madge, "Secret between you and me! Judging by the fearful results on my health … I don't think I shall teach next year. I might take a year out or alternate summers with others! I feel I have given and I also feel I have given enough. Of course when I think of some of my dear pupils I am torn … You can understand the conflict I have with myself. If only I could be casual about things but that is not my way. However I am a painter and that is my life."[41] In August 1946, she wrote Gertrude Ingall, H.O. McCurry's secretary, "At this time I rapidly lose interest although I have 29 rather good students but not to paint makes me quite unhappy."[42]

The effects of small-town politics were also getting her down. In October 1946, she wrote to Marian Scott: "My Maritime venture still bothers me a little. I've always escaped being involved in the meshes of the small town but feel clutching hands every now and then. Feuds and rumours of feuds are always submerging what art there is."[43] Changing her programming always helped, as she recalled to Marian in 1948, "This summer I took the aesthetics department of the Philosophy class, five high school principles [sic] through an ad lib programme on painting, sculpture, music and draws [drawing]. It was a great relief for me to vary my own work."[44]

In 1946, the summer courses attracted so many people that they did not all fit into the Observatory, so the school had to requisition UNB's drafting room and used the little building only as a gallery and meeting place. Later it appropriated Alexander Hall on the campus as a classroom. The prospect of full-time art courses at UNB (which started in 1947, with Lucy as art director) further inclined Pegi to stop teaching. Aware that Lucy's new position had emerged largely because of the success of the summer school and of the classes that Lucy had introduced in term time, Pegi saw the new, permanent position as further reason for her (Pegi) to consider moving on. She had always loved new challenges, and her efforts in Fredericton now seemed to be on stable and fertile ground. The Observatory art centre was fitting well into the emerging cultural renaissance in

the Maritime provinces and the improving art scene in Canada in general. It had been a natural fit with the formation of the Maritime Art Association and the art clubs that had matured in the region in the 1930s.

Pegi had undoubtedly proved a catalyst, adding a wider perspective to a relatively insular society. Her way of life, her base in New York, her reputation in Canadian art circles, and her acquaintance and friendship with many of its leading members added spice to the mix. New Brunswickers who cared deeply about the arts were drawn to her and matched her enthusiasm with their own. She saw herself as part of a wider scheme and wholeheartedly supported other new initiatives in the province, such as the concept of community colleges for arts and crafts. She took great pride in New Brunswick's artists and promoted them where she could, as in her article on Miller Brittain for *Maritime Art*. The province returned her loyalty by keeping her star firmly bright. Her legacy there has been to be a part of a renewed enthusiasm for and participation in the arts that continue to this day.

Figuring War, Part 1

1940–1944

PEGI BECAME ACTIVE IN THE WAR EFFORT while in Fredericton in October 1940. It is the best-documented stage of her life, as most of her work in that context stemmed from official commissions. The documentation captures both the official and the unofficial record of her undertakings, which brought her long-lasting recognition. Her participation followed extensive lobbying for a war art program by many Canadian artists and art writers. The effort during the First World War had brought artists such as A.Y. Jackson and Fred Varley to public attention and done much to expand interest in Canadian art. This legacy, combined with the prevailing belief that artists should support the war effort, spurred creation of a parallel program in the early 1940s. Approved in 1942, the war records program began in earnest in 1943.

Pegi initially approached the subject of conflict, however, as an artist rather than as a social activist, writing in an article in *Canadian Art* in 1944 of how war subjects inspired her:

Among painters, only a modern escapist could avoid being stimulated by the sight of a parade of blue Dianas of the Air Force moving behind their leading Diana, she in turn behind a motorcycle policeman clearing a path through the traffic on a merchant street in Ottawa. What a subject for a Dufy painting! I could see Dufy taking a wide impasto of blue on his palette knife and making a broad band of it on his canvas, drawing into it the distinctive details and outlines of the airwomen, with a varying background of sauntering civilians, slightly droopy, like zoot suits.[1]

Involvement in the war effort required practicality as well as inspiration. So, from Fredericton, in October 1940, after the summer stop in Ottawa when the *Citizen* interviewed her, Pegi wrote to H.O. McCurry: "it was at a party [in Ottawa]… that I heard your poster schemes might advance. So here is what I want to say: 1st. I have a number of sketches to show you. 2nd. A poster with a *poignantly* sleeping child indicating something precious needing protection would be appealing as something to work for."[2] McCurry responded immediately: "I shall be very happy to see your sketches and in fact was greatly disappointed to find that you had skipped off without showing me any."[3]

The wartime federal Bureau of Public Information – directed by George Herbert Lash, the Newfoundland-born First World War hero and journalist – had devised the poster scheme referred to by Pegi. In 1940, Lash set up an advisory committee on poster propaganda chaired by McCurry to help, among other duties, to select artists. McCurry quickly brought forward designs by artists including Eric Aldwinckle, Albert Cloutier, and Charles Comfort, who all eventually became instead official war artists.[4] Disappointingly for McCurry, the poster program never employed these younger artists, who had received so little support during the Depression. He complained bitterly about the committee's choice of "amateur or hack commercial workers" in a letter to the artist Edwin Holgate in November 1940.[5] For Pegi, his discouragement was irrelevant. In January 1941, preoccupied with selecting works for exhibitions and preparing her Guggenheim Fellowship application and her article on Miller Brittain, she wrote to him: "One of these days will send you a poster design. I'm afraid I'm not much on posters."[6] The sleeping child had apparently never materialized.

Fund-raising events, in contrast, were keen to receive works. In her letter of October 1940 to McCurry, Pegi had also inquired about the paintings that she had submitted (with the gallery's assistance) to a Red Cross sale to raise money for refugees. He had replied: "The Refugee sale was a great success and prices were quite good. We got $20.00 for two of yours and $30.00 for another. I enclose a catalogue and clippings."[7] A Jean-Paul Lemieux oil brought in ten dollars; David Milne watercolours, forty to fifty dollars each; and a Goodridge Roberts oil, fifteen dollars. According to the enclosed catalogue, only three artists topped one hundred dollars: Frank Hennessey (for each of two paintings), A.Y. Jackson, and Lilias Torrance Newton. Pegi's work was clearly considered worth collecting. She con-

tributed art to such events throughout the war. In 1945, she wrote to Madge Smith in Fredericton: "My gratifications come when I am able to contribute."[8]

In August 1941, Pegi reported to H.O. McCurry that she had someone from the Royal Canadian Air Force (RCAF) in her summer art class in Fredericton. Rank and file from the armed forces were to feature more and more in her summer courses and provided her with interesting subject matter.[9] However, war itself – as opposed to how it affected her own life and feelings, in the portraits of the sleeping Jane, for example – had not yet become a theme for her art.

All that changed after 7 December 1941, when the Japanese attack on Pearl Harbor brought the United States into the war. Opportunities became available for artists to support the American war effort, particularly in propaganda and information. Pegi now had a permanent home in New York on East 88th Street, and Jane was about to start school. She could now consider war projects. She approved of the propaganda accompanying U.S. entry into the war. Despite heavy pro-German sentiment in her neighbourhood, New York as a whole had always been pro-British. British servicemen on leave in the city rarely had to pay for their drinks and entertainment, and British airmen received a warm welcome. Norman was now working on an Allied shipbuilding program, and some of Pegi's Canadian friends, such as Mary Greey, worked for British organizations. Friends of Pegi and Norman's had experienced the bombing of London and other British cities.

On 2 February 1942, Pegi wrote to McCurry: "Down here more is being done than ever to encourage art because as they say 'The artists' duty is to stimulate the cultural life of the community as their contribution to the "Four Freedoms."'" I know you are more than aware of the attitude but it's fun to see itself working out. Our friend Rowan had his poster competition out four days after Pearl harbour [sic] and now they are joined with the Red Cross for another. Ten thousand artists in a body have offered their services. I'm trying to take part in some of these affairs. It's hard to find a niche."[10]

Pegi had met Edward Rowan at the Kingston conference for artists in June 1941 and now made contact with him again. On 17 February 1942 she wrote again to McCurry: "Hurray for war-art. Ed Rowan is going to get some from me. I've been allowed to draw a ladies' knitting class (bad but

at least I feel I'm trying)."[11] Pegi focused on the complex intermingling of the wool, needles, and fingers of the knitters.[12] She probably intended to use these drawings as a basis for a poster design, for about the same time she also noted to Kathleen Fenwick: "Now I'm going to enter a Red Cross Competition ... Wish you were here for a critique."[13] Furthermore, in the spring, she wrote to Madge: "Wish you could see my Red Cross posters for competition."[14]

The war focused her energy. Later in the year she entered and won a competition to produce designs for crafts for soldiers in hospital.[15] She appears to have based her winning design on one of the horses that she had sketched at the experimental farm in Fredericton that summer. East 88th Street also beckoned: "the most maddening subject pulls at me out the window – preparation for raising the service flag – across and back 88th is strung with pennants under which the ordinary life continues."[16] She wanted to create war art that had something to say.

Seasonal events and changes in her neighbourhood, such as ice delivery, the disposal by fire of Christmas trees, and the arrival of the Good Friday flower carts – all subjects that she eventually painted – made her aware that ordinary life goes on in wartime. She was searching for elements of daily existence that could convey its poignancy in anxious times. Many unfinished, or hastily made watercolours and sketches play with banners, tenement architecture, and street life itself, from the point of view of both the apartments above and the sidewalks below. For a long time, it was a struggle without reward. To Madge she reported: "I want more than ever to do war painting and feel farther from it."[17] But "In the meantime – wartime and I'm on the track of a factory and some portraits."[18]

For her own country, in March 1943, inspired by a program launched by the Canadian Group of Painters (CGP), Pegi designed a poster from a photograph of Fredericton taken by Madge. She wrote to her friend on the 25th: "Your photo of market inflamed me. At last I have done a design suitable for silk screen [sic]. The Can. Group asked for one. They are to be printed and distributed to the bare barrack, camps, etc."[19] This program, though initiated by the CGP, became a co-operative venture involving the National Gallery and the printing firm of Sampson-Matthews in Toronto, and outsiders sponsored particular images. It resulted in the production and distribution of many copies of thirty-six prints by Canadian artists to military bases at home and overseas.[20] A.Y. Jackson was, as in so many

such projects, heavily involved, and he had written to McCurry to pro-
mote the project in May 1942. The army's approval for this decorating
initiative had come through in January 1943. In March, Pegi submitted
three sketches entitled *The Troops in Market Place*. She realized that they
would probably not pass muster and said so in a letter to McCurry.[21] He
agreed, and none of her paintings made the cut.[22]

In her March letter to Madge – who had become a catalyst in her artis-
tic evolution – Pegi also mentioned new subject matter from Fredericton:
"I saw enough last summer [1942] to feel one could achieve some fascinat-
ing records of Can. boys [sic] pre-war experience."[23] She meant military
personnel in training – young, eager recruits who passed through the
University of New Brunswick (UNB) campus for training and occasionally
joined her art classes. She was still searching for a definitive, domestic
wartime subject. She later saw similar compositional possibilities in repa-
triated servicemen and ultimately created several memorable pieces from
this source. "The returned man is subject matter too," she commented to
McCurry in July 1945.[24]

In the summer of 1943, in Fredericton, Pegi developed the approach
hinted at in her letter to Madge. She wrote to McCurry about it in August
and enclosed some of her work: "I'm sending you these sailor boy's draw-
ings to give you an idea of what I did at the Art Centre (U.N.B.) this sum-
mer. There were 60 'naval ratings' stationed here for radio courses. Five of
them came from 4 to 6 every day for the past month. And *enjoyed* it."[25]
Three Royal Air Force (RAF) airmen also took lessons.[26] Pegi's wartime
depictions of service people on the UNB campus are charming portrayals of
untried and untested youths.

Pegi's letters make it clear that depicting war was a struggle for her: the
material of inspiration was simply not to hand, and what was available was
not enough. Conceptualizing the subject in paint for her centred really on
saving the young – she knew no other aspects that she could portray, her
UNB young service people being a case in point. For her, capturing war
meant depicting its absence. A late 1943 letter to Marian Scott in Montreal
reveals her uncertainty about what to prepare for a coming exhibition:
"I'm sure it is a struggle for every painter to paint 'Canada at War'. I have
turned myself inside out … I'm just not equipped … What we want to say
about Canada now is that we don't want war at all … When I sent all those
'sleeping Jane's' to Toronto three years ago [the four-woman show that
included Marian Scott at the Art Gallery of Toronto] it meant, no more

war, but nobody got it and I felt I was a terrible propagandist."[27] A few weeks later, she again wrote to Marian: "Are you sending to the Canada at War Show? I have worked hard for it and haven't produced but one decent thing ... I did a thing of a street dance given for soldiers. I think it's a love-ly theme and I haven't pulled it off ... The joke being that the water-colours sketches I did ... are still better tho [sic] hardly good enough to show."[28]

The search for subject matter continued. In February 1944, Pegi applied for design work with the U.S. government, without success. She informed Marian: "I went to the War Finance Dept. yesterday but my 'painter's style' is not much use to them."[29] But some organizations – Canadian, of course – liked her work. In June 1944, she told the Art Gallery of Toronto about an item that it had purchased:

My picture 'Navy Canteen' which you so kindly purchased was painted in February 1944. The subject is 'The United Services Canteen' on 48th St. near Broadway, N.Y. where I go once a month to do portraits of uniformed men. It is an informal volunteer-run place with lounges, letter-writing rooms, a dance floor, and cafeteria. The food comes from a high-school where the navy learns to cook. Five hundred signed-up volunteer hostesses are there every night. Each girl has to be there three nights of the week. There is an entrance test and no dating allowed. It sounds dull and mostly the boys are just off boats and often fall asleep in the canteen. So the hostess has a dull time. The place is very popular.[30]

Quite clearly capable of immersing herself in the subject of war, Pegi was ready for more challenges.

Figuring War, Part 2

1944–1946

PEGI KNEW THAT ARTISTS of her acquaintance were painting Canada's war effort. From 1941 on, painters, who included Will Ogilvie, had been portraying the work of Canadian soldiers in Britain. Charles Comfort had become one of the first official war artists attached to the Canadian army as part of the Canadian War Records program, which Prime Minister William Lyon Mackenzie King had approved in December 1942. Ultimately, this scheme employed thirty-two artists.[1] Pegi commented to Marian Scott in January 1944, "I find the Can. war artists very disappointing; feel I'd like a chance to do it!"[2] However, those in charge thought it inappropriate work for women, and the only female artist involved, Molly Lamb Bobak, did not receive her commission until 1945, after VE Day. Her experience as a private in the Canadian Women's Army Corps (CWAC) and A.Y. Jackson's influence had helped her obtain the post.

Clearly aware by 1944 that no one was painting the work of the women's services, H.O. McCurry used National Gallery funds to make an offer to Pegi. She became the first woman artist whom he approached and employed. On 14 July she responded to a letter from McCurry: "Could you explain the exact situation as to C.W.A.C.s as clearly as possible. I do not make expenses here … So that a return trip to Ottawa will be an unnecessary expense to me should I make it." She added that she would be working with CWACs in Fredericton as well: "Now this is what gives: The first day I arrived a deputation of C.W.A.C.s came and requested 2 nights a week

of art and creation from me *with pay*. This I accepted, also free roaming of their quarters."[3]

McCurry replied on 17 July: "Now here is what I would like to suggest about the C.W.A.C's, Womens Division, R.C.A.F and possibly the Wrens [Women's Royal Canadian Naval Service (WRCNS)]; no one has done anything about them yet and the service people in authority do not seem to be greatly interested but the fact is that war records would be most incomplete without some vital stuff on the womens' part in the three services." McCurry proposed: "Therefore I am willing to take it on myself to commission you to work for an experimental month here to see what can be done. If the results are successful and we feel we can afford it we could keep you on for a longer period. We could supply your materials besides paying your travelling expenses back to Ottawa. Would a small honorarium of say $300.00 for a month be beneath your notice? This is tentative, of course, and I would have to have the approval of the Trustees but I think I can secure that."[4]

This proposal delighted Pegi: "Nothing would please me better," she replied, "than to return to Ottawa to do all you say. I hope to be entirely at your disposal by finding some way of having Jane looked after for one month ... I'm more than excited about the work. Just one thing – I may start things in the month that I might wish to ponder over later. Could it not be partly material gathering – partly finishing with more to finish later?" And about her Fredericton CWACs: "One of my C.W.A.C.s is a raving beauty – I may go at her."[5] McCurry responded to both plans: "I hope you paint the portrait of the 'raving C.W.A.C.' and bring it up for us to see." He added, "The war isn't likely to last much longer so whatever we do for the Women's Divisions must be done soon. We will fall in line with almost any arrangements you find it possible to make."[6]

Pegi enjoyed the work tremendously. In early September 1944, she informed Madge: "My lovely C.W.A.C. work moves on to R.C.A.F. and Wrens this week."[7] A few weeks later, to Marian: "My work, more than fun. Operating on Wrens now, dear little things!! I work from nine to twelve on the real live creatures. Knock off for sleep – then paint up all the quick sketches. It's good to be used at your best, isn't it?"[8] (Fig. 12.1). Pegi received $600 for her two-month commission.[9] The chairman of the gallery's trustees, Hamilton Southam, told McCurry that he thought the fee inadequate.[10] Pegi herself objected to the fact that the gallery paid her as if it was purchasing the work. To Marian she wrote: "The War-art

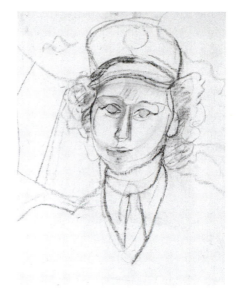

12.1 *A New Officer Visits Unit Office,*
1944; watercolour and coloured pencil on
paper, 63.3 × 48.5 cm

12.2 *Head of Air Woman,* undated;
conté crayon on paper, 63.2 × 48.6 cm

Committee hired *no* women to do *any* women! That is after 2 or 3 years
trying, H.O. McC. did not succeed in getting me or anyone else hired …
We are disappointed. I was paid as if a *work* of mine had been bought. To
me it represented a sort of painting holiday – orgy, sans housework. I hope
there will be no regrets of the bargain. Of course it's a year's job or more,
not 2 months."[11]

For this fee of $600 she had produced, according to a list that she pro-
vided, thirty-one watercolours and three oils on canvas of CWACs at
Ottawa's Glebe Barracks in August and September. She also delivered five
watercolours, three sketches, three oils on canvas, and four oils on board of
the RCAF Women's Division at the Princess Alice Barracks in Ottawa.
(Fig. 12.2) Pegi prepared thirty-one watercolours, four oils on canvas, and
twelve oils on board of naval personnel, largely at HMCS *Carleton* in
Ottawa in October.[12] When she finished the commission, she had trouble
adjusting to New York.

In late November 1944, she wrote to McCurry: "I am lost without
my job and don't settle down with ease."[13] However, she was soon busy
writing an article on her Ottawa experience for the December issue of
Canadian Art.[14] After sending it off, she wrote to Kathleen Fenwick: "I

hope it was decent. I worked hard on it without feeling flowing like genius out of me."[15] It includes four black-and-white illustrations of her work (one also features on the cover). She prepared it in her personal and some-what idiosyncratic writing style, focusing on the conjunction between traditional and modern subjects: "The subject material of women in the services has pattern and colour suited to the needs of moderns. The faces recall Botticelli, or Murillo or even Leonardo and call for realistic treat-ment ... When we come to the kitchens and galleys where the foods are prepared for these war-changed girls, we arrive at a group of animated Brueghels. In the C.W.A.C. barracks, the colours were his, golden walls with scarlet trim setting off white aprons wrapped round husky figures, white coifs and aluminum kettles, and rosy khaki cotton for general duty uniforms."

Pegi already felt strongly, as her subsequent New York work was to show, that the women who stayed behind were important. But above all, she felt that the role of women in the military deserved a painted record also. "It is unfair enough to leave out the mothers of soldiers, the nurses, the factory girls. What an obvious flaw to neglect also the women in the armed serv-ices." As she had reported to Marian, "Only a divorced from life man could say an army of women uninteresting."[16]

In January 1945, she asked McCurry to send some of her "women in uniform" to the upcoming exhibition of the Canadian Society of Painters in Watercolour. "One I would specially like sent," she wrote, "is of W.R.C.N.'s under a tree waiting for a bus: 2nd. C.W.A.C.'s swinging to school – the Beauty Parlour *gal* under dryer? if matted" (Fig. 12.3).[17] The gallery duly dispatched the three items.[18] Pegi was working on another article for *Canadian Art,* comparing the wartime situations for artists in Canada and the United States. It was never published. In two letters she refers to her difficulties in finding out about the American war art pro-grams, most of them privately sponsored.[19]

McCurry in July 1945 mentioned the further work on the women's serv-ices that he had expected from Pegi. He suggested that she submit some compositions to the War Records Committee: "What about war records? Have you done anything that won't horrify the Service members of the Committee?"[20] Pegi replied: "I have all but completed a huge canvas of the Canadian sailors eating ... I am keen to do more and may come to Ottawa later. I'd like to do a troop- train on return but the thought almost bowls me over."[21]

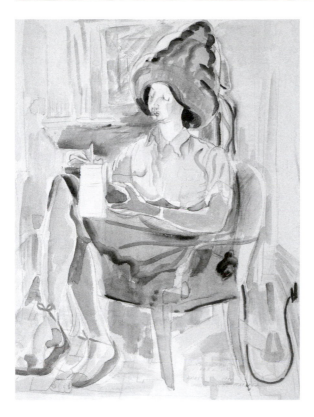

12.3 *CWAC Beauty Parlour #1*, 1944; watercolour on paper, 63.3 × 48.6 cm

By September, she was back in Ottawa with a new commission from the National Gallery. She wrote Madge: "I do C.W.A.C.'s night and day and I love them though I miss my own," a reference to those whom she knew in New Brunswick.[22] Another letter noted: "I am painting Wrens fast and furious and I guess it is my true function! I got to a dance last night – hundreds of them and ratings – their 3rd birthday. My canvasses are all used too."[23] To Marian, more soberly: "I don't know that you would like my W.R.C.N.'s very much but I feel they are for a certain public and it's rather reportage than literature but even so it's not in my best taste. That is the first stages – gathering the material, then of course vistas begin to open."[24]

As before, the National Gallery provided her with materials.[25] A series of notes listing the other equipment that she required has survived. It also indicates her proposed subject matter, all centred on the Wrens at HMCS *Carleton* in the aftermath of V-J Day. Furthermore, it carries a note in McCurry's hand: "Pegi says $300 ample for the year's work." He noted on

the list of works submitted: "Chairman agrees $300.00 is modest remuner-
ation."[26]

 Pegi's National Gallery commissions are uneven. Some watercolours
lack a quality of completeness, and compositions often seem poorly
thought out. At their best, they are buoyantly and resplendently evocative
of the military life of women. They are vibrant with colour and consis-
tently replete with energetic brushwork; the vivid swaths of magenta red
and viridian green enliven the khakis and blues of her subjects' uniforms.
Her subjects are the drills and daily rituals of uniformed life, but also the
off-times – in the beauty parlour or chatting in the barracks. She also cap-
tures the actual work of the women's services – clerical routines, kitchen
labour, waitressing, nursing, telephoning, and cleaning. In the few com-
pleted major oil paintings, the faces of these young, committed women
serve both as icons of a particular war service and as fully rounded human
beings. *Morning Parade* captures the enthusiastic yet serious dedication of
young women recruits (Fig. 12.4). The absence of propaganda and the
depiction of experience in all its aspects distinguish her war art. There is
no other body of paintings like it in Canadian art.

For Pegi, the pre-eminence of war off the battlefield as a subject came to
shape the two large canvases of about 1946 that combined her relationship
with East 88th Street and her war experiences in Fredericton and Ottawa.
The National Gallery commissions crystallized her thoughts as to what
people actually did in war and how she should present it. They had given
her knowledge of service life, and she could combine it with her own
observations of Fredericton and of people left behind on her street in New
York. *When Johnnie Comes Marching Home* (c. 1946) and *The Peace Bird*
(c. 1946) incorporate elements from several experimental variations on the
theme of street parades and also include some of her regular subjects – her
daughter, Jane, for example (Figs. 12.5 and 12.6, respectively). These paint-
ings encapsulate what she had for so long sought to depict – the relation-
ship between wartime military life, which insinuated itself into everyday
existence by virtue of its very absence there, and the lives of those at home.
These two disparate experiences of war both fed its ongoing conduct and
formed its context, and Pegi looked at war from the inside and the outside
of women's experience.
 Four images in New York stayed with her from the war years: the life of
the street itself, the women who watched it from their apartment windows,

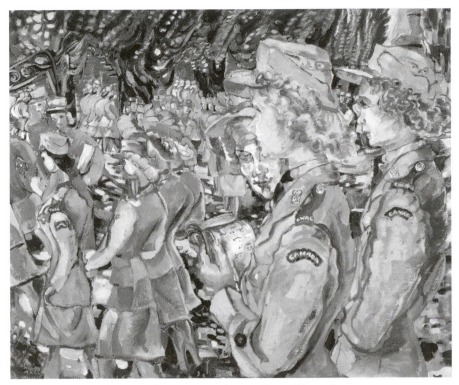

12.4 *Morning Parade*, 1944; oil on canvas, 76.5 × 91.8 cm (Plate 13)

the pigeons that nested on the fire escape outside her kitchen, and, at the end, the victory parades in the street below. An apartment woman herself, she had perfected a compositional device – the perspective on the street below her apartment, the view looking steeply down. In a letter of November 1947 to McCurry, she attached her artist's statement for the exhibition that was to include the two paintings: *Manhattan Cycle*, a show that was still touring Canada after she died in 1949. In it she described her intentions in these two works.[27]

When Johnnie Comes Marching Home (the title is taken from a cele-brated Civil War song of the same name) is a soldier's return seen from the vertiginous viewpoint of a window above the street. Johnnie stands on the top of the steps to the sidewalk in his khaki uniform surrounded by five almost identically dressed blonde girls. Below him on the street, women chat together and children skip and jump; the scene repeats itself further down the street in the background. Above this activity, and proportionally

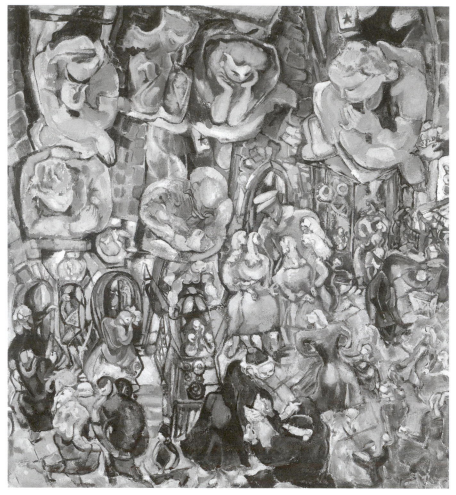

12.5 *When Johnnie Comes Marching Home*, c. 1946; oil on canvas, 122 × 112 cm (Plate 14)

far larger, several women – their arms crossed – lean out of their apartment windows and watch. Their faces are almost expressionless – some bear no features at all. They keep their distance from the celebratory scene, preferring, as they have for so many years, to observe and stay by themselves. The crowded composition, the overlapping figures, the jittery space, the tangled variety of poses, the mix of colours, and swirling brushstrokes give the painting its power, noise, meaning, and individuality.

The Peace Bird, according to Pegi, "is an after vj day painting. The bird cannot decide whether to descend into our street or not." It is disturbing in

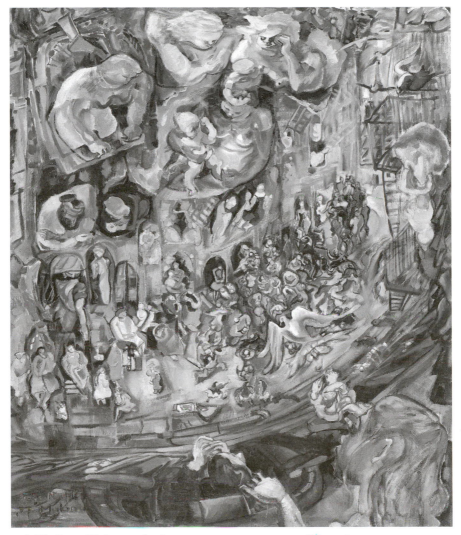

12.6 *The Peace Bird*, c. 1946; oil on canvas, 119.7 × 101.5 cm (Plate 15)

many respects. From high above 88th Street Jane looks down on a victory parade, as do a number of other apartment dwellers. Floating above the street is a mother holding a young child on her lap. She is encased in a protective bubble – possibly a reference back to *Children in Pliofilm* (1939) (Fig. 8.2, p. 107). While Pegi never painted pliofilm after this, its striking resemblance to the foetal amniotic sac struck a chord for her, and in *Johnnie Comes Marching Home* and *The Peace Bird* she encased a number

of her floating figures in shapes strongly reminiscent of this material. A pigeon, whitish wings and tail feathers outstretched, floats above like a Renaissance vision of the Holy Spirit. The components of Pegi's Manhattan life are all there: the fire-escape and its pigeons, innocent young Jane's protected view of the world from their fifth-floor apartment, the watching women in the other apartments that Pegi sketched so often, the ritualized life of her street, and the lively, vertical tenement life of New York that captured her imagination.

In both these compositions, Pegi laid on the paint thickly, and no part of each canvas is free of her swirls and staccato marks. The canvas surfaces almost vibrate with energy. And yet in both, the structure of street and opposite tenement building and the vertiginous viewpoint keep the pulsating and colourful paint surfaces in place. For all the nervous energy that emanates from these works, they hold together. In old age, Maud Brown remembered: "She painted two large canvases of the soldiers homecoming – monumental things … a marvellous effort – who but Peggy could have dared." About *The Peace Bird*: "Jane must have been 7 or 8 then [and] is looking out of a window looking down on the scene which builds up as people in the opposite apartments appear at their windows, [blousy] half-clad things – rather a travesty [of] Michael Angelo's angels. It's real – it lives."[28] Maud bought it.

In her artist's statement, Pegi referred to the dropping of the atomic bomb on Hiroshima on 6 August 1945 and on Nagasaki on 9 August, which brought the reality of the nuclear age home to the world. Pegi, like so many people, was unsure whether peace had arrived as a result of the bombing or whether the bombing represented the beginning of a new sort of war. She was prescient in her understanding, as the threat of nuclear destruction did indeed usher in a new kind of conflict – the Cold War. Deterrence – the prevention of war through the amassing of arms capable of wholesale destruction, but not really intended ever for use – became the guardian of the uneasy peace of the next forty-five years. Pegi's comment on the dove's ambivalence about descending into her street suggests that even when she laid down her brush – perhaps her most important painting complete – she was as ever unsure of her accomplishment. There was still more to achieve.

PART FIVE

Our Kind of Affairs

1940–1949

Wrestling with New York

1940–1947

IN NEW YORK, BETWEEN 1936 AND 1949, Pegi painted in water-colour virtually every day. It was easily transportable and amenable to short working periods. She was also by now proficient in this medium. To the inexperienced eye, the tools look simple: a clean sheet of paper, paints and water to one side, and a favourite brush in hand. One wets the pigment, mixes in more water with a brush to the desired intensity of colour, and applies it to the paper, which absorbs the colour.

Yet, despite its seeming simplicity, watercolour is full of surprises, and using it is always an adventure. The process is spontaneous and unpredictable. One can never be quite sure what the paint is going to do or whether the hand will be able to control what the paper absorbs from the brush. The medium is both an additive and a subtractive process – one can lighten the hues by adding more water or remove them almost entirely by lifting the pigment off the paper with soft paper, a sponge, or even a dry brush. Yet watercolour can be an unforgiving medium. Once dry, it is hard to remove, and over-painting in slowly darkening shades is the common means of altering it. Accidents, however – where edges bleed or colours mix on the paper – can be inspirational. The medium's translucency can make for jewel-like colours that resemble the effects of stained glass when the white of the paper shines through a thin wash of pigment. Contrast with a rich indigo blue-black only intensifies such luminosity. Watercolour can also serve like ink and function as the drawn line, adding definition

and character to unclear areas. Overworked, however, it will not survive but instead reduces itself to a muddy brown and grey morass.

Successes and failures alike, painting in watercolour and oil was as necessary to Pegi as eating and sleeping, and she could no more give it up than she could give up living. In New York during the war years and thereafter, she devoted her life, apart from domestic duties, almost exclusively to painting. In the same period, during summers in New Brunswick, painting took third place to domestic and teaching responsibilities. On one occasion she wrote to Marian Scott from Manhattan to thank her for a sketchbook: "I have it propped in my window and a new kind of easel, and there as I fleet by, even sweeping or just watering the horticulture, I may add to the story of 88th Street by one little sketch."[1] She filled the sketchbook with the swiftest of drawings and watercolours – of Jane, of neighbours leaning from apartment windows, and of the busy sidewalks and street life below. Sometimes she would become over-absorbed. Marjorie Oberne recalled Pegi painting Jane in the bathtub using an increasingly blue palette until Pegi realized that it was actually Jane who was turning blue from cold.[2] Jane, herself, resented being the perpetual subject.[3]

When Pegi began the large canvases and works on paper based on her sketchbooks she started quite simply. Her daughter recalled that she used to pin up the larger pieces on the back of the upright piano.[4] However, over time and according to her inclinations, the compositions became increasingly complex. The watching women whom she sketched from her apartment windows – the housewives who kept a keen eye on their children below or on the seasonal activity of their neighbourhood – became decorative and sometimes symbolic forms when she developed them in more finished compositions. In the context of war, these figures in the windows of East 88th Street became for Pegi the women everywhere who waited, worried, and wanted their men and boys home and finally were able to welcome them.

Several paintings of this time show this developmental leap from the particular to the universal. *The Church of St. Mary the Virgin* (1940), once in the collection of Lucy Jarvis, depicts angel forms that detach from the sculpted interior of the New York building and appear to hover or fly around, giving the composition some hint of the spiritual dimension of any religious practice.[5] In another painting set in the newly constructed United Nations (UN) building in Manhattan in 1946, the ghostly forms of children listen intently during an address to the world organization.[6] Pegi

had made it clear that it was the effect of war on the young that mattered to her. She had painted street children for years and had been concerned for their safety, but she had observed them simply as youngsters who danced, played games, and kept gardens. These ghostly figures at the UN were discernibly different – imagined children, moving into an unknown future. And, as always for her, they were symbols of peace.

Pegi's inspiration for her work came from her immediate environment. Throughout her years in New York from 1936 to 1949, Jane remained Pegi's first subject both in consequence of Pegi's obsession with her and because of circumstances. In 1944, for example, she wrote to Kathleen Fenwick: "I have come to the place where I must paint my daughter or bust."[7] Yet her absorption in her daughter as a subject did not affect Jane in any irreparable way. Their relationship was good. Consistently, much of Pegi's best painting resulted from this sort of immersion, when the subject was an integral part of her daily life. Once Jane was in school Pegi began to discover other subjects – friends and local street scenes and events – but still within a small world.

The imposed domestic round and a tendency to worry, especially about her own and her family's health, held Pegi back, and she complained constantly. She found it very difficult to do more than one thing at a time and claimed always that her role as wife and mother came first, although her addiction to painting and her desire for professional recognition affected her competence in both roles. Fortunately, Jane was a bright and attractive child, and Norman a devoted father and, in the very early days, a tolerant spouse. However, Pegi was not perhaps an easy mate for him. The stress of their poor and arduous life got both of them down. And she did not understand or appreciate Norman's stoical dedication to professional success in challenging domestic circumstances.

In difficult times poverty was always close at hand if he did not have employment, and Pegi seems not to have always understood his pressures. His own bouts of ill health, which sometimes affected his ability to work, were simply an additional annoyance to her. Certainly, she seems never to have sought, or perhaps even considered, income-generating work that would be of substantial help. To Jack Humphrey she explained in 1941: "I'm 'hors concour' from the point of having a husband to support me," she noted. "I make the best of it by painting all I can just as if I were earning my way. In fact, I have assisted my husband in his support of me and child … Now if I hadn't a husband I would take a job. If it weren't an art

job, it would be one of some kind. So you can gather, all my art life is a side issue from housework, dishes, laundry, shopping and nursery … I've worked slavishly all my life and if I have the pleasure of being an artist, I am satisfied."[8]

Coping with her home and family required taking time to paint at the expense of her household. "I have painted six new pictures," she reported to Madge Smith in Fredericton on 10 November 1941. "I am getting very serious. Somehow I've resolved so many housekeeper's problems that I can really go to it. I've been going straight into the street, doing anything at all, what a street though!"[9] It continued to provide subject matter that delighted her. "I am on the street every morning at eight attacking the flower carts with huge canvasses," Madge learned in a subsequent letter.[10] A particularly good series of paintings emerged – the riotous, flowing canvases of brilliant colour were attractive and saleable, and many have ended up in private and public collections (Fig. 13.1). "At night the flowers arrive on trucks," she wrote later. "The are wrapped in newspapers because of the cold. The lurid headlines keep them warm."[11]

Just as the United States entered the war in December 1941, Pegi wrote to Madge Smith in Fredericton: "I am so busy painting and the Canadian Group is having a show in January for the first time in years. From experience I know I'll get caught napping so war or no war, Christmas or not, all-out effort goes on canvas."[12] Unfortunately, trans-border shipments – even of art for shows – soon became more expensive. After Christmas she wrote to Madge: "I am quite destroyed because I can no longer send to Canadian Exhibitions! $12.00 is the charge on each picture and my pictures aren't that good."[13] "I've painted lots of new ones," she informed H.O. McCurry in Ottawa, "and was hoping to take part in the Canadian Group Show this year but I just cannot pay the charges for getting things across."[14]

Consequently, 1942 was rough for Pegi. She had also failed to get the Guggenheim Fellowship that would have let her buy good materials, and a dull summer in Fredericton made her ambivalent about continuing there. Serious foot problems – possibly phlebitis – immobilized Norman, kept him from work, depressed him, and isolated him in their small, disordered apartment. Although his illness made Pegi anxious for paying work, she did little or nothing to find any.

Her own subsequent depression sprang above all, however, from her own lack of faith in her painting. Though obviously cheered by a letter

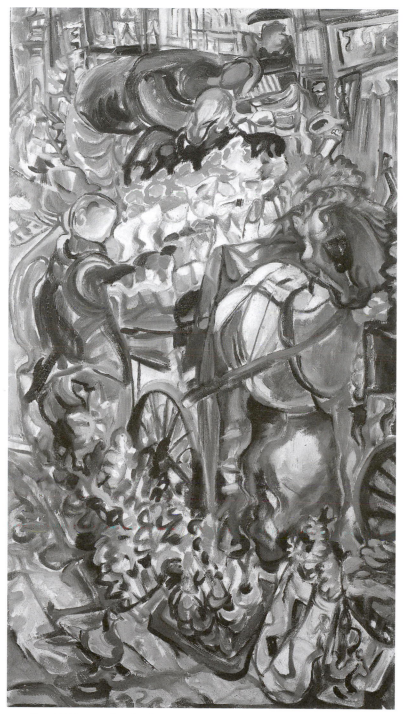

13.1 *Good Friday*, undated; oil on canvas, 98.4 x 55.7 cm (Plate 16)

from Marius Barbeau, she replied, "Seeing the magnificent things one sees here has a devastating effect … For instance, here imagine me still struggling with images of nature and seeing a huge show of Joan Miro. What can I think? Why do I bother. My approach is old fashioned, stupid. The Miro's [sic] aren't all perfect, but there is something about their daring that makes me feel staid and dull."[15] To Madge: "I am trying hard in between house cleaning to finish up a lot of my paintings. I can't tell you how poor I found them when I expected them to seem very beautiful." She was expecting a friend of Marian Scott's from Andover, Massachusetts, to come and look at her work with a view to exhibiting some.[16] "I don't expect him to take anything," she continued, "I feel I'm barking up the wrong tree. You can't make beauty where there is none or can you? Or should you? The sordid sights of our tough street seemed very alive, vital and made your treey and grassy town seem fancy and unreal but now I wonder."[17]

Pegi attempted to explain her despondency to Madge in October 1942. "I wonder if I can explain," she wrote, "but: here in N.Y. one never sees *realism* in modern art. Only incredible, fantastic, interesting surrealism and etc. My painting whatever it is, is at best a search for essential *beauty* within reality, when no such thing is to be found in any gallery, one feels? … We Canadians are babes in the woods in our expressions," she continued. "N.Y. is sophisticated and saturated with the best expatriated Europeans. I like all this stuff but being totally unrelated don't have a very satisfying commune with art unless I go to the Met. and see the old boys. This I do and I've never been failed of a terrific moving experience."[18]

Pegi's difficulties with contemporary art and, specifically, with abstraction were common to many Canadian anglophone artists of her generation. She herself carried the additional burden that her mentors – men such as Eric Brown and H.O. McCurry at the National Gallery of Canada – were distinctly reserved about its worth. In the 1930s, many of her colleagues in Canada expected art to demonstrate some social significance and thought of abstraction as generally lacking this capability. Walter Abell, for example, so influential in the Maritimes and later in Canadian art in general, largely "rejected abstract art as a legitimate form of visual expression" in his 1936 book *Representation and Form*.[19] The same year, Pegi reviewed this study positively for *Canadian Forum*.[20] While she noted that she had "none of the critical language" to assess his argument, she clearly responded to his evaluation of abstract art. Attitudes, as always, changed, however. In the war and the uneasy peace that followed, abstrac-

tion's asocial quality gave it currency in a world looking for something that could not be associated with the frequently figurative tastes of totalitarian regimes. This even though, as revolutionary Russia had shown, politics could harness art. In 1944, Abell revealed in a review in *Canadian Art* that he was modifying his views and was now more sympathetic to abstraction.[21] The subject of his review was the work of Québécois Paul-Émile Borduas, the leading French-Canadian abstract artist of the time. In the face of changing attitudes and the work of Borduas's colleagues in the Contemporary Arts Society (CAS), Abell's appreciation of abstract art had developed.

Pegi's colleagues would almost certainly have talked about Abell's views on art. And they would certainly have been aware of and responsive to the CAS and Borduas's involvement in furthering abstract approaches in Quebec. Despite her dismissal of the CAS in 1944, when Pegi wrote to McCurry that it was "a good *amateur* small picture show," she added that "the abstracts were certainly impressive."[22] And to criticize the group more generally would have been to criticize Marian Scott, who exhibited with it. Certainly Pegi would have adapted her own ideas and eventually her own painting. She was well placed in New York to absorb the tenets of abstract painting, yet she, like Abell, remained uncomfortable with much contemporary art. Her teaching the largely uninitiated in New Brunswick, her consequent exhaustion, and her poor health also prevented any potential change of direction in her own work. As well, her training in observation and in technical skills would also have impeded any move towards abstraction.

She had long appreciated the older, New York-based Ash Can School (she liked its focus on the details of everyday life) but commented disparagingly in 1942 on the "depressing, unfelt drabness of the today's. Those that crawled up the blind alley of abstraction even sadder and deader. No one believes anything! These people have pushed back the Frontiers of Beauty right out of sight."[23] Clearly the influence of Eric Brown, who believed that art and beauty were linked, had gone deep.[24] Pegi had little more affection for the dealers who sold such work. "They cannot judge art as living stuff that has to be made, only as a thing marketable. That point of view clouds the view."[25] The fact that her own pieces were not selling must have coloured her thoughts.

She also felt hampered by what she saw as a lack of democracy in the art world. To Jack Humphrey she wrote in 1947: "I believe … that what

you and I have in common is, apart from art is a belief in democracy. The academy represents – reaction – fascism – free painters will always allow other painters to paint in their own way. Art should be freedom; its essence is freedom; Rules, laws, controls, standards – these works [*sic*: words] smell of the academy (power, lust to dictate). The very word 'taste' is bandied about by people as if it were the exclusive possession of the elect."[26]

In late 1942 things looked up for Pegi. There was a possibility of a show in Andover after all (ultimately not to come to fruition), and she had acquired a quantity of commercial pigments from Harold Kirkpatrick, which she believed made her pictures "richer."[27] She had also obtained a number of portrait commissions, some in barter arrangements with people such as her dentist. Pegi made a little money from portraits, at which she had always been quite good and which make up a significant portion of her surviving works. Her friends the Echlins commissioned three. Her lively and realistic portrait of Letitia and her baby is a carefully observed study of a rather patrician woman caught in mid-sentence.[28] This activity involving people made up for her isolation – she was finding it hard to not exhibit new paintings in Canada, and what appeared there was either from Fredericton and recent or from the National Gallery and had been on display earlier.

 People and activities began to lift her spirits. In 1943, she found a studio space and took to teaching children. The owner had offered it to her on a "you-fix-it" basis, and it ultimately proved inadequate, although the youngsters became willing sitters for portraits. Yet after the school closed, she exclaimed to Madge, "I teach no more! Hurray!"[29] She also for a while instructed a small group of adults – mostly friends – in her kitchen, with Norman sometimes joining in. On occasion this group met at other people's houses; Pegi commented to Madge in 1942, "It's a break from the monotony of being tied to my house forever."[30] She continued to write: a play here, a poem there. Those poems that survive are of indifferent quality, although she seems to have had fun with rhyming. Her marriage was surviving. "Norman is fine – not a bad guy, either," she wrote to Madge.[31] With close friends King Gordon and Alma Rolleston (whose husband, Patrick, was a good friend of Humphrey Carver's) she joined a small choral group.[32] She had always been musical and made good use of the piano in her apartment.

Nevertheless, New York was not home. She confided to Madge: "I can't tell you … but I really loathe New York. The beautiful parts don't enter my everyday life. I grant their greatness when I do see them – as of last night – Radio City and fog and red sky. Incredible."[33] "[But] I would give my soul for a chance at your autumn; or your winter or most any time."[34] "I also miss the clear sparkling air and am depressed at slum conditions," she mourned in a letter to McCurry.[35] Getting Jane to school some twenty blocks away got her down as well. "Taking Jane to school ruins my painting day," she complained to Madge in the winter of 1945. "After the crush on two buses and back again before 9 a.m. I'm nervously exhausted. I realize what a whole season of this does to me."[36] And to the same confidante in April 1945: "Between keeping house and trying to be a painter or let's say leading my divided life, the months collapse behind with no letters written and not too much of anything to show."[37] In this she echoed her complaint of a year earlier, "I feel a fraud sometimes, 'all reputation and *no* pictures.'"[38]

None the less, despite what she viewed as onerous practical difficulties, Pegi was painting more. In fact, that was what kept her going. After leaving Jane at school at noon she continued her practice of sketching outdoors when she could. In her apartment she worked up her Fredericton pieces. Ottawa remained an inspiration too. "I still see motifs in this children's garden in front of Pop's house," she wrote to Marian in September 1945. "I'd like to think it was typically Canadian but fear it is unique. The children pile into a wee house, a tool shed and sing Oh Canada [sic] then file out in rows picking the seeds of their produce for next year."[39]

There is no record as to whether Pegi's parents ever travelled to New York to see her, but friends streamed in from all the periods of her life, and she revelled in it. "It was such fun having them," she reported to Madge in May 1946 after a visit from Miller Brittain and Ted Campbell. "It was a marvellous break for me as I had become quite houseridden."[40] A highlight of those years must have been Maud Brown's stay in 1946 or 1947; ever helpful, she bought several significant works, including *The Peace Bird*. The two women had kept in touch after Eric's death in 1939, and Maud later wrote about Pegi in that period. About her painting habits, she noted: "Peggy [sic] would attempt anything and *did*. I remembered how after she talked of the children and the slum – what a life they led! What could be done for them? She did care – six of them found their way into a canvas – and there they stand still." It is not clear which painting she refers

13.2 *The Slum Book*, undated;
oil on canvas, 122.2 x 91.5 cm

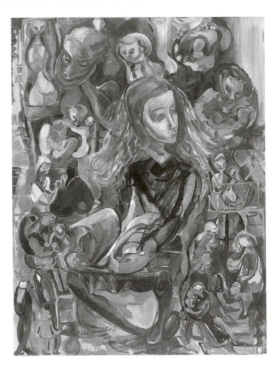

to, but *The Slum Book* is painted in very much the same spirit (Fig. 13.2).[41]
Pegi "was ... sketching endlessly from her windows the street scenes ... she
talked about children there so much – deep down she was sorry for them
and it all comes out in what she painted ... 6 pathetic, undefended chil-
dren looking out at you, huddled together detached from the senseless
street life behind them – women in aprons gossiping [*sic*] – street tum-
blers – girls hopping on a bench – a bright light falling on a grocery store
with a rosy light on door or window."[42]

Perhaps because she was questioning her abilities as a painter, had difficul-
ties exhibiting, and wanted money, Pegi took up rug hooking in 1941. As
well, Walter Abell and others had proposed that artists should engage in
industrial design, because only through producing objects that appealed to
laypeople could they ensure the survival of artists.[43] Rugs based largely on
her own designs and derived from the flora and fauna of New Brunswick
came to decorate her apartment in the mid-1940s. She sent the designs to
Madge, who in turn had local Fredericton women hook them up for sale
in her shop. Mass production of her rug designs was a serious possibility at
one point.[44]

New York got to see her work too. In November 1942 a number of her pastel-shaded rugs appeared in the Canadian section of the 19th Annual Women's International Exposition of Arts and Industries in Madison Square Garden.[45] The next year, one of her rugs won third prize at the Museum of Modern Art's *Arts in Therapy* competition. American sculptor Louise Nevelson's design was fifth.

Pegi also tried illustrating books, despite some earlier problems. King Gordon and his wife worked for the publishers Farrar and Rinehart, and Pegi had written King in 1938 that an "editress" once said to her "your idea of illustration is excoriating to the soul."[46] She did actually get a contract there, as she told McCurry in 1938.[47] For Desmond Pacey, a literature professor at the University of New Brunswick, Pegi did complete some (unused) illustrations for his children's book *Hippety Hobo*.[48] For an unpublished story by Lillian Zanet called *Webster the Pig* she also prepared illustrations, which – though not among her best works – made a posthumous exhibition at the National Gallery of Canada.[49]

Towards the end of the war Norman found relative success in several business ventures, but at times Pegi found their to-ing and fro-ing difficult. "Our position is peculiar," Pegi wrote to Marian in August 1944. "Norman is making more and me making more than we ever did in our lives but not in the same spot nor likely for a month or so."[50] "Excuse complaints," she wrote to Madge in late 1944 or early 1945, "but truly when I get to Fred[ericton] to teach I'm all in and find petty troubles of my pupils very trying!"[51] The complaints were constant. "It is very hard for me to settle down to three meals per day to cook, laundry, scrubbing etc. Just almost unbearable! I just got started on three things ... and now I wonder when I will paint again."[52] However, she *would* keep painting. "I am down to business but sometimes think, I still think I haven't time so I rush at it and do many rather than few potent," she confessed to Marian.[53] She also had a tendency to over-paint, telling Marian in 1943 about pictures for the exhibition *Canada at War*: "I made flexible canvases with thoughts of rolling but now I have overworked the poor things so that the cracking of paint would be heard!"[54]

Friends such as Madge and McCurry placed her paintings into exhibitions in Canada. So did Helen Beals.[55] Beals was still Walter Abell's assistant at *Maritime Art*.[56] She arranged a display of Pegi's work at Acadia University in Wolfville, Nova Scotia, and also sent examples to Montreal and to the joint show of the Canadian Society of Painters in Watercolour, the Canadian Group of Painters,[57] and others in Toronto in 1943.[58] After

Toronto, Beals reported to Madge. "Her work needs enough space and it
was well hung and lighted," she noted. "The Fredericton pictures as you
know were some of them very good and I liked the New York ones even
better. The color is richer and the design and form a bit more coherent."[59]
Artist Charles Goldhamer recalled that Pegi once submitted works to an
exhibition in Toronto "rolled up in the Sunday edition of the *New York
Times*."[60]

The iconography of her paintings from this period of the mid to late 1940s
reflects her feelings about her domestic sphere – a subject about which
she wrote and complained constantly. The sense of imprisonment that she
felt and expressed in letters comes across in many of her canvases. Jane,
initially for Pegi a subject of painterly pleasure, becomes a confined child
who in a number of compositions looks out and down on life through a
window. The imprisonment was to some degree real. As post-war
Manhattan boomed, construction projects removed Pegi's view of the East
River. Her paintings depicting the city's growth are relentlessly claustro-
phobic, with the building workers' activities suffocating the air and space
that her view once afforded her. One portrait of Jane that shows her read-
ing against the backdrop of a construction block suggests one source of
freedom in the presence of the open book.[61] Pegi's assiduously if errati-
cally maintained professional life, however, provided a far more important
freedom. While her subjects may have been domestic and personal, her
reputation in her own country remained high, and she continued to exhib-
it in the majority of group shows that were available to her.

Pegi used her reputation as a Canadian artist of note to introduce
American friends and acquaintances to Canadian art, which she wanted
better known and appreciated. When Donald Buchanan, now head of the
Industrial Design Department at the National Gallery of Canada, was to
speak at the prestigious National Arts Club in New York, he messed up the
sending out of the invitations.[62] Pegi commented to Kathleen Fenwick, "I
feel that Canadian art needs its spokesmen to be very alert."[63] Given this
opinion, it is not surprising that one of Pegi's last endeavours was a lecture
on Canadian art to the New Rochelle Art Association on 30 January 1948.[64]

But she also increasingly wanted to show her own work in the United
States. There had quite clearly been missed opportunities. In 1944, for
example, a number of her women artist friends exhibited at the Yale
University Art Gallery in *Canadian Art 1760–1943*. Thanks to the efforts of

Alison Grant (Vincent and Alice Massey's niece who, a decade earlier, had assisted Pegi with the set for *The Pied Piper* at Hart House) and of others, Lester Pearson, minister (after 1945, ambassador) to the United States, offered her a show at the Canadian Legation in Washington, DC.[65] Alison Grant had married George Ignatieff, who had become Pearson's close friend while they were diplomats in London during the war; Pegi painted a baby-portrait of the Ignatieff's son, Michael, when they lived in New York.[66] The proposed event in the U.S. capital conflicted, however, with Pegi's planning for *Manhattan Cycle*, her upcoming solo exhibition in Toronto.

Pegi first mentioned the work that developed into *Manhattan Cycle* in November 1945. It originated in 1942 and 1943 when she made identical, unsuccessful applications to the Guggenheim Foundation for the fellowships recently opened to Canadians. In her "Plans for Work," she reported that she wished for "an unencumbered year of day in day out painting of New York City subjects ... the push-carts, the ice-man, the flower wagon, the open markets, and the hand-ball games."[67] She intended, she said, to show the finished paintings to Canadians and made no mention of U.S. audiences.

Her references were extraordinary: Walter Abell, Martin Baldwin (director of the Art Gallery of Toronto), Marius Barbeau, Barker Fairley, Maude Grant, A.Y. Jackson, Norman MacKenzie, H.O. McCurry, Graham McInnes, Frank Scott, and Hamilton Southam. They all spoke of Pegi's ability, acknowledged her difficult personal circumstances, and argued that concentrated time painting would enable her to realize her undoubted potential. Barbeau noted, for example: "If she had better opportunities, she would undoubtedly work with enthusiasm and produce materials and canvases that would amply justify the outlay." Abell wrote more positively."I would rather take a chance on an artist like Mrs. MacLeod," he stated, "than on the safer more easily recognized types. One is taking a bet on a certain element of genius, and of course that's the only thing that can make an artist's work really interesting." However, by tending to a focus on her potential rather than on her undoubted achievements several of her referees did her a disservice. McCurry, usually so loyal, was close to critical. "There is a slight tendency to exhibitionism," he wrote, "and an inclination to dart from one project to another without persevering in any particular department."

13.3 *New York Street Scene*, 1945;
watercolour on paper, 60.5 x 45.5 cm

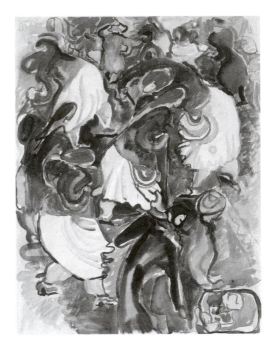

But it was the war commissions for the National Gallery of Canada that enabled her to carry out the plan outlined in the applications. They showed her that her habitual painting and sketching contained the kernels of significant compositions; when she applied herself diligently and consistently, she produced such pieces as *When Johnnie Comes Marching Home* (Fig. 12.5, p. 150) and *The Peace Bird* (Fig. 12.6, p. 151). She herself recognized at their completion, probably in 1946, that they were among her most important paintings – something to build on. She now believed, much more forcefully than in 1942 and 1943, that she could find something substantial in the parade of children's portraits, women, neighbours, activities, and experiences that constituted her life on East 88th Street in the 1940s. While good, her scenes of the street life below her apartment and the seasonal activities of Manhattan had to become more. The woman sweeping below her apartment and the skating rink at Rockefeller Plaza, with its busy activity, suited the fluid immediacy of her watercolour technique, but it was her less certain facility with oil paint and canvas that presented the greater challenge (Figs. 13.3, 13.4).

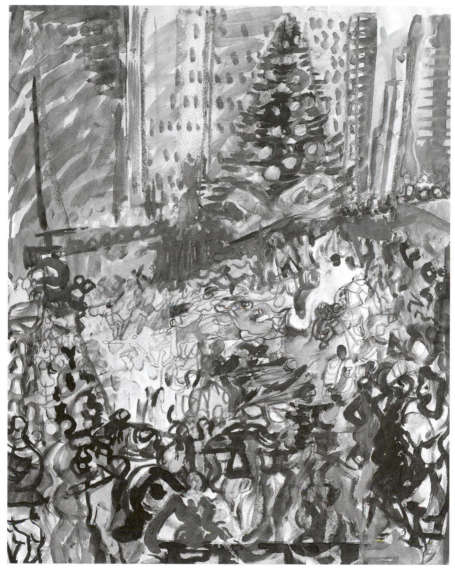

13.4 *Christmas Tree and Skaters, Rockefeller Plaza*, 1946; watercolour over graphite on laid paper, 61 x 47.8 cm

14

Manhattan Cycle in Canada

1947–1949

THUS PEGI'S SPASMODIC AND UNPLANNED BODY OF WORK centred on East 88th Street took on a life of its own in the mid-1940s and gained some sort of coherence. The Manhattan works differed from those that had made her reputation in Canada, as Helen Beals had noted, and did not reflect current stylistic trends. They seemed to please some people and mystify others. "The press couldn't understand my picture," she told Marian Scott in early 1944 about a canvas in a Canadian Group of Painters exhibition. "I suppose [that] can be taken as a sign. I'm troubled to think of the dismay the group people will feel when they see the canvases after the difficulties they had with the customs[.] I seem to need to paint Human's less abstracted even than they were. 88th St. has been a very important experience for me."[1]

The street was central to her conception of the solo exhibition that she was now planning for a tour in Canada. "I try to turn my weird street into 'something rich and strange,'" she wrote to Madge Smith in November 1945.[2] And to H.O. McCurry a week later: "I am working towards a show of my own. It's mighty slow."[3] Almost a year later, after a trip to Canada, she informed Madge that she "intend[ed] to make a desperate attempt to pull my stuff together for a show this year. I feel the time is ripe. I hope to start by having it in Ottawa."[4]

On her return to New York, as she noted to Marian in late October 1946, Pegi wrote to her well-connected artist friend Isabel McLaughlin –

daughter of Colonel R.S. ('Sam') McLaughlin, founder and owner of General Motors Canada – about the proposed exhibition. "It was an assertion of a wish I hoped would bolster my own lack of assertion. However, it apparently worked as a reply from Mrs. Millman [Rose Millman, the Montreal dealer who founded the Dominion Gallery] is not unfavourable and Dick Van Valkenburg [manager of Eaton's Gallery in Toronto] has been here and approved Eaton's next Spring." She continued: "My project is mostly 88th St., Manhattan. I've been involved with this block now six years and still find it fascinating and Dick suggested a few typical N.Y. things to assist understanding. So last week I felt I was back on St. Helen's Island with you. That is not you but me in a state of searching city values in a rather old fashioned way."[5]

Marian Scott's cityscapes of the 1930s expressed much of the disheartened spirit of the Depression years, and Pegi sought something similarly essential in New York to meet Van Valkenburg's needs. "I haven't had the courage to dress up in paint clothes and expose myself to the world on an outdoor sketching trip," she continued, "but it was really fun and I wished you were there." The results, she confided, were heartening. "[They] have brought me an interesting commission to get into my pigment factory and do its interior so I'm glad I made a start. I go weekly to an orchestra rehearsal (Fig. 14.1) and as soon as some good canvases ripen I am going to the u.n. Assembly. Does any of that tempt you? 18 canvasses is more than I have in my house. Isn't [it] fun to give them a push. My biggest pleasure in the plan of a show is to think of the space we are going to have soon."[6]

To her friends it must have come as no surprise that her planned exhibition revolved around East 88th Street – she had written and spoken so much about it and its importance to her technique of painting, about how it was becoming her subject. McCurry, in particular, expressed delight that the show was coming together, noting on 10 December 1946 that he was "interested to hear that you were getting energetic and working up 'stuff' for exhibition in the 'home country.' Good show!"[7] Soon afterwards she wrote to Madge: "I am working really hard and not yet feeling destroyed by work, as you know it goes. Skyscrapers and factories and old 88th St. All my things are now in raw frames and I have a long way to go yet."[8]

A complete body of 110 pieces by early 1947, *Manhattan Cycle* represented the first time that Pegi was exhibiting in Canadian venues a collection

14.1 *Orchestra Sketch II*,
c. 1948; watercolour on paper,
42.6 x 34.9 cm

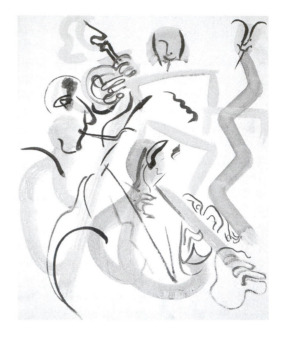

of paintings that focused on New York. For one thing, the war was over, and she could afford again to send paintings across the border. More importantly, she was publicly stating to her Canadian audience that her base was in New York and that community life was her subject. She had found, she was asserting, a rich vein of material for artists beyond traditional landscapes, still lifes, and portraits.

New York's Ash Can School affected *Manhattan Cycle*. Paintings by its well-known artists were readily accessible to Pegi as reproductions and in exhibitions. The street scenes of artists such as John Sloan and George Luks from the 1900s find echoes in her canvases – Sloan (and others) even painted rooftop pigeons, as she was to do.[9] The Fourteenth Street School, which emerged in the late 1920s, revived the Ash Can School's interest in city life and immortalized Greenwich Village, where Pegi first lived in the late 1930s. Reginald Marsh was perhaps its outstanding practitioner; paintings such as *The Bowery* (1930) juxtapose crowds, signs, and urban architecture – elements in many of Pegi's paintings of the 1940s. There are even shared subjects – Coney Island, for example.[10] Some of Pegi's window still lifes show the influence of an artist such as Max Weber – who combined Fauvist colour within a Cubist framework. Even Thomas Hart Benton's

focus on industrial scenes finds an echo in Pegi's paintings of construction work on East 88th Street.

"I have just sent 42 paintings to Eaton's College Street [in Toronto]. Show opens *April* 1. Will send you notices," a delighted Pegi wrote to Madge on 14 March 1947. "I no sooner get those out of the house when the request came for 12 for a new gallery in Ottawa," she continued. "I thought our walls would be denuded and the MacLeods would have more breathing space but it doesn't seem to make any diff [*sic*]."[11] There was a delay in the Toronto opening, but a venue had been found in Ottawa, she reported to Madge on 9 April, after dealing with a flurry of New Brunswick visitors, including Ted Campbell and artist Violet Gillett. "My show hasn't opened yet," she noted, "but one in Ottawa – new Gallery by Leo Heaps."[12]

A variety of sources, including the National Gallery and Pegi herself, delivered to Eaton's 110 works valued at $5,315, minus 33 1/3 per cent commission if sold.[13] Many of Pegi's finest pieces were in the show. *When Johnnie Comes Marching Home* and *The Peace Bird* were priced at $300 each. Eaton's press release for *Manhattan Cycle* was succinct, and the advertisement in the Toronto *Daily Star* read as follows:

This exhibition is a presentation of recent work by one of Canada's outstanding painters. It is pre-eminently a penetrating record of block life in New York as experienced and recorded by a sensitive artist. Mrs. MacLeod has entered fully into this 'block life' during her ten years residence in New York ... and it has become with her a fascinating study of people and their mode of life – the incongruity of the old ways in the midst of modernity. These 'visual comments from a fifth floor window' are accompanied by a written commentary by the artist. The exhibition is up until April 26.[14]

The typescript that Pegi sent with the material is essentially a description of Manhattan. The language is rich but unclear, much like her paintings. "There are fixed characters in each block with chorus and gossips," she notes. "Some, though they move, in the violet shadow of the rusting tin cornices which top the buildings are like Fates for they determine our lives." One wonders what viewers thought of the "March of the Bus Catchers" and the iceman being described as Hermes. Yet, at times, she acutely observes the essence of city life. "There are always figures in the windows. The window is New York's resting place."[15]

The Toronto *Star*'s widely read Augustus Bridle wrote an idiosyncratic review – the literary equivalent to the visual impact of Pegi's paintings.

When Toronto becomes a "megalopolis" a sixth the size of Manhattan's big-top leviathan – as shown in Pegi Nicol's screamario at Eaton's Fine Arts – these pictures by the Emily Carr of the big town will be either ten times the market price of 1947 or in the junk heaps of civilization. Pegi Nicol has been living long enough in New York to have a vivid conception of its humanity-dwarfing walls. Her pictures, brilliant, entirely color-toned, collectively dramatic are not architectural. She scrambles the world's most stupendous area of big-top edifices to depict obviously sprawling millions of people who inhabit both skyscrapers and tenements. Most of her pictures intensify collective humanity. Faces, forms, clothes, moving mobs on streets are impressionized – all but the eyes, which glow with melancholic lustre. Skies, clouds, happy revels, radiant home scenes are usually merged into a multitudinous rabble. People, horses, vehicles, all satirically impressionized – all but casual faces and sadly superb eyes. In many crowd ensembles, such is the artist's outlook on the "Street Scene" of the world's most startling big city. Her color-graphs are vibrant, intense, collective – and commonly hopeless: illustrations of scenes that the artist thought would be dramatically startling. As color ensembles, often wonderful. As pictures of humanity, more often pessimistically weird. And by 2,000 A.D. Toronto may be just such a revelation of art.[16]

Not all reviews were so dramatic. The Toronto *Telegram*'s commentary, though generally favourable, questioned, as had others earlier, whether the works might be better if "she were more selective in matter of detail." Pegi would have savoured the reviewer's claim that her oeuvre had "a strange affiliation with the old painters" – in the groupings at the upper windows, which put the writer in mind of cherubim.[17] Clearly, the unidentified author had grasped the references in *The Peace Bird* and *When Johnnie Comes Marching Home*. Clearly supportive, Pearl McCarthy of the Toronto *Globe and Mail* spoke of the "most important one-man [sic] show of the moment in Toronto."[18]

René Cera wrote movingly to Pegi: "You are a good human being Pegy [sic], an inspired one – I don't know how good or how great an artist you may be because I don't really know which qualifications are indispensable to be acknowledged as an artist great or small, but I certainly know it did me good to see the swarm of your charming canvasses."[19] He saw the works

14.2 *Manhattan Cycle* in Fredericton, 1948

as Gothic because they reminded him of "French cathedrals with their amazingly profuse abundance of small figures, animals, birds, plants sprouting irresistibly from everywhere possible." He continued: "Your stuff is made for our clean animality, not aimed at our fastidious understanding. Modern art is dying because it must at all cost be bearing a certain intellectual mark which separates it from the straight ordinary business of being alive."[20]

By late 1947 *Manhattan Cycle* was in the Maritimes – but only in Fredericton at the library of the teacher's college (Fig. 14.2). Problems regarding a tour of the region led Pegi to point an accusing finger at Lucy Jarvis. "Your letter arrived just as my heart was about to break," she wrote to Jack and Jean Humphrey. "Due to the fact that neither Ted [Campbell] nor Lucy answered her letters (Mrs. Fraser – Charlottetown – director of shows for MAA [Maritime Art Association]), my show has been cut off the list for travelling thro the Maritimes. I know Lucy's feelings as

exemplified – no mention of my name in Can. Art in spite of my 7-seven years work."[21]

None the less, the December 1947 review in the Fredericton *Gleaner* was positive and points out how people there saw her as a "local artist" first and foremost. "That there should be an equally vigorous or even more productive New York 'Pezi' [*sic*], comes upon us as a revelation."[22] Pegi told McCurry in January 1948: "I am willing to bet $10.00 there isn't a place in Canada with a show causing *more stir*."[23] One student in Fredericton thought that an orchestra scene was a medieval battle, noted R.C. Hicklin in W.W.B.'s *Hilltop*, when he wrote of "a powerful sense of colour; and of furious energy that makes for quick, often violent expression." Frederictonians picked up the Gothic references, as René Cera had in Toronto. Hicklin gave particular prominence to what he described as the top-heavy figures like gargoyles brooding over the composition in *The Peace Bird*.[24]

The National Gallery, which would not host retrospectives of living artists, mounted *Manhattan Cycle* in Ottawa (16–28 February 1948) at the Little Gallery, run by Leo Heaps and devoted to Canadian art. Pegi wanted the paintings to tour afterwards, but as nothing had been confirmed by then she asked H.O. McCurry if he could store them. He penned a heartwarming reply. "I have just come from looking at your exhibition and it was full of people rushing out to the telephone to call up their friends to come in and see the show."[25] Pegi's great pleasure in its success and in McCurry's note informs her words to Kathleen Fenwick: "Never have I had such a letter! It gives me back my reward so fully, I visualize not only a slightly successful debut in my hometown but a person in character, perfection. I'm just not used to it. I'm accustomed to sort of go along inventing my faith in myself."[26]

Joe Plaskett from the Winnipeg School of Art requested the exhibition for the art gallery, and Pegi in turn looked to McCurry for advice.[27] He suggested sending it there and then exploring whether the gallery would put it on the western circuit afterwards, which she did.[28] The western loop consisted of galleries in Winnipeg, Saskatoon, Calgary, Edmonton, Victoria, and Vancouver in 1948.[29] The reviewer at the Calgary *Herald* referred to "the almost tapestry quality" of the works.[30] A colleague at the Saskatoon *Star-Phoenix* noted: "Her work is absolutely original."[31]

Donald Buchanan did nothing to help with the arrangements. "I also think that he doesn't like the trend I express. I know some of the abstract quality has left my work since Jane, marriage and New York. I don't think

I could go far in that direction anyway. Life interrupts me too much. Also Donald could be wrong."[32] Yet success was paying dividends. Dr Max Stern, a dealer of some note in Montreal, who eventually took over the Dominion Gallery from Mrs Millman, had requested pictures on consignment.[33] Pegi was thrilled. "I believe my star is in the ascendant so here's luck with the two you have," she wrote to him on 15 November 1948.[34] Disappointingly, Stern returned the two sent as "unsaleable."[35] Pegi responded to the lack of enthusiasm he expressed in his letter. "I can accept the criticism of overcrowding," she wrote on 22 November. She added optimistically: "I shall certainly overcome this problem very soon."[36] Sales were becoming more regular in New York, and Pegi told Kathleen Fenwick: "In a way I do not wish to deprive the supply here as after ten years here I am just beginning to feel some confidence."[37] The tour and the sales took her away from painting, however, except for some whimsical sketches of a woodwind quintet that she completed on music paper. The reviews were sustaining Pegi more than was the act of painting. But *Manhattan Cycle* was to be her swansong.

15.1 Pegi, c. 1940

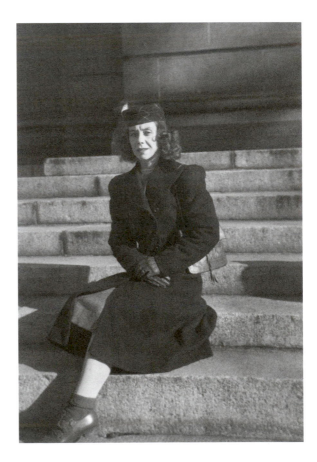

A Cruel Irony

1948–1949

SEATED ON STONE STEPS IN FREDERICTON, and dressed in a neat dark coat and pillbox hat, Pegi looks like a 1940s' version of Hecate, the demonized goddess of death and the netherworld. In the photograph, her face tense and drawn, and her eyes dark and sunken, only her curly mid-length hair, quite clearly permed, speaks to her buoyancy. It looks like the face of a dying woman (Fig. 15.1). In fact, the photograph antedated her death by nearly ten years, but ill-health was a constant companion from her mid-thirties on. Serious illness bided its time.

On 4 June 1948, Pegi informed Madge Smith that there was something critically wrong with her. Letters over the years had mentioned lingering colds, and several in recent months, even years, had suggested chronic poor health. She now baldly stated that "I have had a bout of illness that I was afraid would end up rather badly but have my fingers crossed. I have a spasm in my colon. I am tired of it."[1] She seems to have taken her illness seriously and later that month expressed doubts to Madge about Fredericton. "I have been trully [*sic*] ill," she wrote, "and have been wild wondering if I can manage the job at all this year, but seem to be mending."[2]

As she felt better she resumed her familiar tone with Madge, writing about mutual friends, rug designs, the framing of works for the Dominion Gallery in Montreal, and her feelings about New York. "The city is not as bad as it might be," she writes, "almost cool, but oh so ugly. These years in F. have spoiled me terribly."[3] She travelled to New Brunswick in 1948 to teach the summer courses, and none of her students seems to have noticed

her failing health. Photos, however, disclose a lined and rather drawn face, a woman in pain. One in particular shows her painting. Dressed in baggy pants and a jerkin, a wide belt encircling her slender waist, she retains the supple build of a far younger woman. But the face is old and haggard. She made light of it to those in the know about her health, remarking to Marian Scott that the pain in her stomach was appropriate to the role of Medea.[4] Increasingly ill, she visited a Fredericton doctor, who wanted to operate, but she chose to return to New York to seek out a specialist.[5]

From New York, after leaving Fredericton, she wrote to Madge on 21 August: "We are not meant to go without fun forever. If I don't have to be chopped up I am going to have a holiday."[6] The operation soon afterwards was a major one. She wrote to Erica Deichmann from Lenox Hill Hospital in early September. "Here I be and for six weeks. All my plumbing has to be re-modelled. The cutting scheduled in Fredericton would have been very wrong and perhaps – Well, anyway, just a waste of good organs and all to do again."[7] Jane was staying in New Brunswick with the Deichmanns and then with her grandmother MacLeod until school started in September. Pegi told Madge: "I wish she could always be up there. I see her walking under the yellow elms to school instead of pushing her way into the bus."[8]

The operation was a colostomy – Pegi had cancer, although her doctors did not tell her. Norman knew and kept it to himself. On 17 September, Pegi wrote to Madge: "My first operation is over, I am being built up to the next one which is the big affair. I am really more comfortable than I have been for six months and wonder how I got through the summer the way I was."[9] Cheerfully she informed Marian twelve days later: "What I have in the middle of my stomach would be fine for a Scott canvas. It is a rose with a glass and rubber tube through it."[10] Of the letter that she had received from Marian, she noted: "Yours is the only thing that touches on all my quicker passions."[11] And about Marian's upcoming solo show at the University of Toronto's Hart House, she added, "There is an excitement in our kind of affairs that cannot be compared."

Although Norman was now doing well, the medical expenses were steep.[12] Fortunately pieces from *Manhattan Cycle* sold across Canada – two in Winnipeg, for example.[13] But Pegi discovered that Madge was paying for some pictures that she held on to for a while. "Won't you please take them," Pegi asked, upset, "to sell and when you sell one, pay me then?"[14]

Before Pegi returned home in November after her second operation, Jane arrived back, and friends, including Mary Greey, who had attended the last summer course, went to look after her. On 8 November, Pegi wrote to Madge: "I am home. It is good. Everything is good, I am looking at my own queer house, my own paintings … We are a family and between you and me, a real one, now."[15] Norman had employed a neighbour to keep house while Pegi was in hospital. "Much as you lov' er and me too," she wrote to Mary Greey on 2 December, "Mrs. Hackman proved too much for me at first so I had to be alone in my own queer way. She greeted me with My Gawd are you 'tin and there was so much of that I wasn't equal as I felt a little delicate at first. I've been doing most everything since and it has put me in order and been a pleasure. I was so glad to be home I guess I wanted it to myself"[16] (Fig. 15.2). She kept up a cheerful front even to Madge: "I have awful nights so I'm thinking of a night studio."[17] Soon after leaving hospital she learned that *Manhattan Cycle* was to tour Ontario. As well, she and Norman, not close for several years (he had begun an affair with Lee Rosenthal, a business associate), revelled in the affectionate letters that arrived from concerned friends and relatives.

Pegi felt better. To H.O. McCurry she enthused, "I am painting so much that the canvas problem really drives me mad. Whoever had enough!!"[18] To Mary Greey in England: "Guess what has prevented me from writing? Paint. Yes ma'am, I've been painting every day for ten days. I thought the best way to start was to work on the nurse who worked on me. So I've done one and that started me. A warmed brush! So now I'm at everyone … The ego and health go up with the increasing warming of the painting hand."[19]

We know something about Pegi's last weeks at home from a new friend of hers. Marion (Miles) Pennington, who was at that time a nurse, received an introduction to Pegi from Edith Garbutt, daughter of Mrs F.G. Garbutt, Pegi's old friend in Calgary, and first met her in June, but the friendship solidified that autumn. Marion's mother, Mrs Miles, and Norman's mother had studied at the University of New Brunswick together, and Marion also knew Madge Smith from her childhood visits to Fredericton. Mrs Miles kept her daughter's informative letters from New York.

Marion remembered Pegi calling her over to pose. "I was astounded," she wrote, "when she was thro' for that day at how much of me was on the canvas, and recognisable."[20] Marion ate with the MacLeods on occasion, and they talked about Fredericton. She listened to radio programs with

509 E 85 St.
N.Y.C.
Dec. 2/48.

Mary;

Guess what has prevented me from writing? Paint! Yes ma'am I've been painting every day for ten days. I thought the best way to start was to work on the nurses who worked on me. So I've done one and that started me. A warmed brush! So now I'm at everyone. I did Lititia & her baby to-day. The ego and health go up with the increasing warming up of the painting hand.

Much as you love and me too Mrs. Hackman proved too much for me at first so I had to be alone in my own quar'r. She greeted me with My Lawd are you 'tin and there was so much of that I

them. As so many always did, she listened to Pegi's opinions. On 10 December, on Pegi's advice, she went to the Waldorf Astoria Hotel to the Canadian Club to see a Canadian art exhibition about which Pegi had phoned her. "She said it was good and it was."[21]

Marion Pennington thought that Pegi looked quite well, if tired, for someone who had undergone major surgery. Pegi informed Madge in December: "I paint. I housekeeper [sic]. I am happy. I feel well!"[22] But Norman confided to Mary Greey: "Sometimes the shadows seem rather dark."[23] Early in the new year, 1949, Pegi wrote to Mary: "I live in the kitchen now with the big window behind me, white curtains, lots of pillows, our new telephone, my paints. I sit propped in the pillows … the funniest thing of my life is that my show opens in Listowel [Ontario] this week. I did not know a thing about it. You know it's my birthplace and full of aunties. I haven't been warned in time to warn them. They will be very critical with a proprietary air. If they do not blow up the library with their violence, it, the show, will stagger on through Ontario. It's out of my hands."[24] Ironically, given the success of *Manhattan Cycle* and her passionate advocacy of her nation's art, the Canadian Group of Painters rejected her submitted work for its exhibition in Montreal.[25]

Two weeks later, when Pegi entered hospital again, she learned what was actually wrong with her. She took it badly and would see no one. Ina MacLeod, by then in New York, reported to Madge: "I cannot see her – Norman is the only person allowed in – and he comes away quite overcome. He said yesterday she was crying and that is pretty bad for Pegi."[26] The cancer had spread to her lungs, and the prognosis was poor. Mrs MacLeod remained in New York to care for Jane and Norman. Pegi's own parents did not learn of the gravity of her illness until all they could hear was a fragile voice on the telephone – they were too old to travel to New York.

Pegi gradually reconciled herself to dying and began almost feverishly to see friends. Sometimes she was too tired to do anything more than smile at them, and on other occasions she was strong enough to talk on the phone. Mrs MacLeod observed that she found it hard to put down the receiver, perhaps sensing that she might not talk to that person again.[27] René Cera visited. Years later he recalled: "If I remember her with warmth; it is because of her intense personality as a private Artist who had a perpetual love affair with her own work just for the sake of it."[28]

For a while she continued to fight the disease, struggling out of bed and telling friends of how she would be painting again soon and how newly bright she saw colour now.[29] But she was failing fast. In the last weeks the drugs that she received made her very sleepy, and she hallucinated. Mrs MacLeod thought that she looked beautiful despite her emaciated state.[30] On Monday 7 February, Marion Pennington visited her and rubbed her hands and feet with oil of wintergreen to ease the pain, for the cancer had spread to her joints.[31]

The end was coming quickly. Ina MacLeod saw Pegi for the last time alive on Friday 11 February, shocked by the change from Monday.[32] Yet Margaret Baerman had a totally different reaction. "The day before she died Pegi called me from the hospital to say she would like company and reading material. I found her sitting up in bed attached to many tubes but very spunky and talkative. It did not appear that death was imminent."[33] Her New Brunswick friend Edith Bishop also saw this renewed energy in the final days: "she still gave the impression of vitality and interest in life, although she must have been in great pain."[34]

Norman stayed with Pegi the evening of the 11th, and she never let go of his hand, as though perhaps to absorb some of his strength. He remained until she slept. She never awoke. On 12 February 1949 Norman sent a terse telegram to Madge: "Pegi died at seven this morning. Please inform friends and press."[35]

The service took place at Campbell's Funeral Home on 18 February. Mrs MacLeod looked after details, some of which would have appalled Pegi, such as dressing her body in a specially purchased white crepe dress. The famous people sending telegrams surprised Mrs MacLeod, who clearly had no idea of Pegi's considerable reputation as an artist.[36] Margaret Baerman thought the service "very stereotyped and unlike Pegi."[37] The casket and pulpit were a blaze of colour, as news of her death brought wreaths and bouquets.

The many obituaries in Canadian newspapers outdid themselves in their use of superlatives. To a one they praised Pegi's vision, her sense of colour, her painting of life, her spontaneity, her uniqueness, and her individuality. They commented on the tragedy of her early death. Graham McInnes wrote: "It is a cruel irony that she, who for so many of those who knew her, personified the ageless spirit of enthusiasm and enquiry, should herself have been cut down in her prime."[38] Perhaps Frank Scott said it best in his poem.

In the last week of our waiting
She lay on our eyes
And clouded all our days' work.
Yet when it was final
It was as though we had not been forewarned.

She lived her art in her motion and speech
As her painting spoke and moved.
She entered a room like a self-portrait
And her language cut quickly.
Everything that was ordinary became extraordinary
Through her vision and touch,
And what she approached grew bright colours.
She started songs and joys and bells
And gardens of pigeon and children.

Nothing she did was quite finished
Before another need called her,
Yet so advanced on its road
The leaving was victory.

Her writing wove through its grammar
Like a stem through stones,
As when she wrote on her death-bed
'There is an excitement in our kind of affairs
That cannot be compared.'

She was a Canadian of these difficult days
When greatness is in our thoughts
And our hands are numb.
Only part of her died.
Her alive is alive.[39]

In early March, Donald Buchanan and Alison Ignatieff travelled from Ottawa and reviewed and organized her paintings. Buchanan was her artistic executor. The National Gallery of Canada had proposed a special showing of her work – a considerable honour. Her friend and supporter Vincent Massey – now the head of the royal commission that laid the groundwork for government funding of the arts and sciences in Canada

and soon to be the country's first native-born governor general – opened the memorial exhibition on 13 June 1949. On display were many of Pegi's finest works – from the early portraits, through her Willingdon Prize winner, her Fredericton paintings, and her war art, to pieces from *Manhattan Cycle*.[40] The opening attracted a sizeable crowd, and her parents were there.

That summer Norman took Pegi's ashes to Fredericton. He placed them in a special urn made by the Deichmanns and buried her with earlier generations of MacLeods in a peaceful spot overlooking the Saint John River. People had often misspelled her name in life, and this was to be so also in death. Her gravestone reads: "Pegi Nicol McLeod, Artist, 1904–1949."

Epilogue

A Joyous Prolificness

IN THE COURSE OF MY RESEARCH I inevitably made contact with Jane, Pegi's daughter. In 1984, I visited New York and photographed the hundreds of Pegi's canvases that she and her husband, Aristides, had stored in their attic. We stayed in touch. In 1992, I moved to Ottawa to work at the Canadian War Museum, the repository of Pegi's war paintings, and purchased a house only a few blocks from her former home in the Glebe. In 1998, Jane, Aristides, and their son, MacLeod, stayed with us. The occasion was the opening of an exhibition of Pegi's wartime art at the Ottawa Art Gallery.[1]

The connection expanded when my mother and siblings visited the Pappidas family on a millennium trip to Manhattan. My mother had not seen Jane since just before Pegi's death, more than fifty years earlier. The bond that Pegi had been instrumental in creating held: my mother and Jane walked hand in hand through New York's streets. The next year my eldest children stayed with Jane and Aristides. In 2002, I returned to New York myself and idly asked how many paintings remained unsold from those that I had photographed nearly twenty years earlier. About fifty, replied Aristides. I agreed to photograph them. Three hundred and fifty shots later I ran out of film.

The fact that Jane and Aristides were moving to the state of Washington to be closer to MacLeod, who now lived there, had precipitated my visit. As a result of their decision to relocate, they worried about Pegi's paintings;

storage was already a concern, their turn-of-the century brownstone in Jersey City less than optimal for conservation. I asked their permission to approach the Art Gallery of Ontario (successor to the Art Gallery of Toronto) about their donating the bulk of the work as a study collection so that it would become part of the Canadian patrimony. They agreed, negotiations ensued, and in 2003 Jane and Aristides shipped the collection to the gallery. The sketches, canvases, and curious painted ephemera (painted floor tiles and drawings on the back of Norman's blueprints) are now in Canada.

More than any other body of work, this eclectic collection of first thoughts and experiments covering a lifetime of making art conveys the spirit of Pegi. Here one comes as close to the living personality as might be possible. Seventy years ago, Marian Scott had recorded the nature of such an experience in her journal.

Pegi arrived last night at 10 p.m. and left for Ottawa again this afternoon – as usual I feel fertilized. Last night with beer and chocolates we looked over drawings and water colours she had brought down. Their quality their free abandonment and joyousness kindled those sparks – the true and beautiful sparks within me and the world was strange and wonderful – ready to be explored and created. True there was none among all that quantity that you could pick out as absolutely satisfying most of them were patchy, only here and there a beautiful theme or an exciting discovery – most of them lacked balance but many made my arduously balanced and thought out compositions look so pompous dead and tight. Her method is the method of nature herself a joyous prolificness – content that out of the hundreds produced a few shall survive.[2]

Marian might have been surprised.

Notes

PREFACE

1 I refer to Pegi by her first name throughout the text. I do the same for her closest women friends and her husband. In most cases, this was how their friends and contemporaries knew them.

2 The literature is extensive, but a reader might begin with Heilbrun, *Writing a Woman's Life*. Barry, "Towards a Theory of Women's Biography," in Iles, ed., *All Sides of the Subject: Women and Biography* is also instructive.

3 Luckyj, *Expressions of Will* and *Helen McNicoll*.

4 Murray interview with Atkins, 9 Nov. 1982.

5 I have been unable to establish the name of the exhibition in which I saw this painting.

6 It appears as an illustration in McInnes, "Art of Canada," 58.

7 Brandon, "The Essential Humanism of Pegi Nichol [*sic*] MacLeod," 26-8.

8 *Pegi Nicol MacLeod Retrospective*, an exhibition organized by Gallery 78 in Fredericton in November 1981, travelled till October 1982 to Moncton, Saint John, Campbellton, St Andrews, and Sackville, New Brunswick; Summerside, Prince Edward Island; Wolfville, Nova Scotia; and Montreal.

9 Scott journals, 1 April 1949, LAC, Scott fonds.

INTRODUCTION

1 The exhibition was on view in Ottawa from 14 June to 23 August 1949. A version of it later toured Canada. It was seen in Hamilton (5–30 Sept. 1949) Charlottetown (1–15 Oct. 1949), Fredericton (15 Oct.–15 Nov. 1949), Saint John (15–18 Nov. 1949 and 1–15 Dec. 1949), Montreal at the Montreal Museum of Fine Arts (18 Feb.–5 March 1950), Toronto (21–30 April 1950), Saskatoon (9–23 Sept. 1950), Vancouver (7–31 Oct. 1950), Edmonton (1–26 Dec. 1950), Calgary (5–25 Jan. 1951), and Regina (7–28 Feb. 1951). The NGC published an exhibition catalogue in 1949 entitled *Memorial Exhibition, Pegi Nicol MacLeod 1904–1949*.

2 Mawr, "Pegi Nicol MacLeod."

3 Weiselberger, "Art of Pegi Nicol MacLeod."

4 Harper, "Pegi Nicol MacLeod," 40–50.

5 Hill, *Canadian Painting*, 95–7.

6 Farr and Luckyj, *From Women's Eyes*, 52–3.

7 Luckyj, *Visions and Victories*, 59–60.

8 This publication accompanied an exhibition of Pegi's work, made up largely of paintings that the Robert McLaughlin Gallery in Oshawa, Ontario, had recently acquired from the artist's estate and which travelled to nine venues, including five

in the Maritimes. Of particular note was an accompanying publication put together by Michael Pantazzi of the NGC, *Pegi Nicol MacLeod: Principal Exhibitions*, which listed the paintings that she showed in her lifetime.

9 Reid, *Canadian Painting*, 186.

10 Tippett, *By a Lady*.

11 Clark, "Understandings and Misunderstandings of Modern Art," 49.

12 The Massey Commission, created by Privy Council Order on 8 April 1949, recommended support for a number of public institutions, including the National Film Board, the National Gallery, the National Museum (now the Canadian Museum of Civilization, the Canadian Museum of Nature, and the National Museum of Science and Technology), the Public Archives (now Library and Archives Canada), and the Library of Parliament.

13 Massey, "Foreword," *Memorial Exhibition*, 3.

14 Scott, personal journal, 1 April 1949, LAC, Scott fonds.

15 On her self-portraits, see Brandon, "Exploring 'the Undertheme.'"

16 Scott, personal journal, 3 Jan. 1936, LAC, Scott fonds.

CHAPTER ONE

1 The original photograph was part of Ruth Comfort Jackson's research material in the 1970s, but the author saw it only as a slide reproduction in 1984 and made a print of it. Isa M. Austin, Pegi's former babysitter and family friend, had sent the original snapshot to Jackson. Isa Austin to Ruth Jackson, 28 Jan. 1976, author's collection. A letter from Jackson to the author dated 4 April 1984 in the author's collection states that she (Jackson) "simply cannot find it [the photo] anywhere."

2 Pegi's birth was announced in the Listowel *Banner* on 21 January 1904: "Nichol. In Listowel, on the 17th. Inst., the wife of W.W. Nichol B.A., of a daughter."

3 Eric and Maud Brown knew Pegi originally as Peggy, as Maud's hand-written recollections confirm. LAC, Brown fonds.

4 William Nichol and Myrtle Riggs married 5 August 1902. *Bee*, 15 Aug. 1902.

5 Hall, *Centennial at Listowel*.

6 The staff of the Stratford-Perth Archives kindly searched the 1881 Dominion Census for Stratford and the archives' birth, marriage, and death indexes for information on the Nichol family.

7 William's graduation date is in the Register of Graduates of the University of Toronto, University of Toronto Library. The information on his academic and athletic achievements comes from an unsourced obituary, "First Principal at Tech W.W. Nichol Passes On."

8 "First Principal at Tech" and "Pioneers of Fourth Estate Served Community," 3.

9 "First Principal at Tech."

10 Ibid.

11 "Portrait of W.W. Nichol, Former Principal, Is Unveiled." The school at 440 Albert Street is now the Continuing Education Department of the Ottawa-Carleton District School Board.

12 Burant, *A History of the Fine Arts in Ottawa*, 12–20.

13 The source of this photograph is unknown (possibly Ruth Comfort Jackson). The copy is in the author's collection.

14 Hall, *Centennial at Listowel*, 67.

15 "Portrait of W.W. Nichol."

16 School record for Margaret Kathleen Nichol, Lisgar Collegiate Institute Archive, Ottawa.

17 Pegi started at the Ottawa Collegiate Institute on 17 November 1919, according to her school record.

18 Forsey, "The Ottawa Collegiate Institute," 10.

19 School Record, Margaret Kathleen Nichol.

20 The Ottawa Collegiate Institute's student journal was *Vox Lycei*. Photographs of Pegi appear on p. 70 in the 1919–20 edition and on p. 19 in the 1920–21 edition.

21 School Record, Margaret Kathleen Nichol.

22 See, for example, Burant and Stacey, *North by South*.

23 These words appeared in "Psalm of Montreal," *Spectator*, 18 May 1878.

24 Information on the first year of the École des Beaux-Arts is on file at the Bibliothèque des Arts, Université du Québec à Montréal. See, for example: "School for Fine Arts Opens Soon"; "School of Fine Arts Is Opened"; "Open Exhibition at Arts School"; and "Brillante Fete Artistique A L'Ecole des Beaux-Arts [*sic*]." Advertisements for the school classes have been clipped from Montreal papers and mounted on separate sheets. Those for September 1924 are from *Le Bulletin*, *Le Canada*, *Le Devoir*, *La Patrie*, and the *Herald* and emphasize free tuition, coeducation, and the classes available. While men and women studied together, the sexes had separate studios. Instruction took place almost entirely in French, according to a later article on the success of the school, "Art Courses Are Offered."

25 Buchanan, *The Growth of Canadian Painting*, 70–1. Buchanan wrote one of the earliest Canadian art historical monographs, a volume on James Wilson Morrice (1936). See, for example, Lesser, "Biography and Bibliography," 129–37.

26 For more on Scott, see Esther Trépanier, "A Tribute to Marian Dale Scott" and *Marian Dale Scott: Pioneer of Modern Art* (English translation).

27 Author's interview with Scott, 28 Oct. 1985.

28 Ibid.

29 Ibid.

30 Atelier de modèle vivant, École des Beaux-Arts de Montréal, 1924; collection Bibliothèque des Arts, Université du Québec à Montréal.

31 According to the list of contributors in *Maritime Art* 1, which published Pegi's article on Miller Brittain, she received the Baron de Vitrolle plaque for "assiduity and progress." However, her information form at the NGC, dated 10 February 1927, lists two bronze and two silver medals. "Brillant Fete Artistique," cited above, lists her as winning the Baron de Vitrolle plaque for her decorating work, first prize (silver medal) for her drawing from the antique of the Laocoon, second prize in painting flowers in watercolour, and a second prize (bronze medal) in ornamental modelling for "un carreau de faience."

32 Buchanan, "Pegi Nicol MacLeod," 160.

33 Handwritten notes by Maud Brown regarding hers and Eric's relationship with Pegi. LAC, Brown fonds.

34 Nicol to Comfort, 16 Dec. 1932, LAC, Comfort fonds.

CHAPTER TWO

1 This subject is explored in many sources, but, in terms of Pegi's circle, most recently in Finlay, "The Force of Culture." Finlay's 1999 PhD dissertation was published in 2003 with the same title, but the citations in this book are from the dissertation.

2 The original members of the Group were Franklin Carmichael (1890–1945), Lawren Harris (1885–1970), A.Y. Jackson (1882–1974), Frank Johnston (1888–1949), Arthur Lismer (1885–1969), J.E.H. MacDonald (1873–1932), and Frederick Varley (1881–1969). On the origins and reception of their art, see Hill, *Art for a Nation*.

3 For Brown's attitude to art and nation, see Ord, *The National Gallery*, 55–99.

4 *Portrait in the Evening*, oil on plywood, 46 × 46.5 cm, NGC, 3510. Pegi expressed her high opinion of Brown in a letter to Charles Comfort in 1932. Nicol to Comfort, 16 Dec. 1932, LAC, Comfort fonds.

5 Brown, *Breaking Barriers*, 67.

6 Ord, *The National Gallery*, 86–96.

7 *Samara* (the Elmwood magazine) mentions "Miss Nicol" in two issues: May 1925 and June 1927. The next issue, in 1929, lists a "Miss Haanel" (also a local artist) as the art teacher, so Pegi taught at Elmwood probably from 1925 to 1927–28.

8 Echlin to author, 24 Oct. 1984.

9 Oberne to author, 3 Jan. 1985.

10 Ibid.

11 Ibid.

12 Ord, *The National Gallery*, 83–4.

13 Oberne to author, 3 Jan. 1985.

14 Ibid.

15 Hill, *Art for a Nation*, 223–24.

16 Finnie, "Memories of Pegi Nicol," enclosed in a letter to author, 12 March 1984. This appeared as Appendix 2 in Murray, *Daffodils in Winter*, 319–20. For an assessment of Finnie's career in the north, see Geller, "Northern Exposures."

17 E.W.H. [Harrold], "Drama League Players in Third Bill of Little Theater [*sic*] Season Again Score Distinct Success"; "Drama League Opens Season with Clever, Enjoyable Mystery Play"; and "Thrilling Melodrama, Cock Robin Ably Presented by Drama League;" all in LAC, Ottawa Little Theatre fonds.

18 Finnie, "Memories."

19 Ibid.

20 Oberne to author, 3 Feb. 1985.

21 Mary Graham recalls talking to Pegi over the years about the books that they both enjoyed reading; her recollections form the basis for this list. Pegi does refer to reading Wyndham Lewis's *Apes of God* in a letter to Marian Scott (Nicol to Scott, postmarked 17 Oct. 1935, LAC, Scott fonds).

22 Oberne to author, 3 Feb. 1985.

23 Finnie, "Memories."

24 Geller, "Northern Exposures," 216.

25 Sullivan, *Elizabeth Smart*, 6–17.

26 Oberne to author, 3 Jan. 1985. There is nothing documented that explains why Pegi changed her name, although it clearly happened in this period. In Montreal in 1924 she was still Margaret Nichol, but at Elmwood in 1925, as cited above, she was Miss Nicol. As we saw in chapter 1, the Browns knew her first as Peggy.

27 Author's interview with Scott, 28 Oct. 1985.

28 Murray's interview with Goldhamer, 27 Aug. 1980, LAC, Murray fonds.

29 Nicol to Comfort, 16 Dec. 1932, LAC, Comfort fonds.

CHAPTER THREE

1 Handwritten notes by Maud Brown regarding their relationship with Pegi, LAC, Brown fonds.

2 See, for example, Nowry, *Man of Mana*.

3 See, for example, Dyck, "'These Things Are Our Totems.'"

4 On arrangements requested for her 1927 trip, see Barbeau to J.M. Gibbon, CPR publicity department, 30 May 1927, CMC, Barbeau correspondence, folder Gibbon, J. Murray (1927). The request for passes for her 1928 trip are referred to in a letter to Edwin Holgate, 11 May 1928, CMC, folder Holgate, Edwin (1926–40).

5 As late as 1945 Pegi was writing to Mrs Garbutt about her war commissions; MacLeod to Garbutt, undated, collection Dr David R. Gill, Calgary.

6 *Alice Garbutt*, 1927; oil on canvas, 57.8 × 44.5 cm, collection Dr David Gill, Calgary. Illustrated on p. 129 in Brandon, "Exploring 'the Undertheme'".

7 Author's interview with Edith Garbutt, April 1992. See, for example, Gribbon, *Walter J. Phillips*.

8 It was Brown who pushed for inclusion of her work. In a letter to Brown, Barbeau noted, "As you say, we should have Pegi Nichol also represented by as many pictures as suit the general plan" — presumably the exhibition's layout. Barbeau to Brown, 3 Oct. 1927, NGC, 5.5-W.

9 Photocopied sheet of unsourced clippings enclosed in a letter from Fred Garbutt to the author, 5 Aug. 1991. A note says that the clipping refers to the National Gallery's exhibition of west coast art in December 1927. The originals were formerly in Mrs Garbutt's possession.

10 Carr, *Hundreds and Thousands*, 11–12.

11 Ibid., 9.

12 Carr to Brown, 1 Oct. 1928, NGC, 7.1-C. Pegi's trip appears as a form of cultural tourism in Crosby, "T'emlax'am: An Ada'ox," 93.

13 According to Scott, Pegi's mother destroyed much of the artist's early written work – perhaps including this book draft. Murray interview with Scott, 27 Aug. 1980, LAC, Murray fonds.

14 Oberne to author, 3 Feb. 1985.

15 She exhibited *Mrs. Charley Goodrider* (undated) in the National Gallery's Third

Annual Exhibition of Canadian Art in January 1929 and showed *Indian Boy at Hagwelget Canyon* (undated) and *Fort St. James Boy* (1928) at the Art Gallery of Toronto in March 1929. In the Montreal Art Association's Annual Spring Exhibition of 1929 she hung *Bianinetnan, Aged Indian Woman of Hagwelget Canyon* (c. 1928). This painting and *Indian Boy at Hagwelget Canyon* appeared in Detroit at the Women's International Exposition, 14–19 October 1929, along with *My Western Cousin* (undated). The author acknowledges with grateful thanks the work of Charles Hill, curator of Canadian historical painting at the National Gallery, who first compiled an exhibition history for Pegi's work.

16 *Indian Boy at Hagwelget Canyon*, undated; oil on wood panel, 66.3 × 59.1 cm, collection Edwin Procunier, London, Ontario. *Skeena Landscape*, undated; oil on panel, 53 × 56 cm, collection Darcy Dunton, Montreal.

17 Barbeau to Thompson, 4 Feb. 1929, CMC, Barbeau correspondence, folder Thompson, Walter S. (1925–49).

18 Nicol, "Where Forgotten Gods Sleep."

19 Nichol, "R.C.A. Impressions."

20 Purchased from the 1927 Annual Exhibition of Canadian Art at the NGC. NGC, 5.5-A.

21 Ronald McCall founded the Leonardo Society, a short-lived Montreal gallery that sold Medici prints from England and exhibited the work of young Canadian artists. A veteran of the First World War with a BSc from McGill University and a BA from Oxford, he left the family's firm of iron and steel merchants, Drummond McCall, to farm. Just prior to the Second World War he returned to McGill and trained as a doctor.

22 *Mrs. Charley Goodrider* and *Stoney Indians* were exhibited with work by the Group of Seven at the AGT in February 1928.

23 Jori Smith refers to this double self-portrait as *The Slough* in an interview of 22 March 1983 with Joan Murray. LAC, Murray fonds. Brandon, "Exploring 'the Undertheme,'" refers to it as *Cyclamens*. Since *The Slough* was exhibited, and *Cyclamens* was not at this time, this book uses the former title.

24 *Self Portrait*, c. 1928; oil on board, 41.5 × 35 cm, collection Storrs McCall, Montreal.

25 Scott to author, 8 Sept. 1990. The painting, since split in half, is in two private collections (Figs. 3.7 and 3.8).

26 Brandon, "Exploring 'the Undertheme,'" 32–4.

27 See, for example, *Narcissus*, c. 1931; oil on plywood, 40.7 × 38.3 cm., RMG, 1981MP29. Illustrated (Plate 8) in Murray, *Daffodils*.

28 Nicol to Scott, 9 March 1934, LAC, Scott fonds.

29 Ferguson, *Signs and Symbols*, 30.

30 E.W.H. [Harrold], "Drama League Players in Third Bill of Little Theater [sic] Season Again Score Distinct Success," LAC, Ottawa Little Theatre fonds.

31 Ibid.

32 Finnie, "Memories."

33 The scarf was formerly in the collection of Marian Scott. Its current location is unknown. A photograph of it is in the author's collection.

34 Author's interview with Scott, 28 Oct. 1985.

35 Finnie, "Memories."

36 Ungar has argued in "The Last Ulysseans" that skinny-dipping, with its emphasis

on the nude body, was symbolic of a particular kind of Canadian modernity. Most of Pegi's friends in Montreal and Ottawa had come from conformist backgrounds that saw the naked body as sinful, so that in their eyes the removal of clothing could seem progressive and hence modern. Men swam naked in many contexts: the army, YMCAs, and Hart House at the University of Toronto, founded by Pegi's friend Vincent Massey. There are photos of men and women skinny-dipping in the Comfort fonds at LAC.

37 Duncan, *My Life*, 17–18.
38 See, for example, Tippett, *Making Culture*, 56, 67.
39 *My Western Cousin*, undated; oil on canvas, 61 × 61 cm, collection Gerald and Isabelle Pittman, Calgary.
40 NGC, 7.4-W.
41 E.W.H. [Harrold], "Exhibit Paintings of Pegi Nichol."
42 Brown, *Breaking Barriers*, unpaginated illustration. The words "Pegi by Lismer" appear in the same hand (namely Maud's) as that on the self-portrait entitled *Pegi by herself*.
43 Oberne to author, 3 Jan. 1985.

CHAPTER FOUR

1 Hill, *Canadian Painting*, 13.
2 Nicol to Barbeau, 24 Feb. 1932, CMC, Barbeau correspondence, folder MacLeod, Pegi Nicol (1904–49).
3 At different times artists André Biéler, Marc-Aurèle de Foy Suzor-Coté, Maurice Cullen, Edwin Holgate, and Jean Palardy all had studios nearby at 3531 rue Ste Famille.
4 At the Sixth Annual Exhibition of Canadian Art at the National Gallery in 1932, she showed *Spears of Iris* (undated) and *Guide Camp* (undated); for the Ontario Society of Artists at the Art Gallery of Toronto in March 1932, Snow *Panel* (undated); at the Art Gallery of Vancouver's All Canadian Exhibition May–July 1932, *Spears of Iris* and *Winter Scene* (undated); and at the Royal Canadian Academy exhibition at the Art Gallery of Toronto, *Ice and Snow* (undated).
5 NGC, artist file, MacLeod, Pegi Nicol.
6 Nicol to Barbeau, 24 Feb. 1932, CMC, Barbeau correspondence, folder MacLeod, Pegi Nicol (1904–49).
7 "Pegi Nicol's Landscapes and Portraits."
8 Holgate's classes in wood engraving between 1927 and 1934 were "instrumental to the creation of a school of book illustration original to Quebec." Martin, *Printmaking in Quebec*, 26.
9 Brandon, "Exploring 'the Undertheme,'" 53.
10 A majority of Pegi's earliest published illustrations are associated with Marius Barbeau when he was associate editor of the *Canadian Nation*, a quarterly published by the Association of Canadian Clubs. Pegi contributed several to two issues: March–April 1929 and May–June 1929. I am indebted to Sandra Dyck for discovering these illustrations. Pegi also provided *Blind Joe's Wife* for an article by Barbeau entitled "The Tree of Dreams" published in the *Canadian Geographical Journal* in December 1933

(see Fig. 4.2). For a story retold by Barbeau in Montreal's *La Presse* (4 March 1933), "La déliverance des Loups-Garous," Pegi produced a number of illustrations. She also provided several for his book *L'arbre des rêves*. Others appeared in, for example, *Canadian Forum* of November 1935 and of December 1936.

11 Frances K. Smith to author, 5 May 1984. Smith interviewed the Biélers on behalf of the author, using prepared questions.

12 Ibid. and Jackson interview with Biélers, 12 Oct. 1975.

13 Ibid. and author's interview with Biéler, 11 July 1984.

14 Nicol to Gordon, 6 Oct. 1932, LAC, Gordon fonds.

15 Nicol to Gordon, undated [Nov. 1932], LAC, Gordon fonds.

16 Murray interview with Carver, LAC, Murray fonds.

17 Author's interview with Gordon, 3 April 1984.

18 Frances K. Smith to author, 5 May 1984.

19 Author's interview with Florence Bird, 11 July 1984. Also Smith interview with Bird, March 1976 (photocopy sent by Smith to author attached to letter dated 31 March 1984), and Murray interview with Bird, 6 Dec. 1982, LAC, Murray fonds.

20 *Untitled (The Scott's air-cooled Franklin)*, undated; watercolour on paper, 58.8 × 76.2 cm, collection Esther Trépanier, Montreal.

21 Author's interview with Gordon, 3 April 1984.

22 Jori Smith to author, 22 March 1984.

23 Parkin to author, 30 April 1984.

24 *Untitled (Self-Portrait)*, undated; oil on canvas, 57 × 46 cm, collection William Kaplan, Toronto.

CHAPTER FIVE

1 Nicol to Scott, undated [1932], LAC, Scott fonds.

2 This project receives mention nearly eight years later in a newspaper interview, "Murals Offer Opportunity to Record Canada at War."

3 Nicol to Frank and Marian Scott, undated [1932], LAC, Scott fonds.

4 Pepper to Dennis Reid, 4 Aug. 1979, AGO, Curatorial File, Pegi Nicol MacLeod.

5 Author's interview with Scott, 7 Jan. 2001.

6 Nicol to Scott, Jan. 1933, LAC, Scott fonds.

7 Jackson interview with Selfridge, 14 April 1975.

8 Schaefer to author, 13 Nov. 1983.

9 The Ottawa Public School Gardens were near Glebe Collegiate Institute, between First and Second Avenues. They were in operation between 1916 and 1953.

10 MacLeod to Fenwick, 2 Dec. 1944, NGC, Fenwick fonds.

11 By 1934, the gallery's annual purchasing funds had plummeted to $25,000, down from $130,000 in 1929.

12 Nicol to Comfort, 16 Dec. 1932, LAC, Comfort fonds.

13 Quoted in Jean Sutherland Boggs, "Preface," in Hill, *Canadian Painting*.

14 A useful survey of the arts in this period is Tippett, *Making Culture*. Tippett provides an account of the structures that both supported and instigated Canadian cultural life in the first half of the twentieth century.

15 Ferns, *Reading from Left to Right*, 53–4.
16 Smith, *André Biéler*, 80.
17 Finlay, "The Force of Culture," 155.
18 Brown, *Breaking Barriers*, 33.
19 Luckyj, *Visions and Victories*, 79.
20 See, for example, Aylen, "*Canadian Art* between the Years 1940–1955," and Valliant, "Robert Hugh Ayre."
21 Clark, "Understandings and Misunderstandings of Modern Art," Introduction.
22 See, for example, Greenhorn, "An Art Critic at the Ringside."
23 See, for example, Ellis, *John Grierson*.
24 Masson to author, 17 Aug. 1984.
25 Aylen to author, 12 Aug. 1984.
26 Freiman to author, 16 May 1984.
27 Author's interview with Freiman, 10 July 1984.
28 Until the early 1980s these paintings remained boxed with Jane MacLeod Pappidas in New York. As a result of Joan Murray's pioneering work on the artist, a market developed for MacLeod's work, and a great deal sold in Canada. This activity had largely ended by the late 1990s.
29 Nicol to Scott, 3 Jan. 1933.
30 Nicol to Scott, 9 March 1934.
31 Ibid.

CHAPTER SIX

1 Finlay, "The Force of Culture," 2.
2 The library at Durham House had belonged to their close friend Professor George M. Wrong, the British, Oxford-educated head of the History Department at the University of Toronto.
3 Hart House was Massey's creation, opened at the University of Toronto in 1919 and named after his Massey grandfather, whose estate funded it. To this day it offers athletic, cultural, recreational, social, and spiritual activities in a magnificent neo-Gothic structure built for $3 million around an Oxford-style quadrangle.
4 Finlay, "The Force of Culture," 1.
5 Nicol, "The Un-Drama Festival."
6 Five portraits of Hart Massey (Vincent's son) are in the collection of the Robert McLaughlin Gallery, the gift of his widow.
7 Nicol to Scott, Dec. 1934, LAC, Scott fonds.
8 *Canadian Paintings Collection, Hon. Vincent and Mrs. Massey*, Art Gallery of Toronto, December 1934. A complete listing of the Art Gallery of Toronto's exhibitions is in McKenzie and Pfaff, "The Art Gallery of Ontario." For an outline history of Toronto's art gallery, see Kimmel, "Toronto Gets a Gallery."
9 *Tapisserie des Vaches*, 1934; oil on pressed board, 60 × 71.4 cm, gift of Melodie Massey, RMG, 1997MP65.
10 Nicol to Scott, Dec. 1934, LAC, Scott fonds.
11 Machell to author, 9 July 1984.

12 Nicol to McCurry, Feb. 1935, NGC, 7.1-M.

13 Nicol to McCurry, undated [April 1935], NGC, 7.1-M.

14 Machell to the author, 9 July 1984.

15 Nicol to Scott, Dec. 1934, LAC, Scott fonds.

16 Nicol to Scott, Jan. 1935, LAC, Scott fonds.

17 This is the only set that Pegi is known to have completed, although she retained her interest in theatre all her life.

18 Author's interview with Carver, Feb. 1984.

19 Adams, "Bringing Carlu's Dream Back to Life."

20 Cera to author, 3 March 1984. Three photographs of Pegi's designs are in the Archives of Ontario (AO 2605,6410,6411).

21 Nicol to H.O. and Dorothy McCurry, undated [Nov. 1934], NGC, 7.1-M.

22 Author's interview with Atkins, 14 July 1991.

23 Murray interview with Graham, 8 March 1983, LAC, Murray fonds.

24 "Pegi Nicol has been decorating the restaurant on the fourth floor," *Canadian Forum* 15 (Aug. 1935): 323. The same column, "Causerie," reported that "F.R. and Mrs. Scott are spending the summer in Soviet Russia."

25 Nicol to Brown, undated, [1936], NGC, 7.1-M.

26 Nicol to McCurry, Feb. 1935, NGC, 7.1-M.

27 Author's interview with Atkins, 14 July 1991.

28 Nicol to Scott, postmarked 17 Oct. 1935, LAC, Scott fonds.

29 Murray interview with Graham, 8 March 1983, LAC, Murray fonds.

30 Jackson interview with Scott, 15 March 1976, LAC, Murray fonds.

31 Ibid.

32 Augustus John, *Marchesa Casati*, 1919; oil on canvas, 96.5 × 68.6 cm, AGO, 2164.

33 Boyanoski writes in her catalogue, *Staffage to Centre Stage* (7), "the juxtaposition of the floral arrangement with the artist's semi-clad body may have been intended as an expression of her own sexuality – the flowers, a symbol of fertility, being an extension of herself."

34 Some of these are now in Canadian public collections, but others are still with family members and friends. Ruth Comfort Jackson believed that Pegi simply forgot that she had left them there. This was not an uncommon practice of hers.

35 On 14 September 1936 police in Ottawa arrested Dorothea Palmer, a young social worker, for advising a mother of five on birth control. The University of Waterloo library has a collection of material relating to this event in the Dorothea Palmer Collection.

36 Ungar, "The Last Ulysseans."

37 Trépanier, *Marian Dale Scott.*

38 Paraskeva Clark, *Myself*, 1933; oil on canvas, 101.6 × 76.7 cm, NGC, 18311.

39 Heward's nude portrait – *Girl under a Tree*, 1931; oil on canvas, 122.5 × 192.7 cm, AGH, 61.72.4 – bears an extraordinary resemblance to Man Ray's photograph *Primacy of Matter over Thought*, 1929; gelatin silver print cut-out, 76 × 116 mm, Baltimore Museum of Art (BMA 1988.432), purchased with exchange funds from the Edward Joseph Gallagher III Memorial Collection, and partial gift of George H. Dalsheimer,

Baltimore. The links between all the arts were tangible.

40 Lilias Torrance Newton, *Nude in a Studio*, c. 1934–35; oil on canvas, 203.2 × 91.5 cm, Thomson Collection, Toronto, Ontario, on loan to the AGO. The author discusses the issues surrounding this painting extensively in "Exploring the 'Undertheme.'"

41 O'Keeffe objected to the association of her paintings of natural forms with the female body and the consequent success of her work "as the epitome of emancipated woman-hood." Nevertheless, significant critical writing supports this interpretation. See Chadwick, *Women, Art and Society*, 285–8.

42 MacLeod to Scott, Fall 1937, LAC, Scott fonds.

43 Ferguson, *Signs and Symbols in Christian Art*, 20.

44 Hall, *The Meaning of Dreams*, 55–6.

45 Ibid.

46 Hall, *Signs and Symbols in Christian Art*, 273.

47 For the effect of Surrealism on Canadian art, see Luckyj, *Other Realities: The Legacy of Surrealism in Canadian Art*.

48 Art Gallery of Toronto, *Exhibition of Paintings by John Alfsen, Caven Atkins, Thoreau MacDonald, Pegi Nicol, Robert Ross, Carl Schaefer*, no. 268, Dec. 1935.

49 McInnes, "Contemporary Canadian Artists," 202.

50 Brooker, *Yearbook of the Arts* (1936), plate 60. In his review, Frank Underhill noted that it was "worth some study by every thinking Canadian"; *Canadian Forum* 16, 28. In November 1995, Lora Senechal Carney gave an interesting paper, "Working Out the Destiny of Your Human Nature," at the Universities Art Association of Canada (UAAC) meeting in Guelph, on the relationship of this review, and responses to it, with politics.

51 Scott confirms this event in a letter to the author, 14 Nov. 1990.

52 Nicol to Scott, undated [1935], LAC, Scott fonds. A new treatment, "twilight sleep" was a combination of morphine and other drugs, particularly scopolamine, which dead-ened the pain of labour and encouraged forgetfulness. See Strong-Boag, *The New Day Recalled*, 155.

53 Nicol to Scott, postmarked 17 Oct. 1935, LAC, Scott fonds.

54 *Pavement People*, undated; oil on canvas, 76.2 × 66.6 cm, Glenbow Museum, 991.69.1.

CHAPTER SEVEN

1 Murray interview with Graham, 8 March 1983, LAC, Murray fonds.

2 McInnes, *Finding a Father*, 142–3.

3 McInnes, "Water Colors [sic]," 8.

4 Carver, *Compassionate Landscape*, 43.

5 Jackson interview with Carver, 10 Feb. 1976.

6 Author's interview with Carver, Feb. 1984.

7 Recollections of Mary Graham, a close friend of Alison (Grant) Ignatieff.

8 Letter from Jane Beveridge to the author, 15 Jan. 1984.

9 This information came from Mary Graham, a close friend of Smart's and present at the time.

10 Nicol to Scott, undated letter [1936], LAC, Scott fonds.
11 Feheley, "Douglas Duncan and the Picture Loan Society."
12 Nicol to Brown, undated [1935], NGC, 7.1-M.
13 She was art editor of *Canadian Forum* from December 1935 until May 1936. The July
 1935 issue mentioned her as being a contributing editor; the issue of February 1937
 gave the last such reference.
14 Graham Spry and fellow activist Alan Plaunt founded and led the Canadian Radio
 League to push for a national public broadcasting network. Their efforts culminated
 in the establishment of the Canadian Radio Broadcasting Commission in 1932, which
 evolved into the Canadian Broadcasting Corporation (CBC) four years later.
15 The loan exhibition of paintings celebrating the opening of the Margaret Eaton
 Gallery and the East Gallery on 8 November 1935 occasioned a forty-two-page illus-
 trated catalogue. McKenzie and Pfaff, "The Art Gallery of Ontario," 72.
16 In "The Force of Culture," Finlay explores what she terms "the British bias in
 Canadian art collecting after the War," confirming that it was a trend of significant
 longevity.
17 Nicol, "Loan Exhibition of Paintings," 390.
18 Nicol, "The Kingdom of the Saguenay," 30.
19 The Second Exhibition by the Canadian Group of Painters opened at the Art Gallery
 of Toronto on 3 January 1936. There was a twelve-page illustrated catalogue.
 McKenzie and Pfaff, "The Art Gallery of Ontario," 72.
20 Pegi Nicol, "The Passionate Snow of Yesteryear," 21. The general public was less
 enthusiastic, as noted in a letter from H.G. to the Toronto *Mail and Empire* of
 24 February 1936 entitled "Daubing by Immature Children." This letter initiated a
 spate of correspondence well into March.
21 MacLeod, Park, and Ryerson, *Bethune: The Montreal Years*, 118.
22 McInnes, *Finding a Father*, 143.
23 MacLeod, Harry Fulton (Hon) (1871–1921), PANB, Graves Papers.
24 In his letter to the author, 3 Oct. 1984, Block provides a wealth of details that point to
 an unusually interesting, exciting, and accomplished family.
25 Mersereau Family, PANB, Graves Papers.
26 Author's interview with Adams, Aug. 1984.
27 Block to author, 3 Oct. 1984.
28 Nicol to Scott, undated [1936], LAC, Scott fonds.
29 Nicol to Scott, [Spring] 1936, LAC, Scott fonds.
30 MacLeod to Scott, 17 Dec. 1936, LAC, Scott fonds.
31 MacLeod to Scott, Dec. 1936, LAC, Scott fonds.
32 Recollections of Mary Graham.
33 Photocopy of an original photograph by Charles Comfort (formerly in the collection
 of Ruth Comfort Jackson) in the author's collection.
34 Murray interview with Graham, 8 March 1983, LAC, Murray fonds.
35 MacLeod to Scott, Dec. 1936, LAC, Scott fonds.

CHAPTER EIGHT

1 See, for example, Thurber, *The Years with Ross.*
2 See, for example, Buchanan, *Le monde secret de Zadkine.*
3 Lansing to Isabel Herdle, 22 Oct. 1940, Rochester Memorial Art Gallery, Lansing file. See also, Chambers, *A Rochester Retrospective,* 16.
4 MacLeod to Scott, Jan. 1938, LAC, Scott fonds.
5 MacLeod to Scott, April 1938, LAC, Scott fonds.
6 MacLeod to Scott, May 1938, LAC, Scott fonds.
7 MacLeod to Brown, undated [1938], NGC, 7.1-M.
8 MacLeod to Brown, undated [Easter 1939], NGC, Brown fonds, Letters of sympathy.
9 McInnes, *Finding a Father,* 161.
10 In her e-mail of 26 Dec. 2003 to Michael Ostroff, copied to the author, conservator Sylvestre Carlyle describes the paint-making process that Pegi might have used and the potentially devastating implications for her health.
11 Jackson interview with the Biélers, 12 Oct. 1975, Jackson (now author's) collection. Also, Murray interview with Biéler, 11 Nov. 1982, LAC, Murray fonds.
12 MacLeod to McCurry, Nov. 1938, NGC, 7.1-M.
13 Pliofilm, developed in 1934 by the Goodyear Tire & Rubber Company, was a rubber-based, clear (and later dark green) plastic later used to protect equipment, especially weapons, from water and sand during the D-Day landings on 6 June 1944.
14 MacLeod to McCurry, received 22 June 1939, NGC, 5.4-N. Another painting from this period is *The Captive* (c. 1939). First displayed in 1942 at an exhibition of the Canadian Group of Painters at the Art Gallery of Toronto (6 February–1 March), it shows Jane in a playpen high up on a balcony overlooking the Belleville Street intersection where the MacLeods lived. This painting perhaps precedes *Children in Pliofilm* with its quasi-aerial view. It certainly lacks the liberty that pliofilm provided as a metaphor for the freedom that children enjoy – perhaps Pegi's intention in conceiving the composition. The playpen appears in miniature at the bottom of the piece. (This painting was last seen in the Pappidas collection in 1984. Its current location is unknown.)
15 McCurry to MacLeod, 28 Feb. 1946, NGC, 7.1-M.
16 MacLeod to Baldwin, received 24 June 1939, AGO, Pegi Nicol MacLeod file. *Jarvis Street Sidewalk,* c. 1935–6; watercolour, gouache, oil on paper, 59.1 × 77.7 cm, AGO, 2525.
17 Untitled Christmas card, 1944; watercolour on blueprint, 21.6 × 14 cm, collection Betty Garbutt, Toronto.

CHAPTER NINE

1 Harrison, *Dawn of a New Day.*
2 MacLeod to McCurry, probably Sept. 1939, NGC, 7.1-M.
3 Murray interview with Rosenthal, 1982, LAC, Murray fonds.
4 MacLeod to McCurry, 17 Oct. 1940, NGC, 7.1-M.
5 "Murals Offer Opportunity to Record Canada at War."

6 "Mural Designs for Federal Buildings from the Section of Fine Arts (Federal Works
 Agency Programme), Washington, D.C.," curated by Edward B. Rowan, was on
 display at the National Gallery of Canada, 19 April–6 May 1940.
7 Murray interview with Beals, 1985, LAC, Murray fonds. Mrs Clark has not been
 identified with certainty.
8 Johnston to author, 25 June 1984.
9 McCurry to MacLeod, 5 Nov. 1940, NGC, 5.11-F.
10 Jarvis, "Observatory Art Center [sic]."
11 Jarvis to author, 28 Feb. 1984.
12 Jarvis to Jackson, received 2 May 1975.
13 MacLeod to McCurry, [summer] 1940, NGC, 5.11-F.
14 For Abell's views on art and society, see Sicotte, "Walter Abell au Canada."
15 Aylen, "*Canadian Art* between the Years 1940–1955," 9.
16 Ibid., 20.
17 Author's interview with Cody, 24 Aug. 1984. New Brunswick artist Norman Cody
 was Ted Campbell's closest friend.
18 MacLeod to Smith, 19 Jan. 1948, PANB, Smith fonds. Pegi was not particularly
 penitent.
19 Inglis, *The Turning Point.*
20 Deichmann-Gregg notes, PANB, Deichmann fonds. Erica later married Milton Gregg,
 VC.
21 Ibid.
22 Author's interview with Bailey, 25 Aug. 1984.
23 Bauer, "Alfred Goldsworthy Bailey."
24 Deichmann-Gregg notes, PANB, Deichmann fonds.

CHAPTER TEN

1 MacLeod to Smith, 24 Jan. 1941, PANB, Smith fonds.
2 Pennington to author, 24 Nov. 1984.
3 Baerman to author, 2 Feb. 1984.
4 Ibid.
5 MacLeod to Smith, 10 March 1941, PANB, Smith fonds.
6 Nicol, "Miller Brittain."
7 Guggenheim Fellowships from the John Simon Guggenheim Memorial Foundation
 provide selected individuals with undisturbed time to work with as much creative free-
 dom as possible. There are very few conditions or restrictions on use of the money.
8 Abell quotes McInnes, *Maritime Art* 1 (Feb. 1941), 17.
9 Abell quotes Ayre, *Maritime Art* 1 (March/April 1941), 17.
10 Jewell is quoted in the review of the show in *Maritime Art* 1 (June 1941), 24.
11 Bell, "Introduction."
12 Rowan was assistant chief of the Fine Arts Section, Federal Works Agency, Public
 Buildings Administration – a department of President Roosevelt's Works Progress
 Administration (WPA).

13 Aylen, "*Canadian Art* between the Years 1940–1955," 12.

14 McCurry to MacLeod, 6 May 1941, NGC, 7.1-M.

15 The original photograph was enclosed in a letter to the author from Jarvis, 3 Feb. 1984.

16 She is referring to the Carleton County Vocational School in Woodstock, north of Fredericton. MacLeod to McCurry, 1 Aug. 1941, NGC, 5.11-F.

17 Author's interview with Adams, [Aug.] 1984.

18 In 1941, Miller Brittain was designing for the Saint John tuberculosis hospital a mural on the disease (its treatment and causes), later cancelled for lack of funds. His drawings are in the New Brunswick Museum. MacKay, *A National Soul*, 203–4.

19 Ibid., 199.

20 The original photograph was enclosed in a letter to the author from Jarvis, 3 Feb. 1984.

21 MacLeod, "Adventure in Murals."

22 Ruth Comfort Jackson alerted Moncrieff Williamson, director of the Confederation Centre Art Gallery and Museum in Charlottetown, PEI, to the mural's existence in 1976. Williamson was able to have sections restored that appeared in a 1976 exhibition at Calgary's Glenbow Museum, *Through Canadian Eyes (Trends and Influences in Canadian Art 1815–1965)*. Williamson to Jackson, 10 March 1976, Confederation Centre Art Gallery and Museum.

23 Recollections of Mary Graham.

24 MacLeod to Smith, 6 Nov. 1942, PANB, Smith fonds.

25 Author's interview with Gammon, 22 Aug. 1984. Gammon was editor of *Fiddlehead*, a literary magazine founded by Alfred Bailey and published in Fredericton by UNB.

26 Recollections of Mary Graham, who attended a course in 1948.

27 MacLeod to Smith, [spring] 1942, PANB, Smith fonds.

28 MacLeod to Fenwick, 2 Dec. 1944, NGC, Fenwick fonds.

29 For an account of the CAS, see Varley, *The Contemporary Arts Society*.

30 Ogilvie to author, 16 Feb. 1984.

31 MacLeod to Smith, 10 March 1941, PANB, Smith fonds.

32 Author's interview with Sleep, undated [Aug.] 1984.

33 Wright to Jackson, 22 Jan. 1975, Jackson fonds.

34 Author's interview with Mary Graham, 10 May 2003.

35 Observatory Art Centre course pamphlet for 1942, PANB, Deichmann fonds, MC 498/1-4.

36 Fisher, "For says Pegi Nicol MacLeod."

37 MacLeod to Fenwick, [July] 1944, NGC, Fenwick fonds.

38 MacLeod to Smith, 2 May 1946, PANB, Smith fonds.

39 Saunders to author, 4 Oct. 1984.

40 Garmaise to Buchanan, [1949], NGC, 5.5-M.

41 MacLeod to Smith, 14 Nov. 1945, PANB, Smith fonds.

42 MacLeod to Ingall, 4 Aug. 1946, NGC, 5.11-F.

43 MacLeod to Scott, postmarked 28 Oct. 1946, LAC, Scott fonds.

44 MacLeod to Scott, postmarked 29 Sept. 1948, LAC, Scott fonds.

CHAPTER ELEVEN

1 MacLeod, "Recording the Women's Services."
2 MacLeod to McCurry, received 22 Oct. 1940, NGC, 7.1-M.
3 McCurry to MacLeod, 23 Oct. 1940, NGC, 7.1-M.
4 Zemans describes the program in "Envisioning Nation."
5 McCurry to Holgate, 23 Nov. 1940, NGC, 5.41-P.
6 MacLeod to McCurry, received 29 Jan. 1941, NGC, 7.1-M.
7 McCurry to MacLeod, 23 Oct. 1940, NGC, 7.1-M.
8 MacLeod to Smith, 13 April 1945, PANB, Smith fonds.
9 MacLeod to McCurry, 1 and 24 Aug. 1941, NGCA 7.1-M. See also MacLeod to Scott,
 postmarked 13 Nov. 1943, LAC, Scott fonds.
10 MacLeod to McCurry, 2 Feb. 1942, NGC 7.1-M. Roosevelt delivered his celebrated
 'Four Freedoms' speech to Congress on 6 January 1941.
11 MacLeod to McCurry, 17 Feb. 1942, NGC 7.1-M.
12 Two watercolour sketches in the collection of the National Gallery of Canada – *Pair
 of Hands Knitting with Green Wool*, c. 1942; graphite and red chalk with watercolour
 on wove paper, 27.7 × 38 cm, NGC, 16800; and *Pair of Hands Knitting with Red Wool*,
 c. 1942; graphite and red chalk with watercolour on wove paper, 27.8 × 38 cm, NGC,
 16797 – are clearly preliminary studies from life for the rejected poster design. This oil
 on board, 61 × 76 cm, is in the collection of Alison Gordon, Toronto.
13 MacLeod to Fenwick, undated [1942], NGC, Fenwick fonds.
14 MacLeod to Smith, undated [1942], PANB, Smith fonds.
15 "The Modern Museum has announced a competition – 'Art in Therapy' – asking
 [for] suggestions for crafts for soldiers in hospitals. I would like to send the design
 of the little horse and rug to match." MacLeod to Smith, 27 Oct. 1942, PANB, Smith
 fonds, wherein also appear details of her win, in another letter to Smith, 13 Feb. 1943,
 and see further correspondence to Smith, 6 Nov. 1942–Feb. 1943.
16 MacLeod to Smith, 21 Aug. 1942, PANB, Smith fonds; also 27 Oct. 1942.
17 MacLeod to Smith, undated, PANB, Smith fonds.
18 MacLeod to Smith, 24 Nov. 1942, PANB, Smith fonds.
19 MacLeod to Smith, 25 March 1943, PANB, Smith fonds; painting unknown.
20 Zemans, "Envisioning Nation."
21 MacLeod to McCurry, received 16 April 1943, NGC, 1.8-S.
22 McCurry to MacLeod, 30 April 1943, NGC, 1.8-S; painting unlocated.
23 MacLeod to Smith, 25 March 1943, PANB, Smith fonds.
24 MacLeod to McCurry, received 23 July 1945, NGC, 7.1-M.
25 MacLeod to McCurry, received 1 Sept. 1943, NGC, 7.1-M. The naval ratings continued
 to be a presence on the campus, as the artist also mentioned in letters to Fenwick
 in 1944. "I eat at a table watching 75 naval ratings eating." NGC, 7.1-M. Also, "I sit by
 75 naval ratings while eating. Long baronnial [*sic*] tables of them." MacLeod to Scott,
 21 July 1944, LAC, Scott fonds. See also MacLeod to Scott, postmarked 29 Sept. 1943,
 LAC, Scott fonds, and MacLeod to McCurry, received 14 July 1944, NGC, 7.1-M.
26 MacLeod to Scott, postmarked 29 Sept. 1943, LAC, Scott fonds.

27 MacLeod to Scott, postmarked 25 Oct. 1943, LAC, Scott fonds. The portraits of Jane were included in an exhibition in the Print Room at the Art Gallery of Toronto in January 1941 that featured four women artists: Lockerby, MacLeod, Morris, and Scott.

28 MacLeod to Scott, postmarked 13 Nov. 1943, LAC, Scott fonds.

29 MacLeod to Scott, postmarked 16 Feb. 1944, LAC, Scott fonds.

30 MacLeod to the Art Gallery of Toronto, received 15 June 1944, AGO, Curatorial File.

CHAPTER TWELVE

1 See, for example, Valverde, "The Canadian War Artists' Programme."

2 MacLeod to Scott, 20 Jan. 1944, LAC, Scott fonds.

3 MacLeod to McCurry, received 14 July 1944, NGC, 7.1-M. There are further references to her Fredericton work with CWACs in a letter to Fenwick, July 1944, NGC, 7.1-M; and one to Scott, 21 July 1944, LAC, Scott fonds.

4 McCurry to MacLeod, 17 July 1944, NGC, 7.1-M.

5 MacLeod to McCurry, received 25 July 1944, NGC, 7.1-M. She also commented on this CWAC in a letter to Fenwick, undated, NGC, 7.1–M: "One of my C.W.A.C.'s is more than beautiful!!"

6 McCurry to MacLeod, 26 July 1944, NGC, 7.1-M. See also MacLeod to Scott, postmarked 28 Aug. 1944, LAC, Scott fonds; and to Smith, Sept. 1944, PANB, Smith fonds.

7 MacLeod to Smith, 5 Sept. 1944, PANB, Smith fonds.

8 MacLeod to Scott, postmarked 21 Sept. 1944, LAC, Scott fonds, where see also 28 Aug. 1944; MacLeod to Smith, Sept. 1944, PANB, Smith fonds. MacLeod received $2 an hour.

9 Two statements of payment by cheque, dated 19 Oct. and 19 Nov. 1944, NGC, 5.42-M.

10 Ibid.

11 MacLeod to Scott, 27 Oct. 1944, LAC, Scott fonds.

12 NGC, 5.42-M. A subsequent sheet in the same file indicates a discrepancy in some of the titles and notes that she handed over one more work than she listed.

13 MacLeod to McCurry, received 27 Nov. 1944, NGC, 7.1-M.

14 MacLeod, "Recording the Women's Services."

15 MacLeod to Fenwick, undated, NGC, Fenwick fonds.

16 MacLeod to Scott, postmarked 21 Sept. 1944, LAC, Scott fonds.

17 MacLeod to McCurry, 10 Jan. 1945, NGC, 7.1-M.

18 Fenwick to MacLeod, 15 Jan. 1945, NGC, 7.1-M.

19 MacLeod to Fenwick, undated, NGC, 5.11-F; and to McCurry, 7 Jan. 1945, NGC, 7.1-M.

20 McCurry to MacLeod, 11 July 1945, NGC, 7.1-M.

21 MacLeod to McCurry, received 23 July 1945, NGC, 5.42-M.

22 MacLeod to Smith, undated [Sept. 1945], PANB, Smith fonds.

23 MacLeod to Smith, 4 Sept. 1945, PANB, Smith fonds.

24 MacLeod to Scott, postmarked 16 Sept. 1945, LAC, Scott fonds.

25 A shipping receipt indicates that she picked up two stretched canvases and one masonite panel on 1 October 1945, NGC, 5.42-M.

26 Ibid.

27 MacLeod to McCurry, 6 Nov. 1947, NGC, 7.1-M.
28 Maud Brown, undated handwritten manuscript, LAC, Brown fonds.

CHAPTER THIRTEEN

1 MacLeod to Scott, 20 Jan. 1944, LAC, Scott fonds. At the time of my writing, the
 sketchbook was at the Art Gallery of Ontario (AGO).
2 Murray interview with Oberne, 6 June 1983, LAC, Murray fonds.
3 Murray interview with Pappidas, 22 Jan. 1981, LAC, Murray fonds.
4 Ibid.
5 *Church of St. Mary the Virgin*, 1940; watercolour on paper, 99 × 66.4 cm, Beaverbrook
 Art Gallery, 1959.139.
6 *U.N. General Assembly*, 1946; 50.8 × 86.4 cm, private collection, Ottawa.
7 MacLeod to Fenwick, 2 Dec. 1944, NGC, Fenwick fonds.
8 MacLeod to Humphrey, 23 Aug. 1941, NGC, Humphrey fonds.
9 MacLeod to Smith, 10 Nov. 1941, PANB, Smith fonds.
10 MacLeod to Smith, undated [fall] 1941, PANB, Smith fonds.
11 MacLeod typescript for travelling exhibition *Manhattan Cycle*, NGC, 7.1-M.
12 MacLeod to Smith, Dec. 1941, PANB, Smith fonds.
13 MacLeod to Smith, 24 Jan. 1942, PANB, Smith fonds.
14 MacLeod to McCurry, 2 Feb. 1942, NGC, 7.1-M.
15 MacLeod to Barbeau, Dec. 1941, CMC, Barbeau correspondence, folder MacLeod,
 Pegi Nicol (1904–49).
16 This may have been its director, Bartlett H. Hayes, who had helped plan a 1942
 exhibition of the CAS artists. See Varley, *The Contemporary Arts Society*, 24.
17 MacLeod to Smith, undated [1942], PANB, Smith fonds. The reference may well be
 to the Addison Gallery of American Art at the Phillips Academy, which hosted an
 exhibit *Aspects of Contemporary Painting in Canada* in 1942 that included a work by
 Marian Scott.
18 MacLeod to Smith, 19 Oct. 1942, PANB, Smith fonds. The 'Met' is the Metropolitan
 Museum of Art.
19 Aylen, "*Canadian Art* between the Years 1940–1955," 10.
20 Nicol, "Representation and Form."
21 Aylen, "*Canadian Art* between the Years 1940–1955," 15. The reference is to a review of
 Robert Elie's *Borduas* by Abell in *Canadian Art* 1 (April–May 1944). See also Scalzo,
 "Walter Abell."
22 MacLeod to McCurry, received 27 Nov. 1944, NGC 7.1-M.
23 MacLeod to Scott, postmarked 25 Oct. 1943, LAC, Scott fonds.
24 Ord, *The National Gallery*, 93.
25 MacLeod to Scott, postmarked 18 Jan. 1943, LAC, Scott fonds.
26 MacLeod to Jack and Jean Humphrey, [Nov.–Dec. 1947], NGC, Humphrey fonds.
27 MacLeod to Smith, 1943, PANB, Smith fonds.
28 *Letitia Echlin and Her Baby*, undated; oil on canvas, 78 × 69 cm, at time of writing
 at AGO.
29 MacLeod to Smith, undated [April or May 1944], PANB, Smith fonds.

30 MacLeod to Smith, 24 Jan. 1942, PANB, Smith fonds.

31 MacLeod to Smith, 21 Aug. 1942, PANB, Smith fonds.

32 Gordon to author, 5 June 1985.

33 MacLeod to Smith, 14 Nov. 1945, PANB, Smith fonds.

34 MacLeod to Smith, [fall] 1945, PANB, Smith fonds.

35 MacLeod to McCurry, 27 Nov. 1944, NGC, 7.1-M.

36 MacLeod to Smith, winter/spring 1945, PANB, Smith fonds.

37 MacLeod to Smith, 13 April 1945, PANB, Smith fonds.

38 MacLeod to Smith, 4 April 1944, PANB, Smith fonds.

39 MacLeod to Scott, postmarked 16 Sept. 1945, LAC, Scott fonds.

40 MacLeod to Smith, 2 May 1946, PANB, Smith fonds.

41 Maud Brown, handwritten notes, LAC, Brown fonds.

42 Ibid.

43 Aylen, "*Canadian Art* between the Years 1940–1955."

44 MacLeod to McCurry, 28 Jan. 1946, W.S.A. Daley to McCurry, 18 Feb. 1946, McCurry to MacLeod, 22 Feb. 1946, MacLeod to McCurry, 26 Feb. 1946, and Daley to McCurry, 1 April 1946, all in NGC, 7.1-M.

45 H.I. Drummond (Secretary-Treasurer, Canadian Handicrafts Guild) to Smith, 20 Oct. 1942, UNB, Smith fonds, no. 10, refers to note in *Maritime Art* about MacLeod's hooked rugs.

46 MacLeod to Gordon, undated [1938], LAC, Gordon fonds. The author examined Gordon's correspondence when it was in his custody. This letter is not clearly located in the fonds. A copy is in the author's possession.

47 MacLeod to McCurry, undated [1938], NGC, 7.1-M.

48 Pacey to MacLeod, 3 Dec. 1947, collection of Mary Pacey, Fredericton.

49 "Pegi MacLeod Drawings Are Exhibited."

50 MacLeod to Scott, postmarked 28 Aug. 1944, LAC, Scott fonds.

51 MacLeod to Smith, winter/spring 1945, PANB, Smith fonds.

52 MacLeod to Smith, 10 Sept. 1947, PANB, Smith fonds.

53 MacLeod to Scott, postmarked 15 Sept. 1947, LAC, Scott fonds.

54 MacLeod to Scott, postmarked 25 Oct. 1943, LAC, Scott fonds.

55 Kruschen to author, 18 Jan. 1991.

56 Beals described her work in an interview with Murray, LAC, Murray fonds.

57 Pegi's *School in a Garden* and *Children in Pliofilm* appeared in this 1942–43 joint travelling exhibition. NGC 5.5-C.

58 MacLeod to Smith, Oct. [1943], PANB, Smith fonds.

59 Beals to Smith, 3 June 1944, PANB, Smith fonds.

60 Goldhamer to author, 23 Sept. 1984.

61 *Jane Reading*, c. 1948; oil on canvas, 67.3 × 60.96 cm, Hart House, University of Toronto.

62 Elizabeth Wyn Wood spoke on Canadian handicrafts at the same event.

63 MacLeod to Fenwick, [March 1945], NGC, Fenwick fonds.

64 MacLeod to McCurry, 26 Jan. and 2 Feb. 1948, NGC, 7.1-M, and MacLeod to Smith, 21 Jan. 1948, PANB, Smith fonds.

65 MacLeod to McCurry, 10 Jan. 1945, NGC, 7.1-M.

66 *Michael Ignatieff as a Baby*, 1947; watercolour on paper, 11.1 × 9 cm, author's collection.

67 Pegi Nicol MacLeod, Guggenheim Fellowship Applications, 1942 and 1943. Photocopies in author's collection.

CHAPTER FOURTEEN

1 MacLeod to Scott, postmarked 16 Feb. 1944, LAC, Scott fonds.

2 MacLeod to Smith, 14 Nov. 1945, PANB, Smith fonds.

3 MacLeod to McCurry, 20 Nov. 1945, NGC, 7.1-M.

4 MacLeod to Smith, 25 Sept. 1946, PANB, Smith fonds.

5 MacLeod to Scott, postmarked 28 Oct. 1946, LAC, Scott fonds. See also MacLeod to Millman, 14 Oct. 1946, NGC, Dominion Gallery fonds. In the end, Mrs Millman and her associate Dr Max Stern did not take the exhibition. Stern to MacLeod, 13 May 1947, NGC, Dominion Gallery fonds.

6 Ibid.

7 McCurry to MacLeod, 10 Dec. 1946, NGC, 7.1-M.

8 MacLeod to Smith, [spring] 1947, PANB, Smith fonds.

9 John Sloan, *Pigeons*, 1910; oil on canvas, 66.36 × 81.28 cm, Museum of Fine Arts, Boston: Hayden Collection — Charles Henry Hayden Fund, 35.52.

10 Reginald Marsh, *A Day at Coney Island Beach*, 1946; egg tempera on gessoed paper board, 76.52 × 55.88 cm, Beaverbrook Art Gallery, 1963.30; Pegi Nicol MacLeod, *Coney Island*, c. 1945; oil on canvas, 101.5 × 66.8 cm, Mendel Art Gallery, 1986.6.

11 MacLeod to Smith, 14 March 1947, PANB, Smith fonds.

12 Leo Heaps (born 1923) opened The Gallery at 83 Albert Street in Ottawa in 1946. It existed until 1948. Murray, *Daffodils in Winter*, 262 note.

13 American Order Form, T. Eaton Co. Limited # 28909, 16 April 1947, NGC, 7.1-M.

14 "Manhattan Cycle" (adv.).

15 MacLeod typescript for travelling exhibition *Manhattan Cycle*, NGC, 7.1-M.

16 Bridle, "Pegi Nicol's Scenes Collectively Weird."

17 "Manhattan Cycle Scenes Fascinate after Study."

18 McCarthy, "Honor [*sic*] for Mestrovic Pleases Friends Here."

19 Cera to MacLeod, 14 April 1947, NGC, 7.1-M.

20 Ibid.

21 MacLeod to Jack and Jean Humphrey, [Nov.–Dec.] 1947, NGC, Humphrey fonds.

22 "Noted Artist Had Picture Showing."

23 MacLeod to McCurry, Jan. 1948, NGC, 7.1-M.

24 Hicklin, "Pegi Nicol MacLeod – Painter."

25 McCurry to MacLeod, 24 Feb. 1948, NGC, 7.1-M.

26 MacLeod to Fenwick, undated, NGC, Fenwick fonds.

27 MacLeod to McCurry, received 23 March 1948, NGC, 7.1-M. "Pegi says that Plaskett can have her show the last two weeks of May." MacLeod to McCurry, 7 April 1948, NGC, 7.1-M.

28 McCurry to MacLeod, 24 March 1948, NGC, 7.1-M.

29 R.W. Hedley to R.H. Hubbard, 10 June 1948, NGC, 7.1-M.

30 "Expressionistic Works Feature Art Display."
31 "The Art Centre."
32 MacLeod to Fenwick, [1948], NGC, Fenwick fonds.
33 MacLeod to Fenwick, 15 June 1948, NGC 7.1-M.
34 MacLeod to Stern, 15 Nov. 1948, NGC, Dominion Gallery fonds.
35 Stern to MacLeod, 18 Nov. 1948, NGC, Dominion Gallery fonds. Mrs Millman
 acquired a significant number of Pegi's paintings. Stern evaluated her collection in
 1961 after her death. He listed nearly three hundred works of art by almost as many
 artists and a further sixty-seven by Pegi. Many are still with the Millman family.
 Stern to David Litner, 6 March 1961, NGC, Dominion Gallery fonds.
36 MacLeod to Stern, 22 Nov. 1948, NGC, Dominion Gallery fonds.
37 MacLeod to Fenwick, 15 June 1948, NGC 7.1-M.

CHAPTER FIFTEEN

1 MacLeod to Smith, 4 June 1948, PANB, Smith fonds.
2 MacLeod to Smith, 18 June 1948, PANB, Smith fonds.
3 MacLeod to Smith, 21 Aug. 1948, PANB, Smith fonds.
4 MacLeod to Scott, postmarked 29 Sept. 1948, LAC, Scott fonds.
5 MacLeod to Smith, 21 Aug. 1948, PANB, Smith fonds.
6 Ibid.
7 MacLeod to Deichmann, fall 1948, PANB, Deichmann fonds.
8 MacLeod to Smith, 28 Sept. 1948, PANB, Smith fonds.
9 MacLeod to Smith, 17 Sept. 1948, PANB, Smith fonds.
10 MacLeod to Scott, postmarked 29 Sept. 1948, LAC, Scott fonds.
11 Ibid.
12 Murray interview with Rosenthal, 12 Sept. 1982, LAC, Murray fonds.
13 Albert J. Musgrove (WAG) to McCurry, 29 June 1948, NGC, 7.1-M; also MacLeod to
 Smith, 10 Oct. 1948, PANB, Smith fonds; MacLeod to Smith, 8 Nov. 1948, PANB,
 Smith fonds, confirms sale of four works.
14 MacLeod to Smith, 10 Oct. 1948, PANB, Smith fonds.
15 MacLeod to Smith, 8 Nov. 1948, PANB, Smith fonds.
16 MacLeod to Greey, 2 Dec. 1948, author's collection.
17 MacLeod to Smith, 29 Dec. 1948, PANB, Smith fonds.
18 MacLeod to McCurry, 2 Dec. 1948, NGC, 7.1-M.
19 MacLeod to Greey, 2 Dec. 1948, author's collection.
20 Pennington to Dr and Mrs F.B. Miles (her parents), 3 Dec. 1948 (excerpt enclosed in
 letter from Pennington to author, 24 Nov. 1984).
21 Ibid.
22 MacLeod to Smith, 21 Dec. 1948, PANB, Smith fonds.
23 Norman MacLeod to Greey, 9 Jan. 1949, author's collection.
24 Ibid.
25 Ibid.
26 Ina MacLeod to Smith, 27 Jan. 1949, UNB, Smith fonds, no. 29.
27 Ina MacLeod to Jarvis, 13 Feb. 1949, UNB, Smith fonds, no. 32.

28 Cera to author, 3 March 1984.
29 Author's interview with George Ignatieff, 12 Nov. 1981.
30 Ina MacLeod to Deichmann, 1 March 1949, PANB, Smith fonds.
31 Pennington to author, 24 Nov. 1984.
32 Ina MacLeod to Jarvis, 13 Feb. 1949, UNB, Smith fonds, no. 32.
33 Baerman to author, 2 Feb. 1984.
34 Bishop to author, Dec. 1984. Edith Bishop had worked at the New Brunswick
 Museum before relocating with her husband to New York, where she was for a while
 curator of paintings at the Newark Museum. In Pegi's time, this innovative facility
 aimed to provide a museum service that operated like a library. Her husband, Jack,
 had been a Fredericton-based artist.
35 Norman MacLeod to Smith, 12 Feb. 1949, UNB, Smith fonds, no. 31.
36 Author's interview with Alison Ignatieff, 12 Nov. 1981.
37 Baerman to author, 2 Feb. 1984.
38 McInnes, "Artist of the Wayward Brush."
39 Frank R. Scott, "For Pegi Nicol," 1949; reprinted in Murray, *Daffodils*, 8.
40 "Pegi Nicol MacLeod Memorial Exhibition" (typescript), 1949, NGC, 5.5-M.

EPILOGUE

1 *Paragraphs in Paint*, 1999. The exhibition travelled to Charlottetown (1 November
 1998–3 January 1999), Fredericton (9 January–31 March 1999), Ottawa (13 May–
 4 July 1999), and London (16 January–27 February 2000).
2 Scott journal, Sept. 1938, LAC, Scott fonds.

Bibliography

PRIMARY SOURCES

ART GALLERY OF ONTARIO (AGO)

Curatorial Files, Pegi Nicol MacLeod.

LAURA BRANDON CORRESPONDENCE AND RESEARCH MATERIAL

Correspondence with author
Peter Aylen, 12 Aug. 1984.
Margaret Baerman, 2 Feb. 1984.
Jane Beveridge, 15 Jan. 1984.
Edith Bishop, Dec. 1984.
Horace Block, 3 Oct. 1984.
René Cera, 3 March 1984.
Letitia Echlin, 24 Oct. 1984.
Richard Finnie, 12 March 1984.
Lawrence Freiman, 16 May 1984.
Fred Garbutt, 5 Aug. 1991.
Charles Goldhamer, 23 Sept. 1984.
King Gordon, 5 June 1985.
Lois Gordon, 3 March 1984.
Mary Graham, various, 1981–2003.
Ruth Jackson, 4 April 1984.
Lucy Jarvis, 28 Feb. 1984.
Margot (McCurry) Johnston, 25 June 1984.
Franziska Kruschen, 18 Jan. 1991.
Margaret Machell, 9 July 1984.
Henri Masson, 17 Aug. 1984.
Marjorie Oberne, 3 Jan., 3 Feb. 1985.
Will Ogilvie, 16 Feb. 1984.
Louise Parkin, 30 April 1984.
Marion Pennington, 24 Nov. 1984.
John Saunders, 4 Oct. 1984.
Carl Schaefer, 13 Nov. 1983.
Frances K. Smith, 31 March, 5 May 1984.
Jori Smith, 22 March 1984.

Interviews with author
Mrs Nelson Adams, Aug. 1984.
Caven Atkins, 14 July 1991.
Alfred Bailey, 25 Aug. 1984.
Jacques Biéler, 11 July 1984.
Florence Bird, 5 May, 11 July 1984.
Humphrey Carver, Feb. 1984.
Norman Cody, 24 Aug. 1984.
Lawrence Freiman, 10 July 1984.
Donald Gammon, 22 Aug. 1984.
Edith Garbutt, April 1992.
Lois Gordon, 3 April 1984.
William H. Graham, 4 Oct. 1993
Marian Scott, 28 Oct. 1985, 8 Sept. 1990.
Peter Dale Scott, 7 Jan. 2001.
Dorothy Sleep, [Aug.] 1984.

Miscellaneous correspondence
Mary Greey. Correspondence with Pegi Nicol MacLeod and Norman MacLeod.
Ruth Comfort Jackson. Correspondence and research material, various.

CANADIAN MUSEUM OF CIVILIZATION

Canadian Centre for Folk Culture Studies
 Marius Barbeau Correspondence.

DAVID GILL, CALGARY

Pegi Nicol MacLeod correspondence with Mrs F.G. Garbutt.

JOHN SIMON GUGGENHEIM MEMORIAL FOUNDATION, NEW YORK

Correspondence on Pegi Nicol MacLeod applications in 1942 and 1943.

LIBRARY AND ARCHIVES CANADA (LAC)

Eric and Florence Maud Brown fonds, MG 30, D 253, vol. 2.
Charles Fraser Comfort fonds, MG 30, D 81.
John King Gordon fonds, MG 30 C 241, vol. 10, file 2, 1932.
Joan Murray fonds, MG 31, D 142.
 Series 1, vol. 2, file 6, Atkins, Caven (1979–82).
 Series 1, vol. 2, file 14, Beals, Helen (1985).
 Series 1, vol. 2, file 18, Biéler, André (1982).
 Series 1, vol. 2, file 21, Bird, Florence (1982).
 Series 1, vol. 2, file 41, Carver, Humphrey (1982–3).

Series 1, vol. 3, file 18, Goldhamer, Charles (1977–83).

Series 1, vol. 3, file 24, Graham, William M. [*sic*] (1983).

Series 1, vol. 4, file 25, MacLeod, Jane Nicol (1981–83).

Series 1, vol. 5, file 15, Rosenthal, Lee (1982).

Series 1, vol. 5, file 20, Scott, Marian (1980).

Series 1, vol. 5, file 31, Smith, Jori (1983).

Series 1, vol. 5, file 53, Oberne, Marjorie (1983).

Ottawa Little Theatre fonds, MG 28, I 30, vol. 7.

Marian Scott fonds, MG 30, D 399, vol. 8.

LISGAR COLLEGIATE INSTITUTE, OTTAWA

School Record, Margaret Kathleen Nichol.

NATIONAL GALLERY OF CANADA ARCHIVES (NGCA)

1.8-S, Sampson Matthews Ltd. File 2 (Reproductions of Paintings).

5.4-N, New York World's Fair.

5.41-P, Posters Scheme, file 1 (Canadian War Art).

5.42-M, MacLeod, Pegi Nicol (Canadian War Art).

5.5-A, Annual Ex. 1927, file 2.

5.5-C, Curatorial Files. Paraskeva Clark.

5.5-M, MacLeod, Pegi Nicol, Memorial Exhibition.

5.5-W, West Coast Art – Native and Modern (Exhibitions in Gallery).

5.11-F, Fredericton file 1 (Loans etc. to the Maritimes).

7.1-C, Carr, Emily (Misc. Correspondence).

7.1-M, MacLeod, Pegi Nicol (Correspondence).

7.4-W, Competitions, Canadian – Willingdon.

Artist file, Pegi Nicol MacLeod.

Eric and Maud Brown fonds. Letters of sympathy, death of Eric Brown 1939, file 8, box 1.

Dominion Gallery fonds, Correspondence Series 1948–1967, file MacK–MacV (box 243).

Kathleen Fenwick fonds. (Correspondence from Pegi Nicol MacLeod.)

Jack Humphrey fonds. (Correspondence from Pegi Nicol MacLeod.)

PROVINCIAL ARCHIVES OF NEW BRUNSWICK (PANB)

Deichmann fonds, MC 498 MS4/1-4.

Graves Papers.

Madge Smith fonds, MC 168.

Norah Toole fonds, MG H80.

ROCHESTER MEMORIAL ART GALLERY, ROCHESTER, NEW YORK

Winifred Lansing file.

UNIVERSITÉ DU QUÉBEC À MONTRÉAL

Bibliothèque des Arts, École des Beaux-Arts fonds.

UNIVERSITY OF NEW BRUNSWICK ARCHIVES (UNBA)

Lucy Jarvis fonds, UA RG 357.
Madge Smith fonds, MG H80, Series 1, Correspondence 1941–63.

UNIVERSITY OF WATERLOO LIBRARY

Dorothea Palmer Collection, WA 17.

PRINTED SOURCES

UNATTRIBUTED SOURCES

"All Is Color." *Montreal Star*, 27 Oct. 1951.
"Around the Galleries." *Canadian Homes and Gardens* 11 (April 1934): 38–9.
"Around the Galleries." *Canadian Homes and Gardens* 11 (May 1934): 41.
"Around the Galleries." *Canadian Homes and Gardens* (May 1936): 23.
"Art Association Has Annual Sale: Excellent Display of Variety of Handicrafts Attracts
 Much Attention." *Ottawa Morning Journal*, 27 Nov. 1929.
"Art Association's Seventh Annual Exhibition Is Best Yet Arranged." *Ottawa Citizen*,
 19 April 1927.
"The Art Centre." *Saskatoon Star-Phoenix*, 5 and 12 June 1948.
"Art Collection Arouses Interest: 60 Works of Pegi Nicol McLeod [*sic*] Now on View at
 Museum." *Saint John Evening Times-Globe*, 16 Nov. 1949.
"Art Courses Are Offered." *Windsor Border Cities Star*, 20. Jan. 1928.
"Art Exhibition at University, Work of Outstanding Canadian Artist to Be Shown
 Tomorrow Afternoon." *Fredericton Daily Gleaner*, 29 June 1945.
"Art Talk Today." *Saint John Telegraph-Journal*, 9 July 1982.
"Artist Painting Saint John Scenes." *Saint John Telegraph- Journal*, 25 Aug. 1947.
"Artists Exhibit Many Pictures for Loan Plan: Launch New Scheme – Borrowers May
 Buy Selections under Group's Project." *Toronto Telegram*, 14 Nov. 1936.
The Arts in Canada. Ottawa: Department of Citizenship and Immigration, Canadian
 Citizenship Branch, 1965.
Arts in New Brunswick. Fredericton: Brunswick Press, 1967.
"The Arts in Therapy." (Exhibition catalogue.) New York: Museum of Modern Art, 1943.
"Association News: Fredericton Art Club." *Maritime Art* 1, no. 4 (April 1941): 29.
"Association News: New Brunswick/Saint John Art Club." *Maritime Art* 1, no. 1
 (Oct. 1940): 27.
"Brillante Fete Artistique A L'Ecole des Beaux-Arts [*sic*]," Montreal, *Le Canada*, 24 May
 1924.

"Canadian Art Schools." *Canadian Art* 4 (1946–7): 180–2.

Canadian Perspectives: A Collection of Canadian Art. Lethbridge, Alberta: Lethbridge
 Community College, Buchanan Resource Centre.

"Causerie." *Canadian Forum* 15, no. 177 (Aug. 1935): 323.

"Chaotic Street Life Depicted by Painter." *Ottawa Evening Citizen*, 23 Feb. 1948.

"Cold Window." *Montreal Daily Star*, 25 Feb. 1950.

"College Shows Work of Local Born Artist." *Banner* (Listowel, Ontario), 24 May 1962.

"'Combat Painters' Role in Europe; Canadian Artists Tell Visual Story of Dominion's
 Servicemen and Women." *Fredericton Daily Gleaner*, 5 June 1945.

*Creative Canada: A Biographical Dictionary of Twentieth-Century Creative and
 Performing Artists*. Vol. 1. Toronto: University of Toronto Press, published in association
 with McPherson Library, University of Victoria, BC, 1971.

"Deichmann Pottery." *Northward Journal* 18/19 (1980): 152–6.

"Drama League Opens Season with Clever, Enjoyable Mystery Play." *Ottawa Citizen*,
 13 Nov. 1929: 28.

"Excellent Pictures on Exhibition Here." *Ottawa Evening Citizen*, 27 Nov. 1929.

"Exhibit Opened." *Moncton Times*, 16 Jan. 1982.

"Exhibit Opens at UNB: Works of Pegi Nicol MacLeod." *Saint John Telegraph-Journal*,
 26 April 1962.

"Exhibit Paintings of Pegi Nichol [*sic*]." *Ottawa Citizen*, 24 July 1931.

"Exhibit Set for Florenceville." Unsourced clipping, author's collection, 28 Oct. 1985.

"Exhibition of Art Covers Wide Range: Annual Show of Ottawa Art Club Being Held at
 305½ Bank." *Ottawa Journal*, 20 Nov. 1925.

"Exhibition of the Canadian Group of Painters." *Canadian Art* 5, no. 3 (winter 1948):
 142.

"Exhibition Opens at UNB Tuesday." *Fredericton Daily Gleaner*, 21 April 1962.

"Expo MacLeod." *L'Evangeline* (Moncton), 31 March 1982.

"Expressionistic Works Feature Art Display." *Calgary Herald*, 23 July 1948.

"Feb. 4th–11th – Portraits, Landscapes and Studies by Pegi Nicol." Montreal: Leonardo
 Society, 1928.

"59 Paintings Auctioned for Refugees' Benefit Bring Total of $2,459." *Ottawa Citizen*,
 11 Oct. 1940.

"First Principal at Tech W.W. Nichol Passes On." Anonymous and undated newspaper
 obituary. Stratford-Perth Archives, Stratford, W.W. Nichol file.

"First Prize in Painting Given to Pegi Nichol [*sic*]: 'Log-Run' Wins Honors for Ottawa
 Girl." *Ottawa Evening Citizen*, 19 June 1931.

"Former Associates Pay Last Respects to W.W. Nichol." *Ottawa Journal*, 17 March 1952.

"Former Resident Dies in New York." *Fredericton Daily Gleaner*, 18 June 1956.

"Four Contemporary Woman Painters Exhibited in the Toronto Art Gallery in January."
 Maritime Art 1, no. 4 (April 1941).

"Fredericton." *Maritime Art* 3, no. 2 (Dec. 1942–Jan. 1943).

"Fredericton Art Club." *Maritime Art* 1, no. 1 (Oct. 1940): 27.

"Fredericton Art Club." *Maritime Art* 1, no. 2 (Dec. 1940): 25.

"Fredericton, N.B." *Maritime Art* 3, no. 5 (July–Aug. 1943): 165, 168.

"A Friendly Portrait of Pegi Nicol's Exhibition." *Ottawa Evening Citizen*, 15 June 1949.

"Gallery of Water Colors Opens." *Saint John Telegraph-Journal*, 21 Dec. 1963.

Handicrafts of York County, N.B. Loaned by Miss E. Madge Smith. (Exhibition catalogue.) Fredericton: University of New Brunswick, Harriet Irving Library, 1968.

HERSTORY: A Canadian Women's Calendar. International Women's Year Edition, 1975.

"Keen Interest at Opening of Art Exhibition Here." *Charlottetown Guardian*, 12 Oct. 1949.

"Keenly Admire Display of Art." *Ottawa Journal*, 17 March 1933.

"Leader." *Fredericton Brunswickian*, 15 March 1935.

"Listowel Born Artist Dies in New York." *Banner* (Listowel, Ontario), 17 Feb. 1949.

"MacLeod Exhibit On at Mount A Gallery." *Amherst Daily News*, 23 July 1982.

"MacLeod Exhibition Opens Tuesday." *Saint John Telegraph-Journal*, 21 April 1962.

"MacLeod Paintings Now on Exhibit." *Saint John Telegraph-Journal*, 26 July 1982.

"Manhattan Cycle" (adv.). *Toronto Daily Star*, 14 April 1947.

"Manhattan Cycle by Pegi Nicol MacLeod." *Toronto Daily Star*, 14 April 1947.

"Manhattan Cycle Scenes Fascinate after Study: Affiliation with Old Painters Found Despite Modern Approach." *Toronto Telegram*, 19 April 1947.

"Many View Memorial Exhibition of Pegi Nicol MacLeod's Work." *Ottawa Journal*, 15 June 1949.

"Memorial Art to Be Exhibited." *London Free Press*, 11 June 1949.

"Memorial Exhibition." *Moncton Daily Times*, 13 June 1949.

"Memorial Exhibition Next Week at National Gallery." *Ottawa Citizen*, 13 June 1949.

"Memorial Exhibition Opens at Art Centre." *Fredericton Daily Gleaner*, 25 Feb. 1974.

Memorial Exhibition, Pegi Nicol MacLeod 1904–1949. Ottawa: National Gallery of Canada, 1949.

"Memorial Paintings on Show." *Halifax Chronicle Herald*, 11 June 1949.

Memorial to Madge Smith, 1896–1974. Paintings by Pegi Nicol MacLeod. (Exhibition catalogue.) Fredericton: University of New Brunswick, Art Centre, 24 Feb.–13 March 1974.

"Miss Peggy Nicoll [sic], Artist, Sherbrooke Street, Montreal." *Montreal Herald*, 1932.

"Miss Pegi Nichol [sic] Bride of Mr. Norman MacLeod." *Toronto Globe and Mail*, 11 Dec. 1936.

"Modern Painting before Art Club, Mrs. Norman MacLeod, Canadian Artist, Visitor at Last Night's Meeting." *Fredericton Daily Gleaner*, 22 Oct. 1940.

"Mrs. MacLeod Laid to Rest in N.Y. City." *Ottawa Evening Citizen*, 15 Feb. 1949.

"Mrs. M'Leod, [sic] Painted Local Street Scenes." *New York Times*, 15 Feb. 1949.

"Mrs. P.N. MacLeod: Artist Held Shows in Toronto Galleries." *Toronto Globe and Mail*, 14 Feb. 1949.

"Murals Offer Opportunity to Record Canada at War: The Former Pegi Nicol, Visiting Here, Is Collecting Her Paintings for Toronto Exhibition Next January." *Ottawa Citizen*, 12 Aug. 1940.

"Museum Showing MacLeod Art Works." *Saint John Evening Times Globe*, 17 Feb. 1982.

"New and Better Art at Third Exhibition: Her Excellency at Women's Art Association Display." *Ottawa Journal*, 23 April 1923.

"New Brunswick Scenes Included." *Saint John Telegraph-Journal*, 12 June 1949.

"New Work of Art in Vocational School." *Carleton Sentinel* (Woodstock, New Brunswick), 22 Jan. 1942.

"Nicol, Pegi (Mrs. McLeod) [sic]." *Hamilton Spectator*, 19 April 1950.

"Notable Exhibit of Paintings Opens." *Ottawa Evening Journal*, 24 Dec. 1929.

"Notable Picture by Ottawa Artist: Pegi Nichol [sic] Works Brightness and Pattern into 'Amateur Hockey.'" *Ottawa Morning Journal*, 3 March 1934.

"Noted Artist Had Picture Showing: Pegi Nicol MacLeod Almost Belongs to the Capital City." *Fredericton Daily Gleaner*, 17 Dec. 1947.

"Observatory Art Centre." *Canadian Art* 2, no. 1 (Oct.–Nov. 1944): 34.

"Observatory Art Centre Opened October 19." *Fredericton Brunswicker*, 25 Oct. 1946.

"120 Students Complete Session at University of New Brunswick." *Fredericton Daily Gleaner*, 19 Aug. 1946.

"Open Exhibition at Arts School … Pupils Receive Prizes." *Montreal Gazette*, 24 May 1924.

"Ottawa Art Club." *Ottawa Citizen*, 21 Nov. 1925.

"Ottawa Artists Represented in New York Show." *Ottawa Journal*, April 1947.

"Ottawa Artists Show Their Work: Lady Byng Says Women's Art Association Doing Much to Encourage Art." *Ottawa Morning Journal*, 26 April 1923.

"Ottawa Artists Win Mention in Arts Contest: Mrs. Madge MacBeth Wins Honor in Drama Section of Willingdon Competition, Three Others among Painters Mentioned: Miss Pegi Nichol, George D. Pepper and Paul Alfred Successful Ottawans." *Ottawa Evening Citizen*, 3 May 1929.

"Painting Exhibit Most Attractive, Much Talent Shown by Those Who Have Work on Display." *Fredericton Daily Gleaner*, 26 Sept. 1942.

"Pegi MacLeod Drawings Are Exhibited," *Ottawa Citizen*, 15 Dec. 1950.

"Pegi MacLeod Paintings on Display." *Vancouver Daily Province*, 13 Oct. 1950.

"Pegi Nichol [sic]." *Ottawa Citizen*, 17 March 1933.

"Pegi Nichol [sic] MacLeod." *Montreal Gazette*, 7 March 1964.

Pegi Nicol. (Exhibition catalogue.) Montreal: Eaton's, Feb. 1932.

"Pegi Nicol." *Winnipeg Free Press*, 5 June 1949.

"Pegi Nicol has been decorating the restaurant on the fourth floor of T. Eaton and Company. The murals will be on view at the end of August." "Causerie," *Canadian Forum* 15, no. 175 (Aug. 1935): 323.

"Pegi Nicol MacLeod." *Moncton Times*, 2 and 16 Jan. 1982.

"Pegi Nicol MacLeod." *Saturday Night*, 11 Jan. 1941.

"Pegi Nicol MacLeod Collection Housed in UNB Observatory." *Fredericton Daily Gleaner*, 19 Dec. 1963.

"Pegi Nicol MacLeod Day at University of New Brunswick." *Fredericton Daily Gleaner*, 4 Nov. 1949.

"Pegi Nicol MacLeod Exhibition." *Montreal Gazette*, 29 Feb. 1964.

Pegi Nicol MacLeod Exhibition: Encaenia Programme. (Exhibition catalogue, 24 April–17 May 1962.) Fredericton: University of New Brunswick Art Centre, 1962.

"Pegi Nicol MacLeod Exhibition Opens in Permanent Gallery." *Fredericton Daily Gleaner*, 21 Dec. 1963.

"Pegi Nicol MacLeod (Galerie Walter Klinkoff)." *Montreal Gazette*, 11 Sept. 1982.

"Pegi Nicol McLeod [sic] Makes a Welcome Return to Canadian Galleries This Month." *Saturday Night*, 11 Jan. 1941.

"Pegi Nicol MacLeod Memorial Exhibition: Canadian Painter's Individuality Revealed in
 Collection at Fine Arts Museum." *Montreal Gazette*, 18 Feb. 1950.
"Pegi Nicol MacLeod 1904–1949 Retrospective Exhibition, Kitchener-Waterloo Gallery
 29 March–29 April, 1984." *Canadian Art* 5, no. 4 (summer 1984): 5–6.
"Pegi Nicol MacLeod Paintings Depict Confusion of Metropolis." *Ottawa Journal*,
 17 Feb. 1948.
"Pegi Nicol MacLeod Paintings on View: Characteristic Oils and Watercolors [*sic*]
 in Collection at West End Gallery." *Montreal Gazette*, 20 Oct. 1951.
Pegi Nicol MacLeod Retrospective. Fredericton: Gallery 78, 1981.
"Pegi Nicol MacLeod Retrospective Exhibition." Montreal, Royal Gallery, 26 Feb.–
 11 March 1964.
"Pegi Nicol MacLeod Show Opens Tuesday." *Ottawa Journal*, 13 June 1949.
"Pegi Nicol MacLeod Was Noted Artist: Was Instructor of Art in U.N.B. Summer School –
 Familiar Figure in Fredericton." *Fredericton Daily Gleaner*, 14 Feb. 1949.
Pegi Nicol Month. (Exhibition catalogue.) Fredericton: University of New Brunswick,
 Art Centre, 1981.
"Pegi Nicol's Landscapes and Portraits." *Montreal Star*. 17 Feb. 1932.
"Permanent Collection." *Fredericton Daily Gleaner*, 20 Dec. 1963.
"Pioneers of Fourth Estate Served Community Loyally; Stated Views Vigorously."
 Unsourced and undated article on the history of Stratford newspapers. Stratford,
 Stratford-Perth Archives, 691.3 c. 33.
"Portrait of W.W. Nichol, Former Principal, Is Unveiled at Twenty-Third Annual
 Commencement." Unsourced and undated newspaper obituary. Stratford, Stratford-
 Perth Archives, W.W. Nichol file.
"Portraits" Oil Paintings by Pegi Nicol MacLeod. (9–22 Nov. 1986.) Fredericton:
 Gallery 78, 1986.
"Recollections Sought of Pegi Nicol MacLeod." *University of New Brunswick Alumni
 News* (Dec. 1981): 6–7.
Robert McLaughlin Gallery. *Pegi Nicol MacLeod 1904–1949: A Retrospective Exhibition*.
 Oshawa: Robert MacLaughlin Gallery, 1983.
"Russell Harper Speaks at UNB." *Fredericton Daily Gleaner*, 17 May 1962.
Samara. Ottawa: Elmwood School (May 1925).
Samara. Ottawa: Elmwood School (June 1927).
"School for Fine Arts Opens Soon." *Montreal Gazette*, 6 Sept. 1923.
"School of Fine Arts Is Opened: Provincial Sec'y, French Consul-General and Others
 Give Awards." *Montreal Daily Star*, 24 May 1924.
"Small Picture Show." *Ottawa Citizen*, 8 Dec. 1932.
"Some Fine Paintings on Exhibition Here." *Charlottetown Patriot*, 12 Oct. 1949.
"Thrilling Melodrama, Cock Robin Ably Presented by Drama League." *Ottawa Journal*,
 13 Nov. 1929.
Through Canadian Eyes. (Exhibition catalogue.) Calgary: Glenbow Museum, 1976.
"A Tribute to Walter Abell." *Canadian Art* 2, no. 1 (Oct.–Nov. 1944): 14.
Twentieth Century Canadian Drawings. (Exhibition catalogue.) Stratford: Gallery
 Stratford, 1979.
"Two Paintings." *Northern Review* 3, no. 3 (Feb.–March 1950): 28–9.

"The Untimely Death." *Hanover Post*, 3 March 1949.

"Valedictorian of the Class of '35.'" *Fredericton Brunswickian*, 5 April 1935.

Vox Lycei. Ottawa: Lisgar Collegiate Institute, 1920.

Vox Lycei. Ottawa: Lisgar Collegiate Institute, 1921.

"War Art Exhibition Opening Next Week." *Saint John Telegraph Journal*, 29 Aug. 1980.

"War through Women's Eyes." *Capital City* [Ottawa] (27 May–2 June 1999):22.

"Water Colors [*sic*] to Hang at UNB." *Saint John Telegraph- Journal*, 17 Dec. 1963.

"Water Colour Annual." *Canadian Art* 2, no. 4 (April–May 1945): 170.

Watercolours and Oils by Pegi Nicol MacLeod. (21 Oct.–3 Nov. 1984.) Fredericton:
 Gallery 78, 1984.

"Will Exhibit Paintings of Pegi Nicol MacLeod." *Ottawa Evening Citizen*, 11 June 1949.

"William W. Nicol [*sic*] Dies, Was First Principal of Tech." *Ottawa Journal*, 15 March
 1952.

"Willingdon Arts Competition Has Proven Success: Second Year Prize Winners
 Announced." *Ottawa Evening Citizen*, 3 May 1930.

"With Trilliums in Her Hair." *Canadian Art* 4, no. 4 (summer 1947): 147–8.

"Wolfville Galleries Host Joint Shows." *Halifax Chronicle Herald*, 24 Sept. 1982.

"Women's Works on Exhibit." *Montreal Standard*, 2 April 1949.

"Work of Canadian Artist in Regina College Exhibit." *Regina Leader Post*, 10 Feb. 1951.

ATTRIBUTED SOURCES

Abell, Walter. "Canadian Aspirations in Painting." *Culture*, 3 (1942): 172–7.

– "Changing Attitudes toward Art." *Maritime Art* 1, no. 5 (June 1941): 3–7.

– "Contributors in This Issue." *Maritime Art* 1, no. 4 (April 1941): 1.

– "Editorial." *Maritime Art* 2, no. 1 (Oct.–Nov. 1941): 4.

– *Representation and Form*. Connecticut: Greenwood Press, 1971 (reprint).

– "Some Canadian Moderns." *Magazine of Art* 30, no. 7 (July 1937): 422–7.

Adams, James. "Bringing Carlu's Dream Back to Life." *Toronto Globe and Mail*
 (12 April 2003): R5.

Adaskin, Harry. *A Fiddler's World: Memoirs to 1938*. Vancouver: November House, 1977.

Alford, John. "The Development of Painting in Canada." *Canadian Art* 2, no. 3
 (Feb.–March 1945): 95–103.

Aylen, Marielle. "*Canadian Art* between the Years 1940–1955: The Editorial Vision of
 Walter H. Abell, Donald Buchanan and H.O. McCurry." (Extended essay.) Ottawa:
 Carleton University, 1993.

– *Making Faces: Canadian Portraiture between the Wars*. Ottawa: Carleton University Art
 Gallery, 1996.

Ayre, Robert. "Appeal, Charm of Pegi MacLeod Revived at Fine Arts Museum." *Montreal
 Daily Star*, 4 March 1950.

– "Art in Montreal – from Good to Indifferent." *Canadian Art* 8 (1950–51): 30–4.

– "Art Notes." *Montreal Daily Star*, 25 Feb. 1950.

– "Canadian Group of Painters." *Canadian Art* 6 (1948–49): 98–102.

– "Canadian Group of Painters." *Canadian Forum* 14, no. 159 (Dec. 1933): 98–100.

– "Pegi Nicol – As Refreshing As a Child." *Montreal Star*, 3 March 1964.

– "Picture-Loan Society Means of Acquiring Paintings You Admire." *Montreal Star*,
 17 Dec. 1933.
Banville, Judith. "MacLeod's works on exhibit: McLaughlin gallery director aims to raise
 artist's profile." *Toronto Star*, 3 Nov. 1983.
Barbeau, Marius. *L'arbre des rêves*. Montreal: Les Éditions Lumen, 1948.
– "The Canadian Northwest Theme for Modern Painters." *American Magazine of Art* 24,
 no. 5 (May 1932): 331–8.
– "La déliverance des Loups-Garous." Montreal *La Presse*, 4 March 1933.
– "The Tree of Dreams." *Canadian Geographical Journal* 7, no. 6 (Dec. 1933).
Barnes, Carol, and Judy Goodson. "Beauty in Business." *Montréal en ville*, 14 March
 1964.
Barry, Kathleen. "Towards a Theory of Women's Biography," in Teresa Iles, ed., *All Sides
 of the Subject: Women and Biography*. New York: Pergamon Press, 1992.
Barwick, Frances. *Pictures from the Douglas M. Duncan Collection*. Toronto: University
 of Toronto Press, 1975.
Bauer, Nancy. "Alfred Goldsworthy Bailey." *Toronto Globe and Mail* (28 May 1997): A 30.
Beals, Helen D. "Eighth Annual Meeting of the Maritime Art Association." *Maritime
 Art* 3, no. 5 (July–Aug. 1943): 162–5, 168.
– "Maritime Provinces." *Maritime Art* 3, no. 1 (Oct.–Nov. 1942): 27.
– "Maritime Provinces." *Maritime Art* 3, no. 2 (Dec.–Jan. 1942–3): 61.
Bell, Michael. "Introduction." *The Kingston Conference Proceedings*. Kingston:
 Agnes Etherington Art Centre, 1991.
Benton, Mary. "'Visions and Victories: Canadian Women Artists 1914-1945': Bringing
 Humanism and Emotion to an Emerging Canadian Art." *Antiques and Art* 10, no. 2
 (Nov. 1983): 3, 11.
Biéler, André, and Elizabeth Harrison, eds. *Proceedings, Conference of Canadian Artists*.
 Kingston: Queen's University, 1941.
Boyanoski, Christine. *Staffage to Centre Stage: The Figure in Canadian Art*. Toronto:
 Art Gallery of Ontario, 1989.
Brandon, Laura. "The Art of Pegi Nicol MacLeod." *Garrison* 2, no. 7 (Nov. 1993): 19.
– "The Canadian War Museum's Art Collections as a Site of Meaning, Memory, and
 Identity in the 20th Century." PhD dissertation, Carleton University, 2002.
– "The Essential Humanism of Pegi Nichol [*sic*] MacLeod." *Arts Atlantic* 17 (summer
 1983): 26–8.
– "Exploring 'the Undertheme': The Self-Portraits of Pegi Nicol MacLeod (1904–1949)."
 MA thesis, Queen's University, 1992.
– *Paragraphs in Paint: The Second World War Art of Pegi Nicol MacLeod*. Ottawa: Ottawa
 Art Gallery, 1999.
Brandon, Laura, and Dean Oliver. *Canvas of War*. Vancouver: Douglas & McIntyre,
 2000.
Bridle, Augustus. "Pegi Nicol's Scenes Collectively Weird." *Toronto Daily Star*, 16 April
 1947.
Brooker, Bertram, ed. *Yearbook of the Arts in Canada*. Toronto: Macmillan, 1936.
Brown, Maud. *Breaking Barriers: Eric Brown and the National Gallery*. Ottawa: Society
 for Art Publications, c. 1964.

Buchanan, Donald W. "Contemporary Painting in Canada." *Studio* 129, no. 525 (April 1945): 98–111.

– *The Growth of Canadian Painting*. London: Collins, 1950.

– *Le monde secret de Zadkine vu par Donald Buchanan*. Paris: Éditions L'art, c. 1966.

– "Naked Ladies." *Canadian Forum* 15, no. 175 (April 1935) 273–4.

– "Pegi Nicol MacLeod 1904–1949." *Canadian Art* 6, no. 4 (summer 1949): 158–62.

– "Pegi Nicol MacLeod 1904–1949." *Ottawa Evening Citizen*, 18 July 1949.

Burant, Jim. *The History of the Fine Arts in Ottawa and Surroundings, Part II: 1880–1945*. Ottawa: Ottawa Art Gallery, 1994.

Burant, Jim, and Robert Stacey. *North by South: The Art of Peleg Franklin Brownell (1857–1946)*. Ottawa: Ottawa Art Gallery, 1998.

Butler, Samuel. "Psalm of Montreal." *Spectator*, 18 May 1878.

Carney, Lora Senechal. "Working out the Destiny of Your Human Nature." Presented paper to Universities Art Association of Canada, Guelph, Ontario, Nov. 1995.

Carr, Emily. *Hundreds and Thousands: The Journals of Emily Carr*. Toronto: Clarke, Irwin, 1966.

Carver, Humphrey. *Compassionate Landscape*. Toronto: University of Toronto Press, 1975.

Cauglin, Grace A. "Woodstock's Reaction to Murals." *Carleton Sentinel* (Woodstock, New Brunswick), 1942.

– "Woodstock's Reaction to Murals." *Maritime Art* 2, no. 2 (Dec. 1941): 39.

Chadwick, Whitney. *Women, Art and Society*. London: Thames and Hudson, 1990.

Chambers, Bruce W.A. *Rochester Retrospective: Paintings and Sculpture (1880–1950)*. Rochester, New York: Memorial Art Gallery of the University of Rochester, 1980.

Clark, Nancy Cynthia. "Understandings and Misunderstandings of Modern Art in Canada: Aspects of Canadian Art Criticism and Theory c. 1910–c. 1940." MA thesis, Carleton University, 1986.

Claus, Joanne. "Stand Back and Appreciate Artist Pegi Nicol MacLeod." *Saint John Evening Times-Globe*, 24 Feb. 1982.

Conde, Valerie. "Women at War." *Windsor Daily Star*, 24 Feb. 1945.

Crosby, Marcia. "T'emlax'am: An Ada'ox," in Catharine M. Mastin, ed., *The Group of Seven in Western Canada*. Toronto: Key Porter, 2002.

Devree, Howard. "The Realm of Art: Activities of the Early Summer: Flames in the Embers. Season Continues to Offer New Shows – Canadians at the World's Fair." *Sunday New York Times*, 25 June 1939.

Dowling, Julie. "Women in War and Art not Well Known Subject." *Charlottetown Guardian*, 16 November 1998, C 3.

Duncan, Isadora. *My Life*. New York: Boni and Liveright, 1927.

Duval, Paul. *Canadian Water Colour Painting*. Toronto: Burns and MacEachern, 1954.

– *Four Decades: The Canadian Group of Painters and Their Contemporaries, 1930–1970*. Toronto: Clark Irwin, 1972.

Dyck, Sandra. "'These Things Are Our Totems': Marius Barbeau and the Indigenization of Canadian Art and Culture in the 1920s." MA thesis, Carleton University, 1995.

Ellis, John C. *John Grierson: Life, Contributions, Influence*. Carbondale: Southern Illinois University Press, 2000.

Farr, Dorothy, and Natalie Luckyj. *From Women's Eyes: Women Painters in Canada*. Kingston: Agnes Etherington Art Centre, 1975.

Feheley, Patricia Maureen. "Douglas Duncan and the Picture Loan Society, 1936–1950." MMuseol. thesis, University of Toronto, 1979.

Ferguson, George. *Signs and Symbols in Christian Art*. Oxford University Press, 1961.

Ferns, H.S. *Reading from Left to Right*. Toronto: University of Toronto Press, 1983.

Finlay, Karen. "The Force of Culture: Vincent Massey and Canadian Sovereignty." PhD dissertation, University of Victoria, 1999.

– *The Force of Culture: Vincent Massey and Canadian Sovereignty*. Toronto: University of Toronto Press, 2003.

Finnie, Richard S. "Memories of Pegi Nicol." Quoted in Murray, ed., *Daffodils in Winter*. Appendix 2, 319–20.

Firth, Edith G. *Toronto in Art: 150 Years through Artists' Eyes*. Toronto: Fitzhenry & Whiteside, in co-operation with the City of Toronto, 1983.

Fisher, Barbara E. Scott. "For, says Pegi Nicol MacLeod, you can successfully teach anything through art." *Christian Science Monitor*, 26 June 1946.

Forsey, Eugene. "The Ottawa Collegiate Institute, Sixty Years Ago." In *Lisgar's 140th*. Ottawa: Lisgar Collegiate Institute, 1984.

Frye, Northrop. "Men as Trees Walking." *Canadian Forum* 18 (Oct. 1938): 208–10.

Geller, Peter. "Northern Exposures: Photographic and Filmic Representations of the Canadian North, 1920–1945." PhD dissertation, Carleton University, 1995.

Gessell, Paul. "Politically Incorrect Art Correctly Reflects Time." *Ottawa Citizen* (May 1999).

Greenhorn, Beth, "An Art Critic at the Ringside: Mapping the Public and Private Lives of Pearl McCarthy." MA thesis, Carleton University, 1996.

Gregg, Erica Deichmann. *Pegi Nicol MacLeod*. Fredericton: 1982.

Gribbon, Michael. *Walter J. Phillips: A Selection of His Works and Thoughts*. Ottawa: National Gallery of Canada, 1978.

Hall, Calvin S. *The Meaning of Dreams*. New York: McGraw Hill, 1966.

Hall, James. *Dictionary of Subjects and Symbols in Art*. London: John Murray, 1989.

Hall, Joanne, ed. *Centennial at Listowel*. London: Murray Kelly Limited and Centennial Committee of The Town of Listowel, 1975.

Harper, J. Russell. *Painting in Canada: A History*. Toronto: University of Toronto Press, 1966.

– "Pegi Nichol [sic] MacLeod." Transcript of speech delivered in connection with the Convocation Conversazione at the University of New Brunswick Art Centre, 16 May 1962.

– "Pegi Nicol MacLeod: A Maritime Artist." *Dalhousie Review* 43, no. 1 (spring 1963): 40–50.

Harrison, Helen A., et al. *Dawn of a New Day: The New York World's Fair, 1939/40*. New York: Queens Museum, 1980.

[Harrold], E.W. "Art Association Exhibition." *Ottawa Evening Citizen*, 23 (or 28) Dec. 1929.

– "Art Association's Seventh Annual Exhibition Is Best Yet Arranged." *Ottawa Morning Citizen*, 10 April 1927.

– "Drama League Players in Third Bill of Little Theater [*sic*] Season Again Score Distinct Success." *Ottawa Citizen*, 7 March 1928.

– "Exhibit Paintings of Pegi Nichol." Ottawa *Citizen*, 24 July 1931.

Heilbrun, Carolyn G. *Writing a Woman's Life*. New York: Ballantine Books, 1988.

Hersey, Richard. "Two Artists Hold Show at Gallery: Pegi Nicol MacLeod, Ernst Neumann Widely Contrasting." *Montreal Standard*, 4 March 1950.

Hicklin, R.C. "Pegi Nicol MacLeod – Painter." W.W.B.'s *Hilltop* 1, no. 1 (April 1948).

Hill, Charles C. *Canadian Painting in the Thirties*. Ottawa: National Gallery of Canada, 1976.

– *The Group of Seven: Art for a Nation*. Toronto: McClelland and Stewart, 1995.

Housser, Yvonne McKague. "Canadian Group of Painters – 1944. A Biennial Exhibition Shown at the Art Association of Montreal January 7 to 31; at the London Art Museum February 11 to March 7; at the Art Gallery of Toronto April 21 to May 21." *Canadian Art* 1, no. 4 (April–May 1944): 142–6.

Hubbard, R.H., ed. *An Anthology of Canadian Art*. Toronto: Oxford University Press, 1960.

Inglis, Stephen. *The Turning Point: The Deichmann Pottery, 1935–1963*. Hull, Quebec: Canadian Museum of Civilization, 1991.

Jarvis, Lucy. "Observatory Art Center [*sic*]." *Maritime Art* 1, no. 5 (June 1941): 33.

Jordan, Katharine A. *Fifty Years: The Canadian Society of Painters in Water Colour 1925–1975*. Toronto: Art Gallery of Ontario, 1974.

Kilbourn, Elizabeth. *Great Canadian Painting: A Century of Art*. Toronto: McClelland & Stewart, 1966.

Kimmel, David. "Toronto Gets a Gallery: The Origins and Development of the City's Permanent Public Art Museum." *Ontario History* 84, no. 3 (Sept. 1992): 195–210.

Kritzwiser, Kay. "Artistic Fire from Women's Eyes." *Toronto Globe and Mail*, 17 Jan. 1976.

Lalonde, Christine. "'A Real Blaze of Sunshine': The Career of Kathleen M. Fenwick." *National Gallery of Canada Review/Revue du Musée des beaux-arts du Canada* 1 (2000): 89–98.

Lambe, Virginia. "Sir George [Williams University] Show Fills Many Gaps." *Montreal Gazette*, 6 Jan. 1968.

Lesser, Gloria. "Biography and Bibliography of the Writings of Donald William Buchanan (1908–1966)." *Journal of Canadian Art History* 5 (1980–81): 129–37.

Lister, May. "Fredericton." *Maritime Art* 2, no. 2 (Oct.–Nov. 1941): 24.

– "Fredericton, N.B." *Maritime Art* 2, no. 4 (June–July 1942): 163–4.

Lort, Kit. "Pegi Nicol MacLeod: 1904–1949: Retrospective Exhibition." *Arts Atlantic* 5, no. 4 (summer 1984): 4–5.

Luckyj, Natalie. *Expressions of Will: The Art of Prudence Heward*. Kingston, Ontario: Agnes Etherington Art Centre, 1986.

– *Helen McNicoll: A Canadian Impressionist*. Toronto: Art Gallery of Ontario, 1999.

– *Other Realities: The Legacy of Surrealism in Canadian Art*. Kingston, Ontario: Agnes Etherington Art Centre, 1978.

– *Visions and Victories: Ten Canadian Women Artists 1914–1945*. London, Ontario: London Regional Art Gallery, 1983.

MacDonald, Colin S. *A Dictionary of Canadian Artists*. Vol. 4. Ottawa: Canadian
 Paperbacks, 1967, 1066–9.

MacKay, Marylin J. *A National Soul: Canadian Mural Painting 1860s–1930s*. Montreal:
 McGill-Queen's University Press, 2002.

MacLeod, Pegi Nichol [sic]. "Adventure in Murals." *Carleton Sentinel* (Woodstock,
 New Brunswick), 1942.

– "Adventure in Murals." *Maritime Art* 2, no. 2 (Dec. 1941): 37–9.

– "Canadian Women Painters." *Toronto Daily Star* (3 Sept. 1947).

– "Recording the Women's Services." *Canadian Art* 2, no. 2 (Nov./Dec. 1944): 48–51.

– Women's Divisions of the Army, Navy and Air Force: Oil and Water Colours,
 Aug.–Sept.–Oct. 1944. [Typescript.] National Gallery of Canada, Ottawa, 1944.

MacLeod, Wendell, Libbie Park, and Stanley Ryerson. *Bethune: The Montreal Years,
 an Informal Portrait*. Toronto: James Lorimer and Company, 1978.

Martin, Denis. *Printmaking in Quebec, 1900–1950*. Quebec: Musée du Quebec, 1988.

Massey, Vincent. "Foreword." In *Memorial Exhibition: Pegi Nicol MacLeod: 1904–1949*.
 Ottawa: National Gallery of Canada, 1949.

Mawr, David. "Pegi Nicol MacLeod." *Windsor Daily Star* (18 June 1949).

McCarthy, Pearl. "Art and Artists: Honor [sic] for Mestrovic Pleases Friends Here."
 Toronto Review, 1947.

McInnes, Graham [Campbell]. "Art and Artists." *Saturday Night* (14 Dec. 1940).

– "Art of Canada." *Studio* 64, no. 533 (Aug. 1937): 55–72.

– "Artist of the Wayward Brush." *Ottawa Citizen*, 14 Feb. 1949.

– *Canadian Art*. Toronto: MacMillan Company of Canada, 1950.

– "Canadian Artists to Confer." *Saturday Night*, 19 April 1941.

– "Canadian Critic Proclaims Independence of the Dominion's Art." *Art Digest* 10, no. 11
 (March 1936): 10–11.

– "Canadian Group of Painters." *Canadian Art* 3, no. 2 (Jan.–Feb. 1946): 76–7.

– "Contemporary Canadian Artist: No. 8 – Pegi Nicol." *Canadian Forum* 17, no. 202
 (Sept. 1937): 202–3.

– "The Decline of Genre." *Canadian Art* 9, no. 1 (autumn 1951): 11–14.

– *Finding a Father*. London: Hamish Hamilton, 1967.

– "Four Women Painters Made up a 'Four-Man' Show in the Print Room at the Art
 Gallery of Toronto." *Maritime Art* 1, no. 3 (Feb. 1941): 17.

– "Picture Loaning New Force in Art: Bargaining against Rules in Latest Toronto
 Project." *Mail and Empire*, 16 Nov. 1936.

– "The Purpose of Painting." *Canadian Forum* 16, no. 190 (Nov. 1936): 30.

– "Vivacious Artist." *Saturday Night*, 9 Feb. 1935.

– "Water Colors [sic]." *Saturday Night* (April 1936): 8.

– "World of Art." *Saturday Night*, 4 Dec. 1937.

– "World of Art." *Saturday Night*, 23 April 1938.

McKenzie, Karen, and Larry Pfaff. "The Art Gallery of Ontario: Sixty Years of Exhibitions,
 1906–1966." *Revue d'art canadienne/Canadian Art Review* 7, nos. 1 and 2 (1980): 62–84.

McTavish, Lianne. "Pegi Nicol MacLeod: Paragraphs in Paint." *Arts Atlantic* 65, no. 1
 (winter 2000): 4.

Murray, Joan. "A Century of Canadian Women Artists." *Art Impressions* 4, no. 2
 (summer 1988): 14–16.
– ed. *Daffodils in Winter: The Life and Letters of Pegi Nicol MacLeod, 1904–1949*.
 Moonbeam, Ontario: Penumbra Press, 1984.
Nichol [*sic*], Pegi. "R.C.A. Impressions." *Ottawa Citizen*, 4 May 1929.
Nichol [*sic*], Pegi, illus. *Canadian Nation* 2, no. 1 (March–April 1929): 3, 15.
– *Canadian Nation* 2, no. 2 (May–June 1929): 3, 5, 18.
– *Prism* 2, no. 1 (fall 1960): cover.
Nicol, Pegi. "The Kingdom of the Saguenay." *Canadian Forum* 16, no. 187 (Aug. 1936):
 30.
– "Loan Exhibition of Paintings." *Canadian Forum* 15, no. 177 (Aug. 1935): 390.
– "Miller Brittain." *Canadian Art* 1, no. 4 (April 1941): 14–18.
– "The Passionate Snow of Yesteryear." *Canadian Forum* 16, no. 183 (April 1936): 21.
– "Representation and Form." *Canadian Forum* 16, no. 190 (Nov. 1936): 30–1.
– "Where Forgotten Gods Sleep." *Canadian National Magazine* 17, no. 1 (March 1931):
 25, 52.
Nicol, Pegi, and illus. "The Un-Drama Festival: The Canadian Drama Festival from the
 Competitors' Point of View." *Canadian Forum* 13, no. 153 (June 1933): 339.
Nicol, Pegi, illus. "Blind Joe's Wife, a Woodcut." *Seigneur, Magazine of the Seigniory
 Club* 3 (June 1932): 2.
– "Five O'Clock." *Canadian Forum* 16, no. 189 (Oct. 1936): 17.
– "Légende française du Laurent–Dessins de Pegi Nicol." Montreal *La Presse*, 7 Jan. 1933.
– "Merry Christmas." *Canadian Forum* 16 (Dec. 1936): 13.
– Marius Barbeau. *L'arbre des rêves*. Montreal: Les editions Lumen, 1947: 54, 119.
– "Récits de grand'mere Angèle." Montreal *La Presse*, 4 March 1933.
Norbury, F.H. "Museum Displays Memorial Exhibit." *Edmonton Journal*, 6 Dec. 1950.
Nowry, Lawrence. *Man of Mana: Marius Barbeau*. Toronto: NC Press, 1995.
Ogilvie, Will. "Pegi Nicol MacLeod." Unpublished essay, Feb. 1984. Author's collection.
Ord, Douglas. *The National Gallery of Canada: Ideas, Art, Architecture*. Montreal:
 McGill-Queen's University Press, 2003.
Pacey, Desmond. "Pegi Nicol MacLeod's Memorial Display – A Tribute." *Fredericton
 Daily Gleaner*, 8 Nov. 1949.
Page, P.K. "Treasures from Maritime Soil, the Story of the Deichmann Pottery." *Maritime
 Art* 1, no. 2 (Dec. 1940): 7–11.
Pageot, Édith-Anne. "Ambiguïtés de la reception critique de l'exposition «*Canadian
 Women Artists*», Riverside Museum, New York, 1947." *Revue d'art canadienne/
 Canadian Art Review* 27, nos. 1–2 (2000): 123–34.
Palette. "Interesting Exhibition at UBC Art Gallery." *Vancouver Daily Province*,
 21 Oct. 1950.
Pantazzi, Michael. "Pegi Nicol MacLeod: Principal Exhibitions," in Murray, ed.,
 Daffodils in Winter, separately printed.
Peabody, Josephine Preston. *The Piper*. Scenery designed by Pegi Nicol. (Theatre
 program.) Toronto: University of Toronto, Hart House Theatre, 1934–35.
Pfeiffer, Dorothy. "Pegi Nicol MacLeod." *Montreal Gazette*, 7 March 1964.

Rahr, Valentina. "Special Exhibit Opens Here." *Montreal Monitor*, 27 Feb. 1964.

Reid, Dennis. *A Concise History of Canadian Painting*, 2nd ed. Toronto: Oxford University Press, 1988.

Rex, Kay. "Exciting Exhibition for National Gallery." *Toronto Globe and Mail*, 11 June 1949.

– "Memorial Exhibition Next Week at National Gallery." *Ottawa Evening Citizen*, 11 June 1949.

Riopelle, Christopher. "A Checklist of Christmas Cards by Canadian Artists Sent to the National Gallery of Canada." Ottawa: National Gallery, 1974: 10.

Robertson, Heather. *A Terrible Beauty: Art of Canada at War*. Toronto: James Lorimer and Company, 1977.

Robitaille, Adrien. "Pegi Nicol et E. Neumann au musée des Beaux-Arts." Montreal *Le Devoir*, 4 March 1950.

Sabat, Christina. "A Look at Artist's Canadian Connection." *Toronto Globe and Mail*, 27 Nov. 1981.

– "Visual Arts in Review." *Fredericton Daily Gleaner*, 21 Nov. 1981.

– "Visual Arts in Review." *Fredericton Daily Gleaner*, 23 April 1983.

– "Visual Arts in Review." *Fredericton Daily Gleaner*, 20 Oct. 1984.

Scalzo, Julia. "Walter Abell: From Maritime Art to Canadian Art." *Vanguard* 16, no. 1 (Feb.–March 1987): 20–2.

Schama, Simon. *Dead Certainties (Unwarranted Speculations)*. New York: Vintage, 1992.

Shackleton, Kathleen. "Art in Action." *Maritime Art* 2, no. 4 (July 1942): 158–9, 172–3.

Shinhat, Molly Amoli K. "War Widows: Two Views of Women from the Homefront." *Ottawa X Press*, 27 May 1999, 18

Sicotte, Helen. "Walter Abell au Canada, 1928–1944, contribution d'un critique d'art americain au discours canadien en faveur de l'intégration sociale de l'art." *Journal of Canadian Art History /Annales d'histoire de l'art canadien* 9, nos. 1 and 2: 88–108.

Smith, Frances K. *André Biéler: An Artist's Life and Times*. Toronto: Meritt, 1980.

Smith, Stuart Allen. Catalogue essay in *Pegi Nicol MacLeod Retrospective*. Fredericton: University of New Brunswick Art Centre, 1981.

– "Daffodils in Winter: Pegi Nicol MacLeod." *Vanguard* (summer 1985): 22–4.

Stoffman, Judy. "The Rediscovery of Paraskeva Clark." *Chatelaine* (August 1983): 40, 102, 104, 106.

Strong-Boag, Veronica. *The New Day Recalled: Lives of Girls and Women in English Canada, 1919–1939*. Markham, Ontario: Penguin Books Canada Ltd., 1988.

Sullivan, Rosemary. *Elizabeth Smart, A Life*. Toronto: Viking, 1991.

Swanick, Lynne Struthers. "Madge Smith, New Brunswick." *Canadian Women's Studies* (summer 1980).

Thornton, Mildred Valley. "Coast Group Exhibits at Art Gallery." Unattributed newspaper clipping, 13 Nov. 1948.

– "Memorial Exhibit at UBC Gallery." *Vancouver Sun*, 23 October 1950.

Thurber, James. *The Years with Ross*. New York: Harper Perennial, 2001.

Tippett, Maria. *By a Lady: Celebrating Three Centuries of Art by Canadian Women*. Toronto: Penguin Books, 1992.

– *Making Culture: English-Canadian Institutions and the Arts before the Massey Commission.* Toronto: University of Toronto Press, 1990.

Trépanier, Esther. *Marian Dale Scott: Pioneer of Modern Art.* Quebec: Musée du Québec, 2000.

– "In Memoriam, Hommage à Marian Dale Scott (1906–1993) – A Tribute to Marian Dale Scott (1906–1993)." *Journal of Canadian Art History/Annales d'histoire de l'art canadien* 15, no. 2 (1994): 68–96.

Tweedie, R.A., Fred Cogswell, and W. Stewart MacNutt, eds. *Arts in New Brunswick.* Fredericton: Brunswick Press, 1967.

Underhill, Frank. "Yearbook of the Arts in Canada." *Canadian Forum* 16, no. 191 (Dec. 1936): 27–8.

Ungar, Molly. "The Last Ulysseans: Culture and Modernism in Montréal, 1930–39." PhD dissertation, York University, 2003.

Valliant, Lois. "Robert Hugh Ayre (1900–1980), Art – A Place in the Community. Reviews at *The Gazette*, Montreal (1935–1937) and at *The Standard*, Montreal (1938–1942)." MA thesis, Concordia University, 1991.

Valverde, Fiona. "The Canadian War Artists' Programme 1942–1946." MLitt. thesis, Cambridge University, 1997.

Varley, Christopher. *The Contemporary Arts Society.* Edmonton: Edmonton Art Gallery, 1980.

Weiselberger, Carl. "Art of Pegi Nicol MacLeod at National Gallery." *Ottawa Citizen*, 13 June 1949.

Zemans, Joyce. "Envisioning Nation: Nationhood, Identity and the Sampson Matthews Silkscreen Project: The Wartime Prints." *Journal of Canadian Art History/Annales d'histoire de l'art canadien* 19, no. 1 (1998).

Acknowledgments

An extraordinary number of people have helped me with this biography of Pegi Nicol MacLeod over the years. I am grateful to all of them. In terms of the research – part of which resulted in my MA thesis in 1992 and a section of which I incorporated into my PhD dissertation in 2002 – I would like to acknowledge the help of the following friends and colleagues of the artist, the many collectors of her work, and the archivists, librarians, and art historians without whose assistance and suggestions this undertaking would not have progressed. Where they were specifically associated with this study, I identify them, or their institutions, in the endnotes and/or bibliography. If I have inadvertently missed anyone, I apologize unreservedly. While I am not specifying the fact alongside their names here, a significant number of the people mentioned here are now dead. My one regret is that they will never know that I did finish what I set out to do some twenty years ago.

I wish to thank Reuben Abramowsky, Mrs Nelson Adams, Frances Adaskin, Danielle Allard, Richard Alway, Arthur Ament, James Anderson, Shirley Andreae, Geoffrey Andrew, Maggie Arbour-Doucette, Margaret Archibald, Caven Atkins, Howard Averill, John Aylen, Marielle Aylen, Peter Aylen, Fred Azar, Margaret Baerman, Dr and Mrs Alfred Bailey, John Barbour, Murray Barnard, Wayne Barrett, Michael Bell, Molly Bell, Jane Bender, Jane Beveridge, Marion Beyea, André and Jeanette Biéler, Jacques Biéler, Ted Bieler, Florence Bird, Edith Bishop, Hunter Bishop, Claude Bissell, Horace Block, Bruno and Molly Bobak, Laurel Boone, Pat Bovey, Michael Bowie, Christine Boyanoski, Raymond Boyer, George Brandak, Jim Brennan, Caroline Brettell, Allan Brown, Donna L. Brown, Tobi Bruce, Jim Burant, Jean Burd, Cyndie Campbell, Rosamond Campbell, Susan Campbell, Sylvestre Carlyle, Lora Senechal Carney, Humphrey Carver, Peter Carver, Douglas E. Cass, Mimi Cazort, René Cera, Monica Chagoya, Nicole Chamberland, Louisa Chapman, James A. Clapperton, Mary Clark, Paraskeva Clark, Jessie Clary, Patricia Claxton-Oldfield, Dorothea Coates, Marion Helen Cobb, Norman R. Cody, Terri Collins, Louise Comfort, Mela Constantinidi, Sandy Cooke, Catherine M. Cowan, Judith Crawley, Lisa Christensen, Felicia Cuckier,

Cynthia Culbert, Greg Curnoe, J. Cuthbertson, John Dean, Henrik
Deichmann, Barry Dennis, Joanne Déry, Louise Dompierre, Marjorie
Donaldson, Lise Dubois, Daphne Dufresne, France Duhamel, Alma
Duncan, Darcy Dunton, Deborah Dunton, T. Davidson Dunton, Paul
Duval, Sandra Dyck, Letitia Echlin, Barry Fair, Barker Fairley, Dorothy
Farr, Fred Farrell, Richard Finnie, Jennie Fleming, Mary Flagg, Eugene
Forsey, Margaret Forsyth, David Franklin, Ted Fraser, Lawrence Freiman,
Lillian Freiman, André Fronton, Frances Fyfe, Donald Gammon,
Geoffrey Gammon, Elizabeth Garbutt, Mr and Mrs F.E. Garbutt, George
Garbutt, Alec Gardner-Medwin, Cassandra Getty, Denis R. Giblin,
David Gill, Stephen Glavin, Laurie Glenn, Anne Goddard, Tim Godfrey,
Charles Goldhamer, Anne Goluska, Alison Gordon, Charles Gordon,
Mr and Mrs J. King Gordon, Lois Gordon, Fiona Graham, Gerald S.
Graham, Hugh Graham, John Graham, W.H. Graham, J.L. Granatstein,
Bridget Toole Grant, Charity Grant, George Grant, Charlotte Gray,
Rod Green, Mr and Mrs Jack Greenwald, Michael Greenwood, Erica
Deichmann Gregg, Nan Gregg, Michael Gribbon, Elizabeth Griffin,
Naomi Jackson Groves, Paul A. Hachey, Nora Hague, Hugh Halliday,
Annabel Hanson, Catherine Harding, Byrne Harper, Mary Beth Harris,
Susan Hasbury, Kent M. Haworth, Joy Heft, William Heick, Charles C.
Hill, Thomas A. Hillman, Quyen Hoang, Vicki Hollington, Owen G.
Holmes, Helen Holt, Mark Holton, Yvonne McKague Housser, Judy
Howard, D.L. Howson, William L. Hoyt, R.H. Hubbard, Robert Hucal,
Dr Anna Hudson, Mrs Jack Humphrey, Alison Ignatieff, George Ignatieff,
Michael Ignatieff, Ray Jackson, Linda Jansma, Lucy Jarvis, Lynda Jessup,
Vojtech Jirat-Wasiutinski, Frances Johnston, George Johnston, Margot
Johnston, Robert Jordan, Paul Kastel, Martha Kelleher, Mrs A. Kemp,
H.G. Kettle, George and Lola Kidd, Harold Kirkpatrick, Virginia
Kopachevsky, Lori Korolnek, Ludwig Kosche, Franzisca Kruschen,
Linda Kurtz, Renée P. Landry, Victor Lange, Richard Lansing, Brenda
Large, Peter Larocque, Jonathan Lathigee, John Latour, Helen Lazier,
Kathy Lea, Kelly LeBlanc, R. LeBlanc, Jean L'Ésperance, Dawn Logan,
Susan Luckhardt, Natalie Luckyj, Ian Lumsden, Harold E. Lusher,
Margaret S. Machell, Colin B. MacKay, Margaret Mackenzie, Jean G.
Macknight, Mary MacLachlan, Lisa MacLean, Lachlan MacQuarrie,
Edna Magder, Marie Maltais, Angela Marcus, Kent Martin, Hart Massey,
Henri Masson, Master and Fellows of Massey College (University
of Toronto), Catharine Mastin, Storrs McCall, Norah McCullough,

Joan McInnes, Isabel McLaughlin, Rodger and Joann McLennan, John McLeod, Ann McMurdo, Lucy McNeill, David McTavish, Marjorie Mersereau, Carl Michailoff, Marilyn Miller, Sherry Miller, Susan Miller, Florence Millman, Sandra Mitchinson, Isabel Montplaisir, Frances G. Moore, Tom Moore, Linda Morita, Robert Muir, Edward Mullaly, Donald G. Mutch, Peter Neary, Janet Nelin, Connie Nichols, Sheila Nichols, Virginia Nixon, Marjorie Borden Oberne, Jane O'Brian, Cheryl O'Brien, Paddy O'Brien, Robert Ogilvie, Will Ogilvie, Brian Oickle, Karen O'Reilly, William Ormsby, Michael Ostroff, Louise Ouelette, Libby Oughton, Mary Pacey, Sandra Paikowsky, Denyse Papineau, MacLeod Pappidas, Libbie Park, Louise Parkin, Inge Pataki, Ghislaine Peloquin, Marion C. Pennington, Kathleen Daly Pepper, Allan Pettie, Elaine Phillips, Gerald and Isabelle Pittman, Barbara Potter, Robert Power, Mary Pratt, Dalila Barbeau Price, Edwin Procunier, Steve Proulx, Cameron Pulsifer, A.G. Rain, Mr and Mrs G.S. Rankin, Amiro Raven, Phyllis Rea, Dennis Reid, Kevin Rice, Brenda Rix, Clive Roberts, Marion S. Roberts, Marcia Rodriguez, Linden Rogers, Francis Rolleston, Susan Roote, A.W. Ross, Mr and Mrs Leo Rosshandler, Margot Rousset, Bernadette Routhier, David W. Rozniatowski, Peggy and Harold Samuels, John Saunders, Pamela Sawyer, Carl Schaefer, Cynthia C. Schaefer, Judith Schwartz, Frank Scott, Martha Scott, Peter Scott, Anne Scotton, Joseph Sherman, Judy Simpson, Dorothy Sleep, Tom Smart, Frances K. Smith, Jori Smith, Marta Smith, David Somers, Irene Spry, Bill Stapleton, Joan Stebbins, Mr and Mrs David Stein, Dr Max Stern, Rosemary Sullivan, Erma Lennox Sutcliffe, Maia-Mari Sutnik, G. Thomas Tanselle, Ralph Taylor, Ian Thom, Joan A. Thornley, Maria Tippett, Norah Toole, Juanita Toupin, Rosemarie Tovell, Vern Tozer, Clarence Tracy, Esther Trépanier, R.A. Tweedie, Molly Ungar, Juta Upshall, Lucille Vachon, Lois Valliant, Christopher Varley, Helle K. Viirlaid, Maija Vilcins, Sandra Vilimas, Herman Voaden, Jana Vosikovska, Janet Walters, Duncan and Jennifer White, Bruce Whiteman, Kathy Wideman, Betty F. Wilkinson, Megan Williams, Michael Williams, Moncrieff and Pamela Williamson, Olexander Wlasenko, Fay Wood, Hilda Woolnough, Marion Wyse, and Joyce Zemans.

Pegi Nicol MacLeod was much loved, and over the course of the long gestation of this book her friends have been more help than I can ever adequately express. It was a privilege to have met, and in some cases

known, them. They were, and remain, an unusually talented generation
of imaginative, ambitious, dedicated, generous, and courteous people.

It is appropriate, however, to draw particular attention to some of them
here. The late Ruth Comfort Jackson, the daughter of Pegi's friends
Charles and Louise Comfort, deserves special mention: she determined
to begin – as her United Nations Women's Year project in 1975 – what I
have completed here. She kept all her material, which included taped
interviews with friends of Pegi's who had passed away even before I began
my research. One important interview was with Maud Brown, the widow
of Eric Brown, first director of the National Gallery of Canada and an
enormous influence on Pegi. This and all her other encounters were
willingly shared with me. Pegi's closest and most loved artist friend, the
late Marian Scott, gave me two days of her valuable time to talk about
her and granted me permission to use the most significant collection
of Pegi's letters – those that Pegi wrote to her, which stretch from 1930
to 1948. This correspondence is now in Library and Archives Canada.
In the course of a lengthy interview, Winifred Lansing, one of Pegi's
closest New York friends, provided me with remarkable psychological
insight into the Pegi of the New York period. Grateful thanks are also
due Pegi's daughter, Jane, who, with her husband, Aristides Pappidas,
has been unstintingly supportive and generous.

Joan Murray, who edited Pegi's letters in 1984 and conducted innu-
merable interviews with artists on the subject of Pegi, deserves special
gratitude for making her pioneering work on the painter publicly acces-
sible. While she and I began our research at the same time, her 1984
publication of Pegi's letters, *Daffodils in Winter*, remains an essential
resource for any study of the artist.

And, of course, I extend grateful appreciation to the Prince Edward
Island Council of the Arts for a research grant and to the Canada
Council for two awards, one of which was an Explorations Grant that
included sufficient money for childcare, without which I probably never
would have completed the initial research. John Parry's contribution
shortened the manuscript but left my own words – the mark of an
extraordinary editor. Ellen McLeod's supportive contribution, particularly
to the bibliography and endnotes, was critical and much appreciated.
Equally so was the support provided by Aurèle Parisien, Joan McGilvray,
Glenn Goluska, and their colleagues at McGill-Queen's University Press.
The contribution of the outside readers who agreed to review the manu-

script was of enormous assistance and did much to improve it. I would also like to thank those who assisted so generously and efficiently in providing and producing the photography for this book. In particular, here, I would like to acknowledge the early and generous support of this project by Anne Scotton in memory of Marian Scott.

I would also like to thank the Beaverbrook Canadian Foundation, whose generous support made publication of this book possible.

To the many childminders who have helped me in past years I owe a significant debt of gratitude. My husband and children know that I thank them from the bottom of my heart for their patience and tolerance. My mother, Mary Graham, worked tirelessly on the manuscript in several iterations – the first time in a period in which she was also caring for my dying father. I dedicate the finished volume to her.

Index